IMAGES
of America

BELLEVILLE

To my husband, Rick, and my late grandmother, Ann—two special people who taught me to believe in myself.

IMAGES
of America

BELLEVILLE

Nicole T. Canfora

ARCADIA
PUBLISHING

Copyright © 2002 by Nicole T. Canfora
ISBN 978-1-5316-0654-9

Published by Arcadia Publishing
Charleston, South Carolina

Library of Congress Catalog Card Number: 2002101209

For all general information contact Arcadia Publishing at:
Telephone 843-853-2070
Fax 843-853-0044
E-mail sales@arcadiapublishing.com
For customer service and orders:
Toll-Free 1-888-313-2665

Visit us on the Internet at www.arcadiapublishing.com

CONTENTS

ACKNOWLEDGMENTS

To everyone who contributed their time and energy toward the completion of this project, the author is forever indebted. The willingness to research, explore, and share in the deep history of Belleville was an enlightening experience.

For their endless support, advice, and cooperation, the author gives special recognition to the staff at the Belleville Public Library and Information Center—especially Joan Taub, Cindy LaRue, Diana Price, and the library's board of trustees—for without them, this book would not have been possible.

Thanks also go to Nancy D'Uva, Richard Dickon, Mike Lamberti, Kathryn Lesko of Clara Maass Medical Center, Karen Lewis and Bethany Lutheran Church, Tim Monaghan, Scott Wentworth and the Belleville Fire Department, Isabel Wittinger, and Joanne Wysocki.

INTRODUCTION

Originally a part of Newark, which was established in 1666 by about 30 Puritan families headed by Robert Treat of Connecticut, Belleville was inhabited by both Dutch and English settlers among the wooded areas near the Passaic River. These settlers on the west bank of the watercourse called their new abode Second River, named after one of the streams that flowed around their community. This original land purchased from the Native Americans by Treat's group stretched from Newark Bay north to the Third River in present-day Nutley, west to the foot of the Orange Mountains, and from there, east to the Passaic River. Today, this area is part of Essex County, New Jersey.

Belleville went through a host of boundary changes, beginning in 1812 with its annexation from Newark and incorporation into the newly created township of Bloomfield. In 1839, Belleville gained its independence when it was spun off into its own township. Found within its boundaries at this time was North Belleville (Franklinville). Officially, this section separated from Belleville in 1875, creating the town of Franklin, which was finally renamed Nutley. In the end, Belleville covers 3.3 square miles of land.

Second River was a highly wooded area yet received its name from the stream of the same name that would later form its southern border with the city of Newark. The first documented landowner in the Second River colony was Hendrick Spier, who was said to have owned property across two miles from the Passaic River to where his home was located, in the present Soho section of town. These early settlers built Belleville's first house of worship, the Dutch Reformed Church, in 1697 along the banks of the Passaic, where it still stands on its original foundation today—a bastion hearkening back to the settlement's Colonial days.

Inspiration for the change of the name from Second River to Belleville is said to have come from town forefather Josiah Hornblower on June 26, 1797. Hornblower suggested that "Belle Ville," French for "beautiful village," be chosen as the new name at a second meeting held by the interested male residents of the town. For the two days prior to this conference, the town had carried the name Washington. At that first meeting, the name was found to be not specific enough to describe the settlement, causing a second debate.

In Revolutionary War times, the residents of Second River defended their new home against the British heathen, who occupied land across the Passaic River settlement and attempted forays into the territory of the colonists. Numerous instances of British raids have been documented and, as legend would have it, a few of the soldiers were captured and held in the homes of Second River residents.

From this time until halfway through the 18th century, families lived off the land, creating a mainly agricultural society. It was only with the arrival of the steam engine in America that Belleville's development began to progress at lightning-quick speed. Industry in America as we know it began with Josiah Hornblower, who brought with him from England in 1753 this country's first steam engine and used it to pump water from the Schuyler copper mines in present-day North Arlington. Nearly 40 years later, the first steam engine manufactured in America was commissioned by Nicholas Roosevelt to be built in a foundry in Belleville from Hornblower's designs. On October 21, 1798, the *Polacca* set sail on the Passaic River under the power of this steam engine, the first experimental steamboat in the country. This event single-handedly ushered in the Industrial Revolution into the new colonies, and an explosion of industry along the Passaic followed for decades to come.

Thanks to a strong local economy from industry and manufacturing, Belleville grew into a rich and prosperous place to live. The population increased more than tenfold from 3,000 in 1884 to 30,000 by the mid-20th century. In response, more schools, homes, and churches were built to accommodate the influx of residents. Washington Avenue became a hub of commercial activity. Transportation would evolve from steamboats and stagecoaches to horsecars and from trolleys and trains to buses, planes, and automobiles. The increasing mobility led to contact with other communities and even other nations—a boon to the trade of raw materials and manufactured goods.

Many intellectuals were drawn to the town, including inventor Thomas Edison, architect Charles Granville Jones, George Washington, and many others who passed through this community and left their mark here and elsewhere across the nation. Abolitionists, U.S. Army generals, singers, actors, and athletes all would call Belleville home at one time or another. Immigrants left an indelible mark on each section of town in which they settled. The Irish, Italians, Chinese, and the immigrants from other nations across the world all came to Belleville and America with its promise of liberty, prosperity, and freedom.

From Belleville's inception as a village in the larger Newark colony in the mid-17th century up until present times, few have taken the time to record the vibrant and deep-seated history of the town. Viewing a collection of photographs can be a fantastic visual stimulus for many, but much more needs to be done to preserve Belleville's past. Historic buildings need to be designated as such for protection from major alteration or demolition—saving them to testify to our town's rich history—but, more than this, the written word can carry the events of years gone by to future generations.

—Nicole T. Canfora

One

BUSINESS AND INDUSTRY

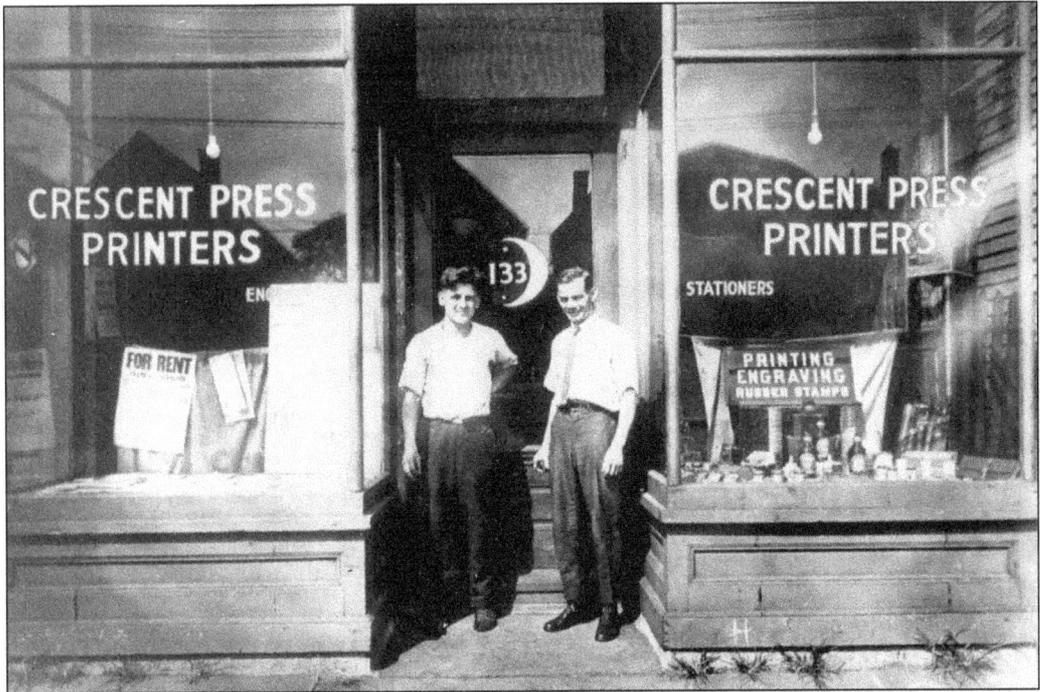

August Bechtoldt (left) and Henry Charrier pose outside Crescent Press Printers, a company founded by Charrier in 1925, a few years before this photograph was taken. The store on Main Street offered stationers services, such as printing, engraving, and rubber-stamping. Bechtoldt later became a Belleville fireman.

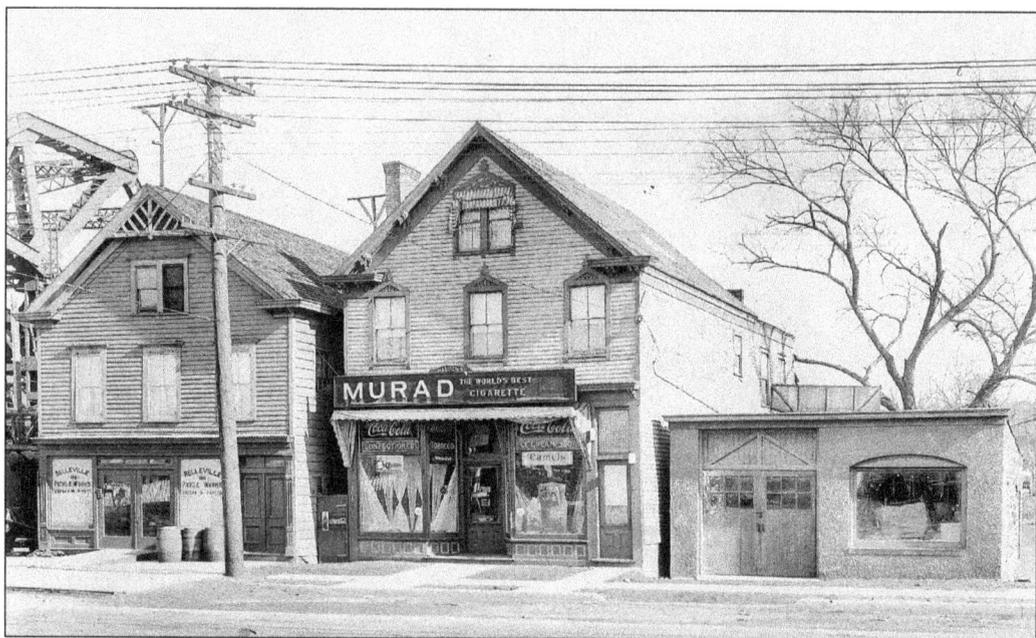

The Main Street approach to the Belleville bridge in the 1930s shows Madison's Confectionary Store and the Belleville Pickle Works, owned by the Adelman and Reibold families. O.A. Reid owned the garage on the far right. Today, Route 21 traverses the property on which these buildings rested. The iron bridge was disassembled in 1999, and a new one is under construction.

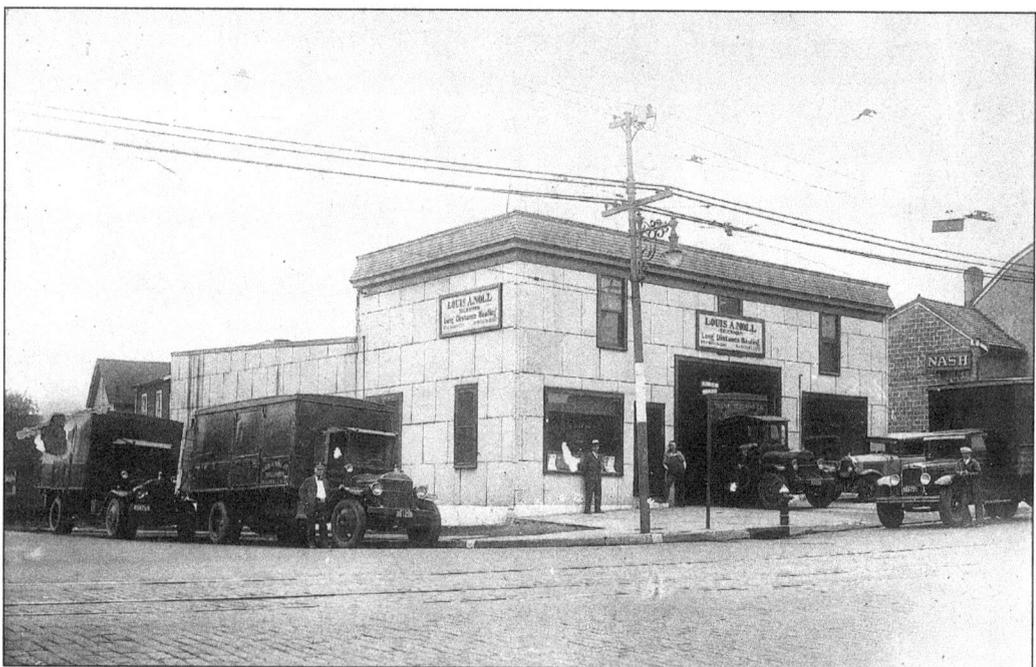

Drivers for the Louis A. Noll long-distance trucking company stand outside the headquarters for the business, at the corner of Mill Street and a brick-paved Washington Avenue. Emery Peckham, Andrew Lukwiak, and William J. Richmond owned other trucking services at the time throughout the town of Belleville.

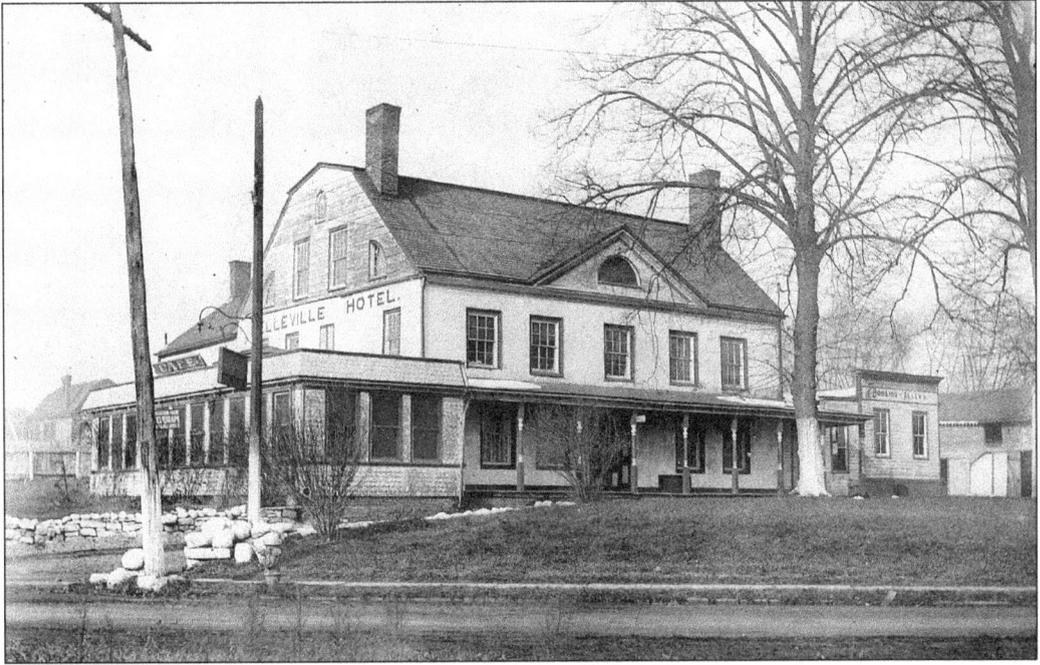

Said to be the first structure built in town in 1683 by Stephen van Cortlandt, the Belleville Hotel was situated on the corner of Mill and Main Streets. Owned by John Williams, the original stone structure was torn down and rebuilt by O.A. Fairchild. The older building served as the stage house for coach passengers on their way to New York City. A bowling alley was later added to the side of the building, as seen on the right.

Aphanus van Cortlandt was one of the first landowners in Belleville. He was a close relative of Stephen van Cortlandt, who in 1683 built what later became known as the Van Cortlandt–Van Rennelaer Mansion on Main Street. This building was converted into a business after many years but was best known as the Belleville Hotel.

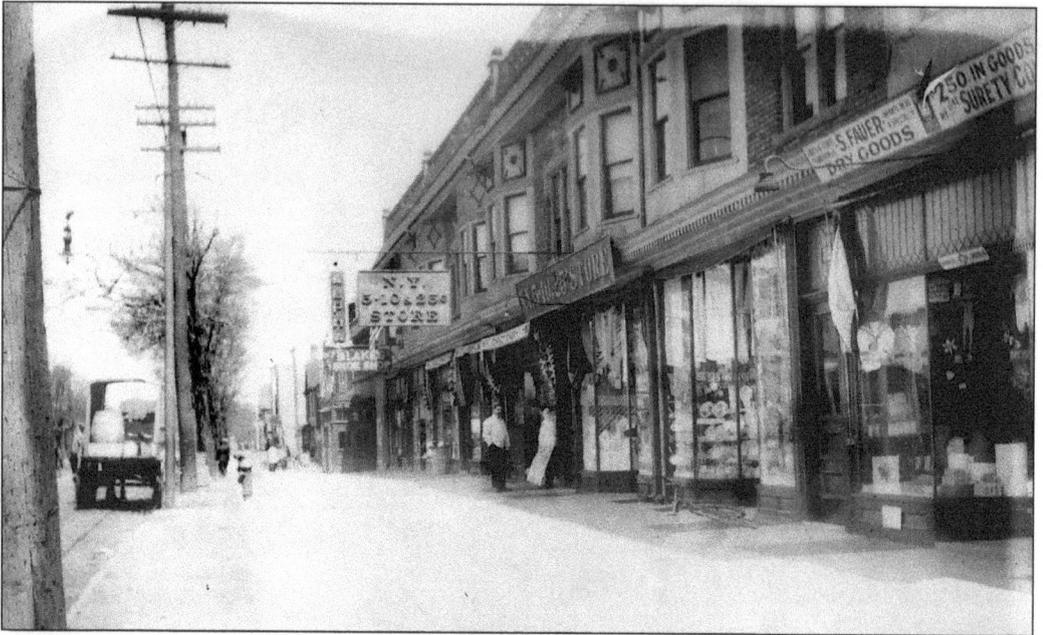

Business on Washington Avenue thrived in its heyday. Beginning at Cleveland Street, residents could find S. Fauer's dry goods store, Blake's Shoe Shop, a five-and-dime store, and the Alpha movie house, which showed nickelodeons, vaudeville shows, and silent movies. This view looks north down the avenue.

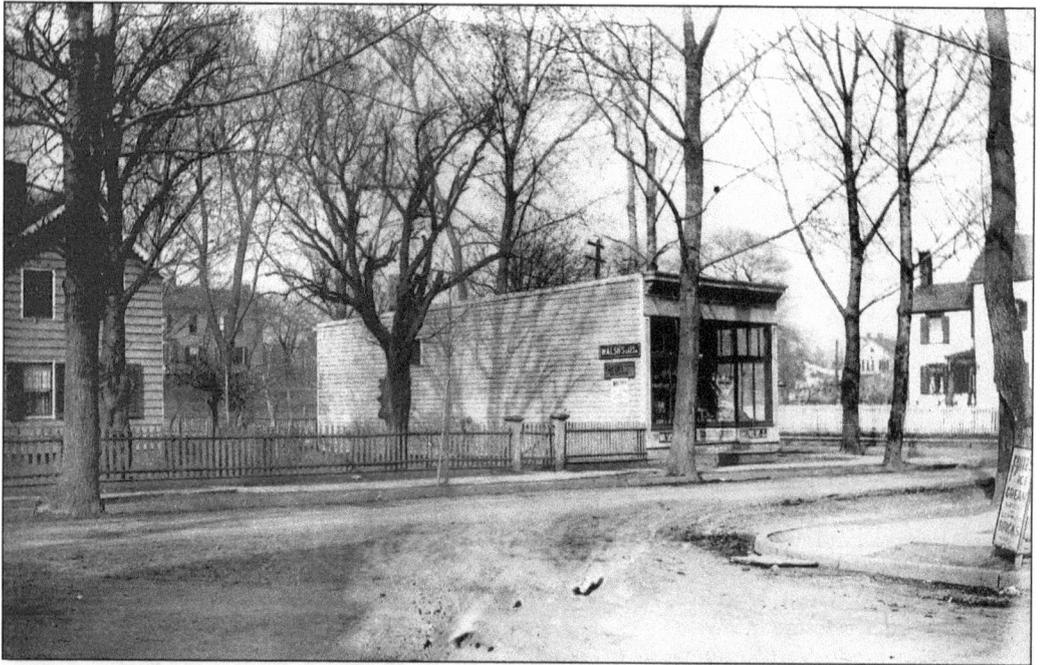

In the 1900s, grocers were plentiful in town. In the center is George Gebhard's grocery store on William Street, offering fruits, vegetables, teas, coffees, butter, Feifer cigars, and Walsh's ice cream in what looks to be the dead of winter. The sign in the lower right-hand corner advertises Fritz's ice cream. Curbs and sidewalks had been installed, but the road was unpaved as of yet.

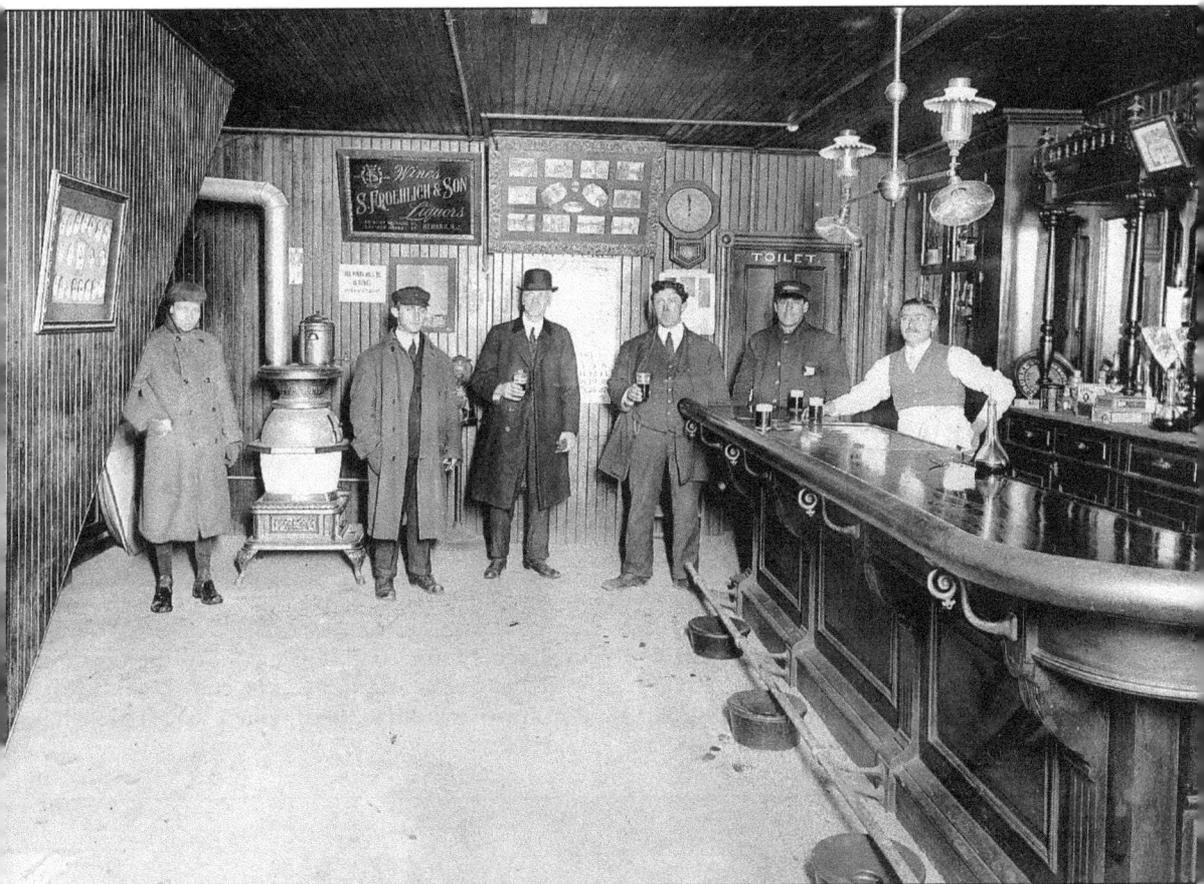

At the beginning of the 20th century, taverns were a staple of everyday life in small towns. The Ziegler Tavern, on Holmes Street between Ralph and Main Streets, served as a meeting place for the menfolk, with the conveniences of an indoor toilet and a wood-burning stove for warmth. Stairs from the tavern led upstairs to the living quarters. There were no barstools, but note the three spittoons on the floor. Beer from Ballantine & Company of Newark was sold, along with ales, wines, and liquors from other local manufacturers. In March 1902, the tavern building was inundated with water after a week of steady rain followed by a nor'easter. Floodwaters from the Passaic River reached up two blocks from Main Street but, luckily, did not hit the Erie Railroad line.

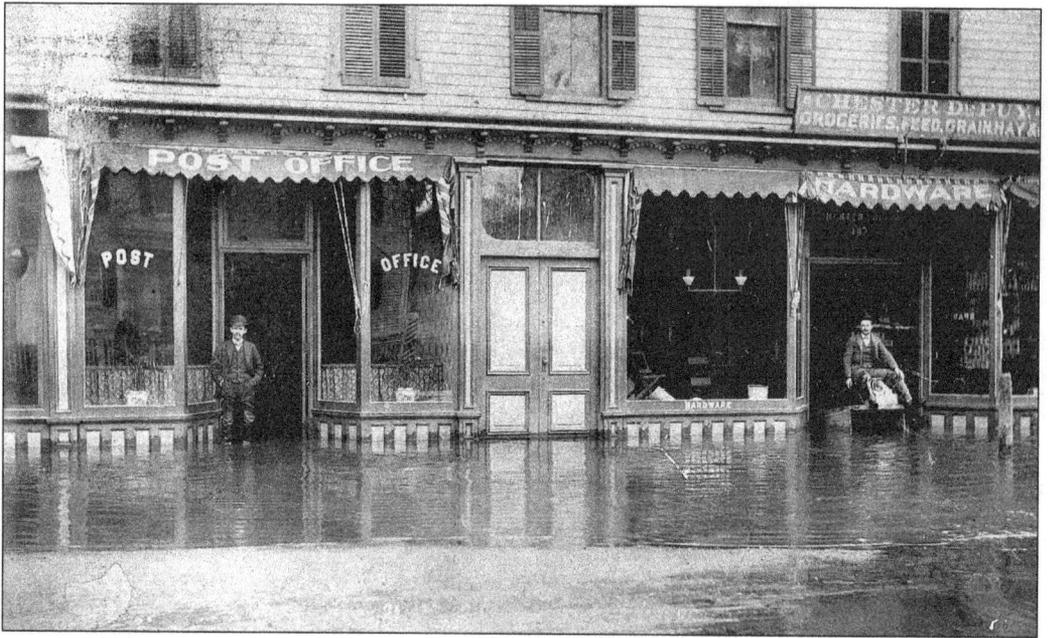

The Belleville Post Office and Chester DePuy's grocery store both fell victim to the flood of October 1903, when the Passaic River overflowed its banks and spilled out onto Main Street in town at the bridge. DePuy was a merchant in town and offered feed, grain, hay, cigars, and hardware for sale at his store.

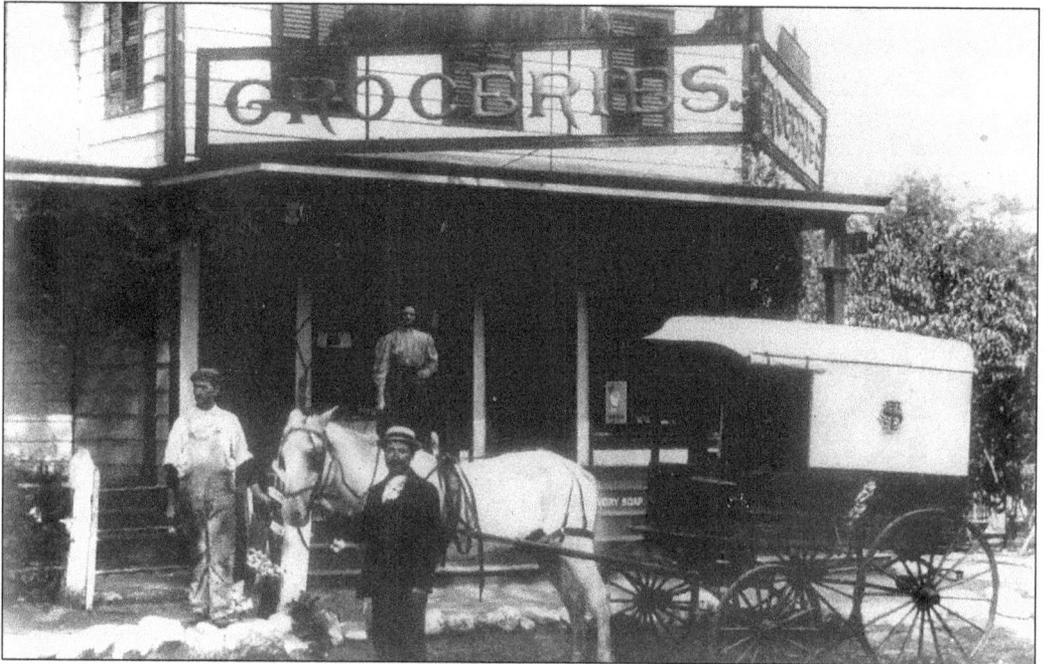

Timothy Sidley opened a grocery store in the Montgomery section of Belleville sometime in the early 1900s. Goods were delivered to customers via horsedrawn wagon. His wife minded the store while he was out on his errands. The store was located on Mill Street west of the copper works.

14

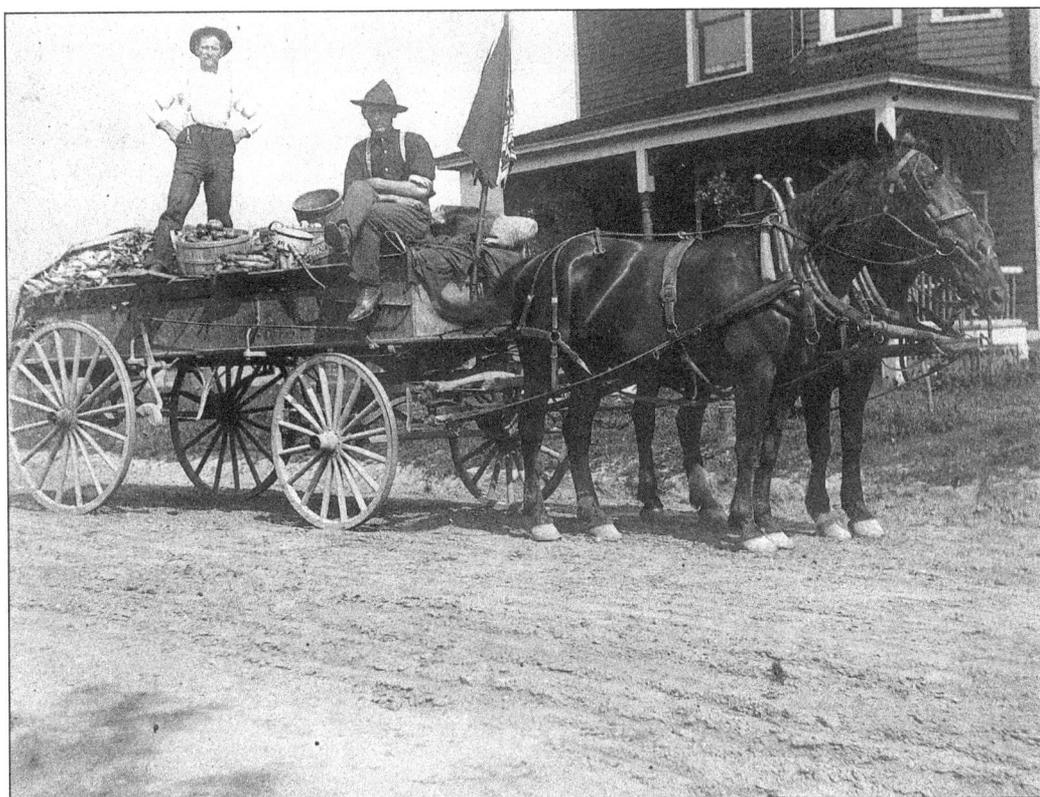

Fruits and vegetables straight from the farm were once sold right off the horse cart, as seen here. An umbrella is ready to keep away the hot sun during the heat of the day. In the early 20th century, nearly 35 grocers were selling their wares throughout the town, either by cart or from storefronts and homes.

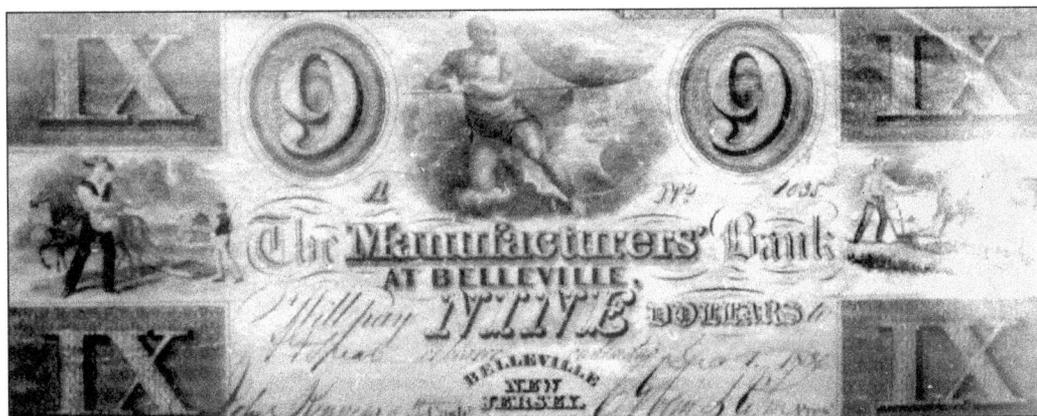

Typical of the currency found in the area in the early part of the 19th century were notes such as this one issued from the Manufacturers Bank of Belleville on December 1, 1838. This $9 bill was equal to cash, and the imprinting was done by Rawdon, Wright, Hatch & Company of New York.

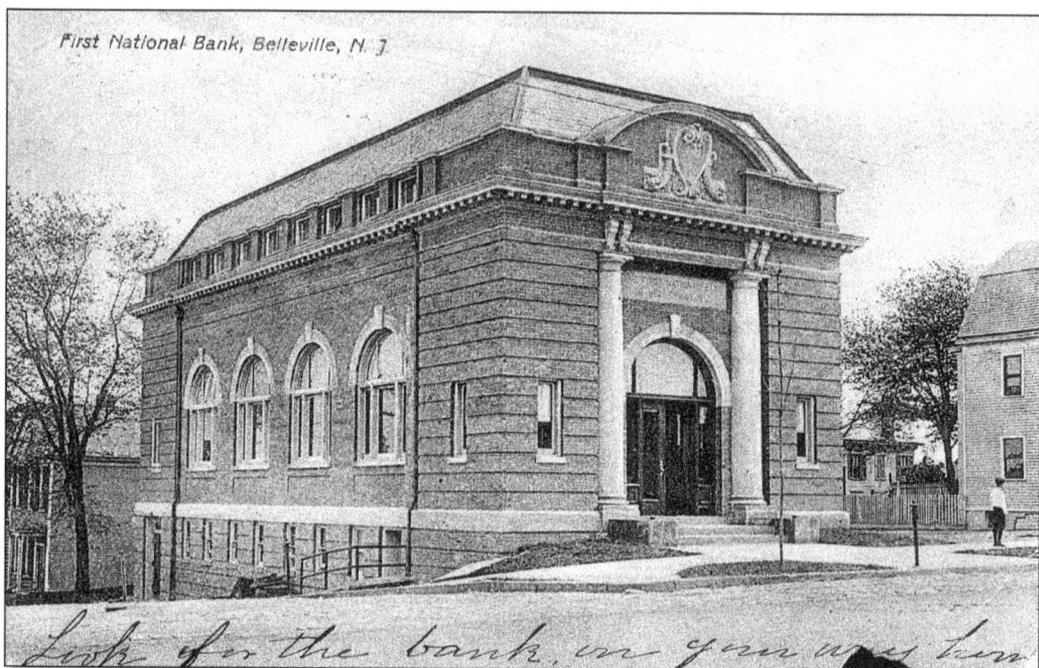

First National Bank, Belleville, N. J.

Look for the bank on your way home

The First National Bank, still standing at Washington and Belleville Avenues, is one of many township buildings designed by Belleville resident and architect Charles Granville Jones. In this 1908 postcard, Washington Avenue was still a muddy dirt road with trolley tracks set in the center of the boulevard.

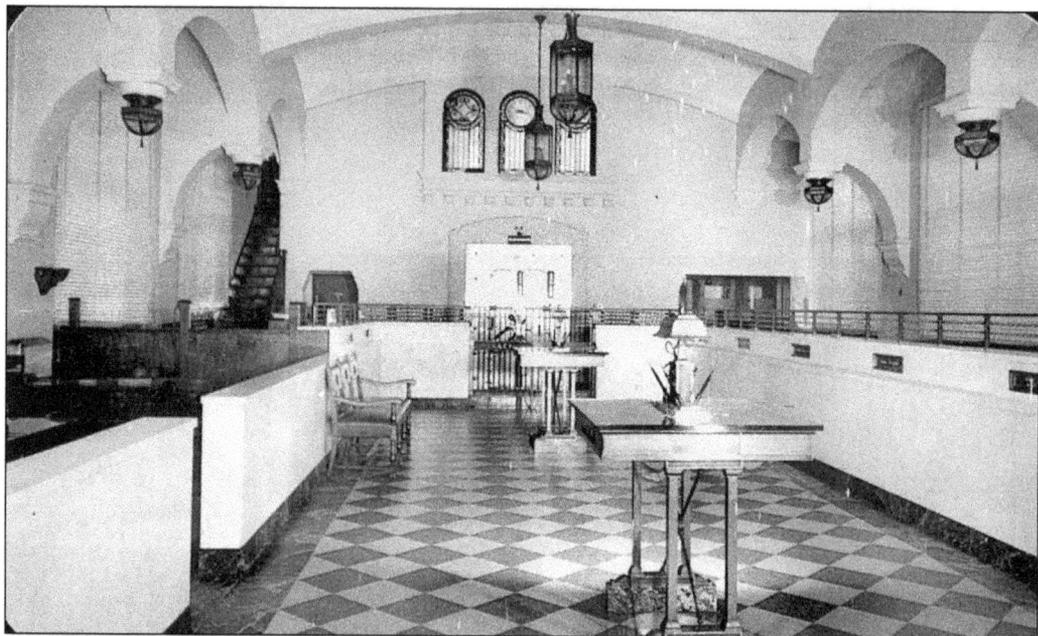

At Christmastime in 1950, the First National Bank sent postcards to its customers, depicting the interior of the bank. This particular postcard was mailed to Leroy A. Davenport (of Union Avenue). The bank boasted $50,000 in capital and $40,000 in surplus and profits during the year 1912 and offered safe-deposit boxes for rent.

16

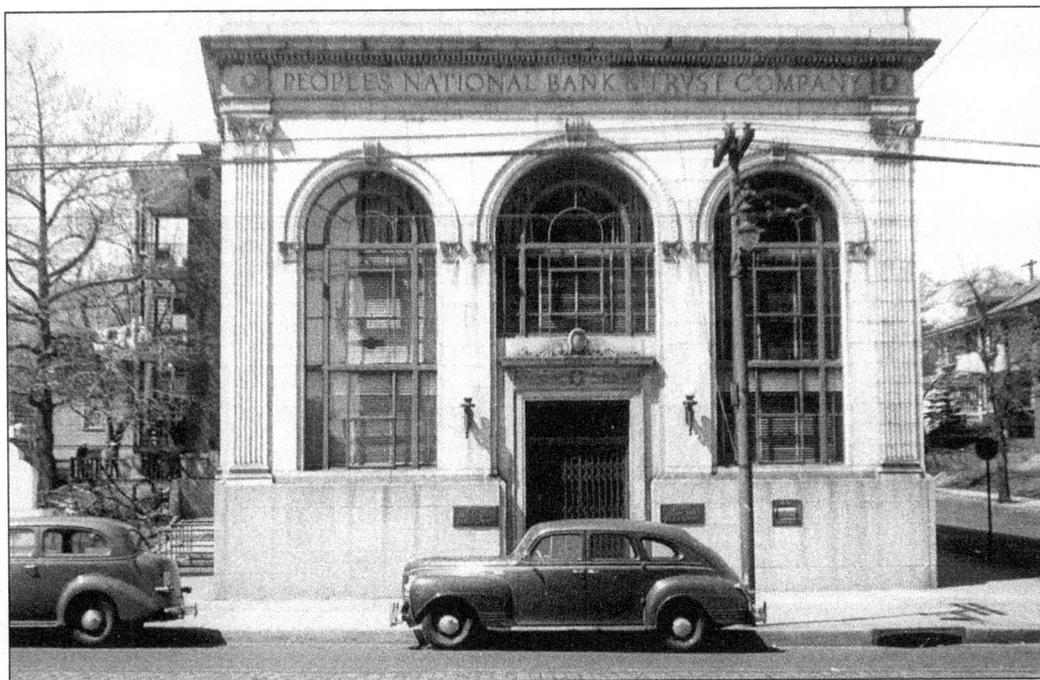

Just south of the old Elks Club and former Disabled American Veterans post, People's National Bank on Washington Avenue at Van Houten Place is a structure built with a classical Roman architecture, with halved ionic columns across the façade. Today, the building houses Valley National Bank.

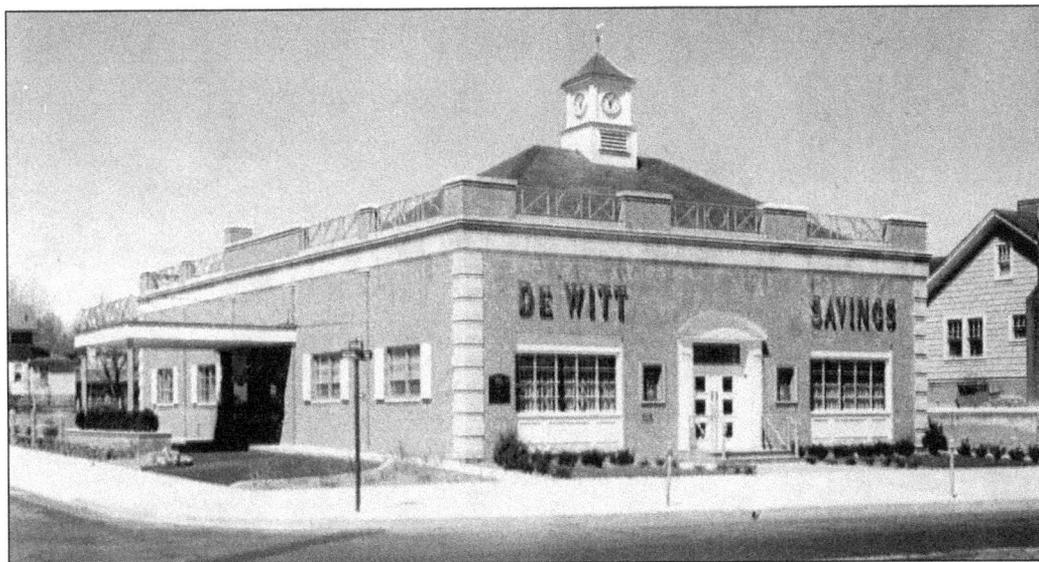

DeWitt Savings and Loan Association built its own home in 1955 at 463 Washington Avenue at the corner of Tappan Avenue. The bank was named for Gasherie DeWitt, the grandson of Josiah Hornblower, who brought the first steam engine to Belleville and also named the town Belle Ville ("beautiful village" in French). DeWitt's commitment to the community and its residents helped Belleville's growth, a reason the bank was named after him.

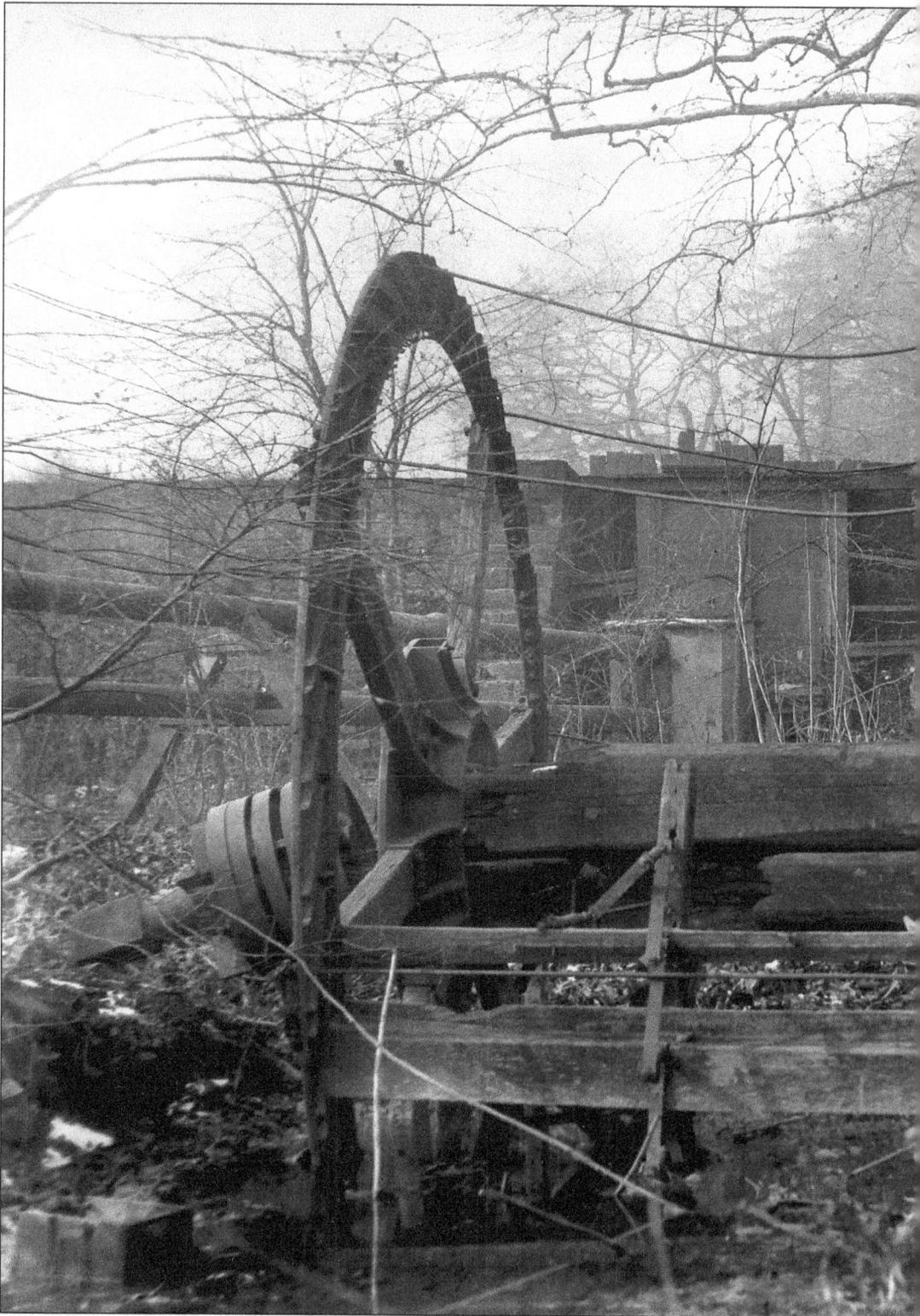

This old waterwheel used to sit on what was said to be the site where the first steam engine was built in 1798. This was the old property of the Soho Copper Works, off Mill Street next to the Second River. Harmon Hendricks purchased the property in May 1814 for nearly $41,000 (completely paid for with borrowed money), more than $20,000 below what it appraised for in 1801. Here, copper was brought from the company's New York warehouse via waterway by two schooners and then refined by the skilled workers who came from all over New Jersey and New York for employment. The copper works was said to have received one of the first known copper contracts from the federal government.

Rubber and metal were produced at the Riverside Rubber Company factory on the east side of Main Street, owned and operated by James Hardman Jr. Formerly, the property was a cotton-waste works. Supplies for druggists and stationers were also manufactured at the plant, which expanded a few years after its beginnings in 1878.

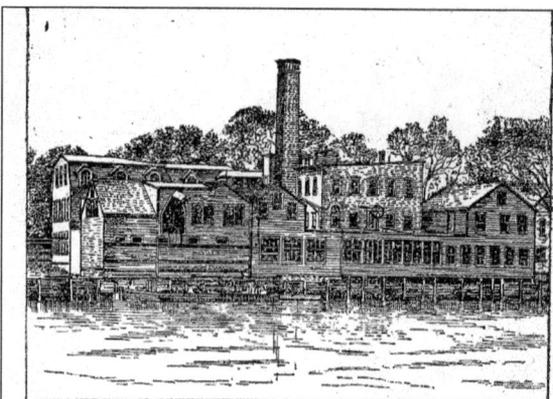

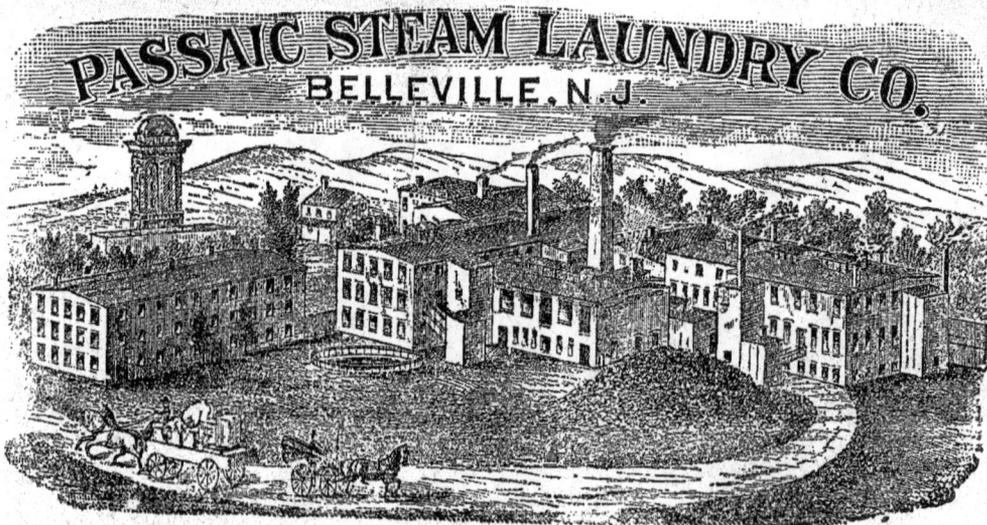

This advertisement for the Belleville Steam Laundry was featured in former Belleville mayor Hugh Holmes's c. 1890 book *A Brief History of Belleville*. The steam works, established in 1856 and located near the Passaic River, employed a large contingent of Chinese immigrants who lived in dormitories in town. Some of the workers worshiped at the Dutch Reformed Church.

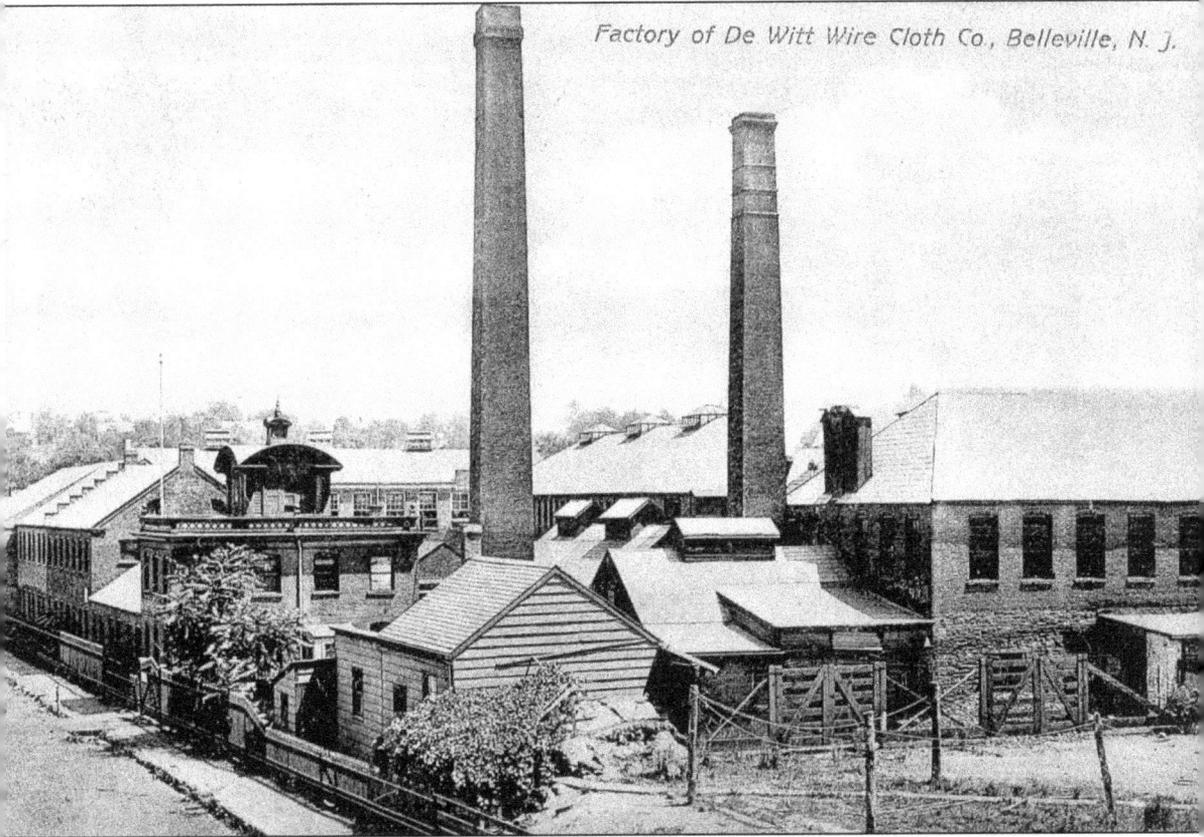

Factory of De Witt Wire Cloth Co., Belleville, N. J.

A gunpowder mill was first set upon this land at Mill Street along the Second River in 1812 by Decatur, Rucker & Bullard, and it served its purpose until a horrific accident two years later, which led to the complete destruction of the plant in one large explosion and the deaths of many workers. In 1876, Gasherie DeWitt, Josiah H. DeWitt, Cornelius Van Houten, and James G. DeWitt organized the DeWitt Wire Cloth Company here with $200,000 worth of capital, a very large sum for the time. William Stevens and Thomas Uffington had purchased the land before the DeWitt company was established, and here the first coarse-wire cloth was made in the United States. The Fourdrinier technique was used to make tighter wire cloth in 1847, and it was this wire that was used for Samuel Morse's first telegraph line from Washington to Baltimore.

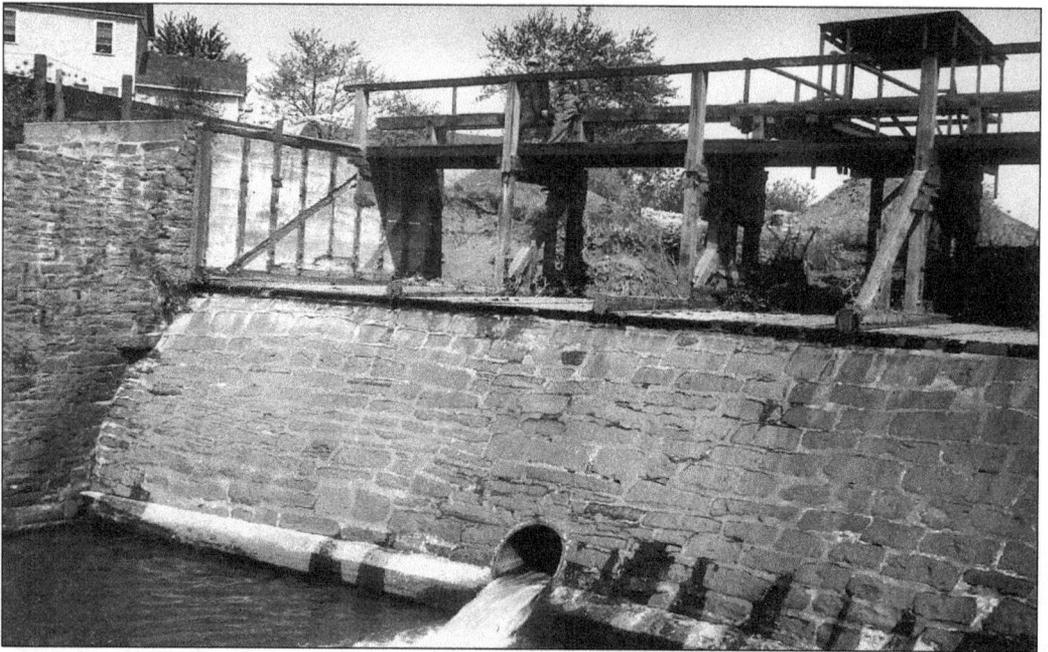

Harmon Hendricks and his brother-in-law Solomon Isaacs built the Hendricks Copper Mill in 1812 along the banks of the Second River. It was the first copper mill in America and helped make the country less dependent on imported metals. Patriot Paul Revere is said to have used copper from the Belleville mill to resheath the sides of the U.S. Navy vessel *Constitution*, better known as "Old Ironsides."

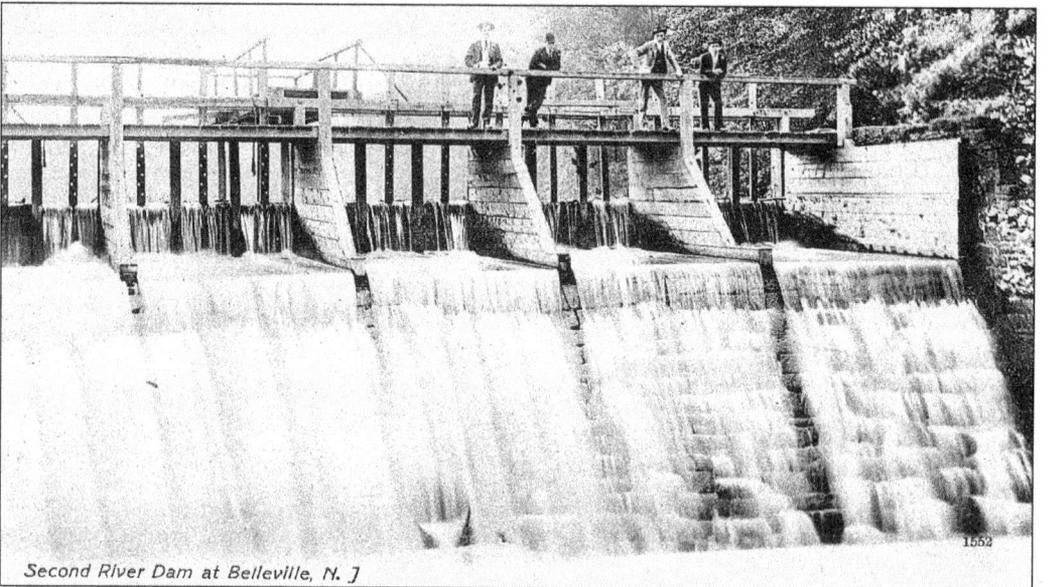

Second River Dam at Belleville, N. J

Later named the Soho Copper Works, the Hendricks Copper Mill at Second River was situated west of the site of the former paint mill on property formerly part of the neighboring town of Bloomfield. The dam built on the river provided 60 horsepower, and two steam engines (one of 300 and one of 90 horsepower) added to the company's ability to produce 350 tons of copper per year during the 1820s.

22

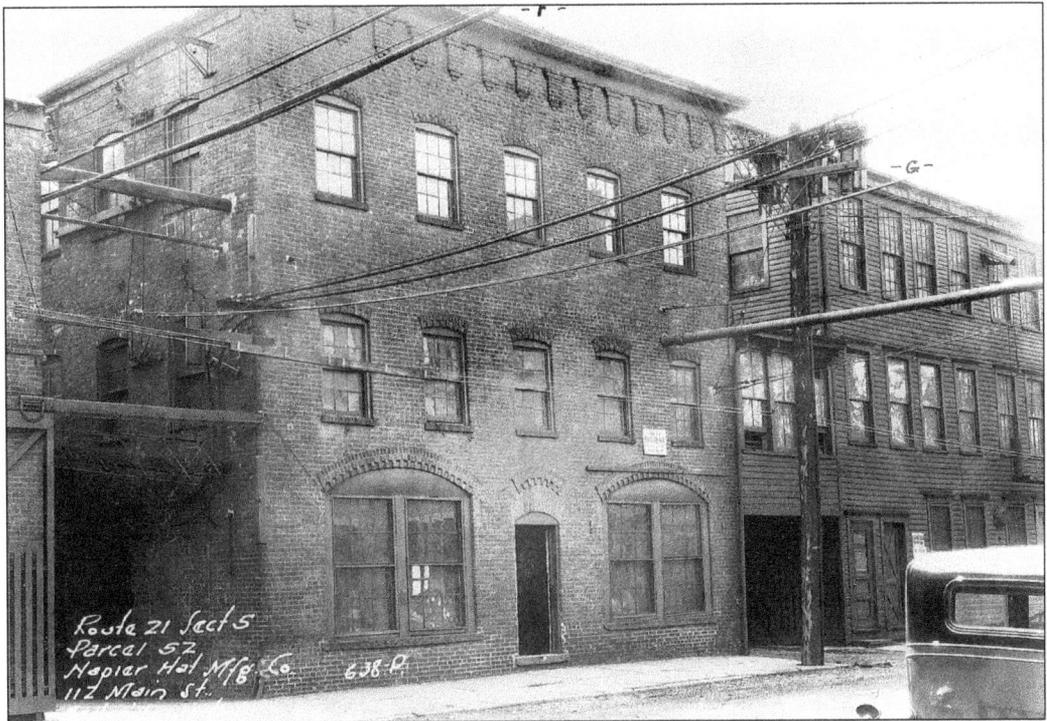

The Napier Manufacturing Company created felt hats at its plant on Main and William Streets. Belleville was home to many different manufacturers in the 19th and 20th centuries that made such diverse goods as perforated music rolls for player pianos, electric motors, paper tags, fences, tires, butter, and tile. Most of the industries were built next to either the Passaic or Second Rivers to make use of the waterpower.

The D.C. McAllister Company was a textile printer at 294 Main Street. In the late 1920s, the land was valued at $13,000. A trustee of the company was Walter Cripley. It is unclear what products exactly the company manufactured, but in 1926, a textile workers' strike in Passaic would bring the industry to a halt in the area.

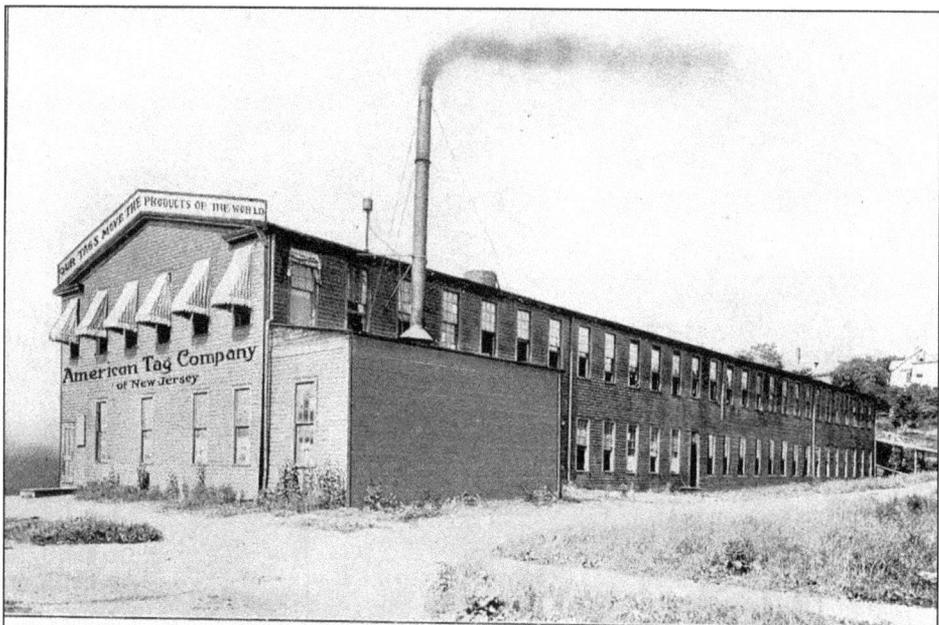

Claiming, "Our tags move the products of the world," the American Tag Company of New Jersey based its operations at 350 Cortlandt Street behind the Erie Railroad tracks near Holmes Street. This advertisement along with many others appeared in the historical souvenir program for Belleville Day, held on August 24, 1912. Other businesses took out advertisements in the program, including larger companies, such as the First National Bank, Hillside Park, Borden's Condensed Milk Company, Newark Business College, the Hardman Tire & Rubber Company, and the Thomson Machine Company. The Thomson plant on Main Street was the manufacturer of dough-handling machinery and used large covered horse-drawn wagons as company vehicles. A parade was held that day, with vaudeville entertainment and athletic races held for the townspeople. Gold watches, silver and bronze medals, and silver cups made and provided by another advertiser, John C. Slattery of Harrison, were awarded to the winners of the individual races and relays.

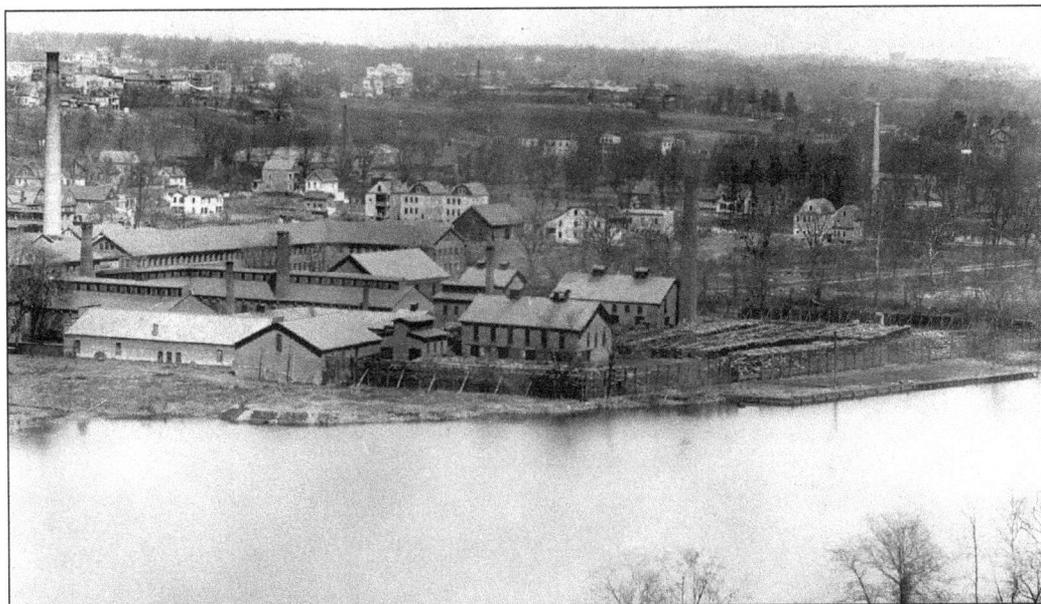

John H. Eastwood's plant on Main Street was formed in 1877 when Eastwood joined with Charles Smith and William Buchanan to manufacture Fourdrinier wire cloth made of iron, copper, and brass wire. As business increased, additions to the building and equipment were constructed until the company was twice its original size. The required machinery and looms were purchased with the start-up funds.

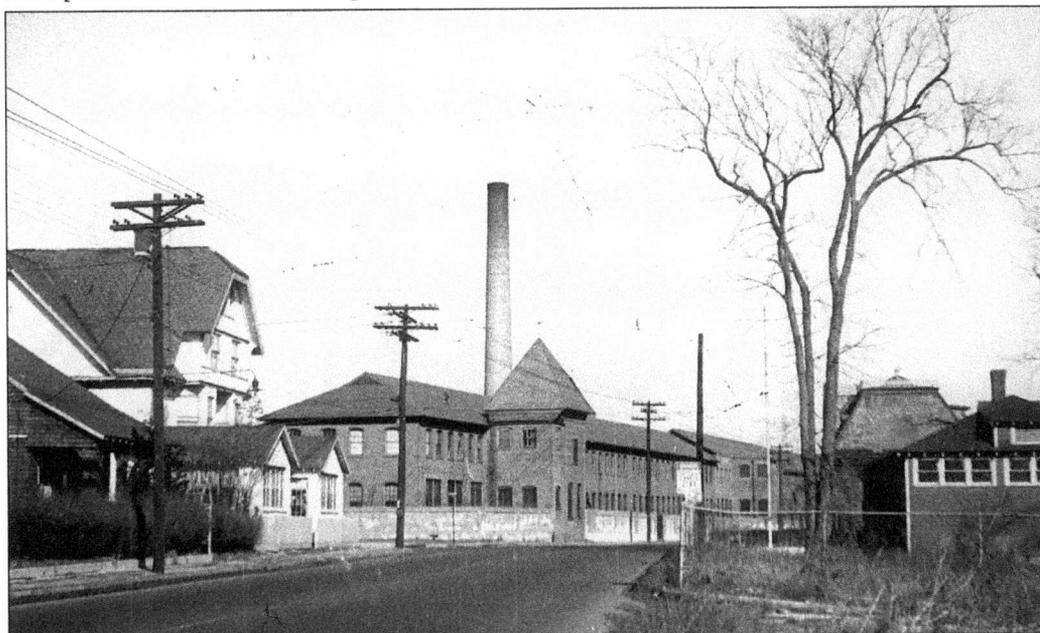

Once the original funds were used up, a stock company was organized in 1880 to raise more capital for the Eastwood plant. John H. Eastwood served as president, and Charles Smith as secretary. In addition to Fourdrinier wire cloth and all grades of fine iron, copper, and brass wire, the plant also had a chemical division and employed 45 people by then. One of the first fire companies in town, established on June 14, 1882, was called the Eastwood Company.

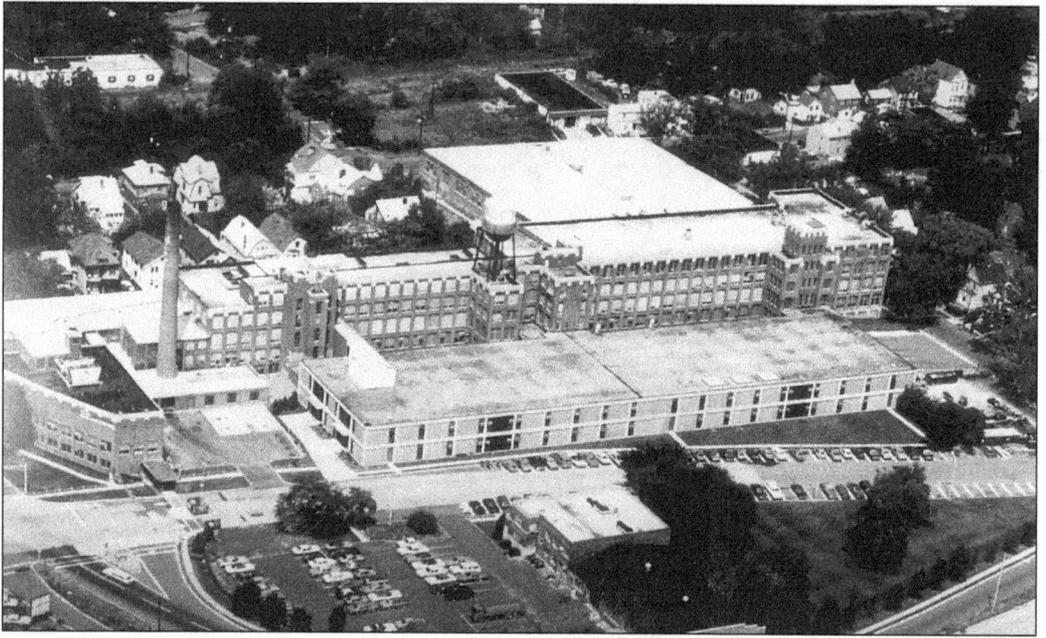

This is an aerial view of Wallace and Tiernan, manufacturer of water and wastewater treatment products, located at 25 Main Street. Founder Charles Wallace Tiernan (1885–1964) invented the "chlorinator," the first practical and effective means of using chlorine gas to sterilize drinking water. The Belleville plant was closed in 1996 after 85 years.

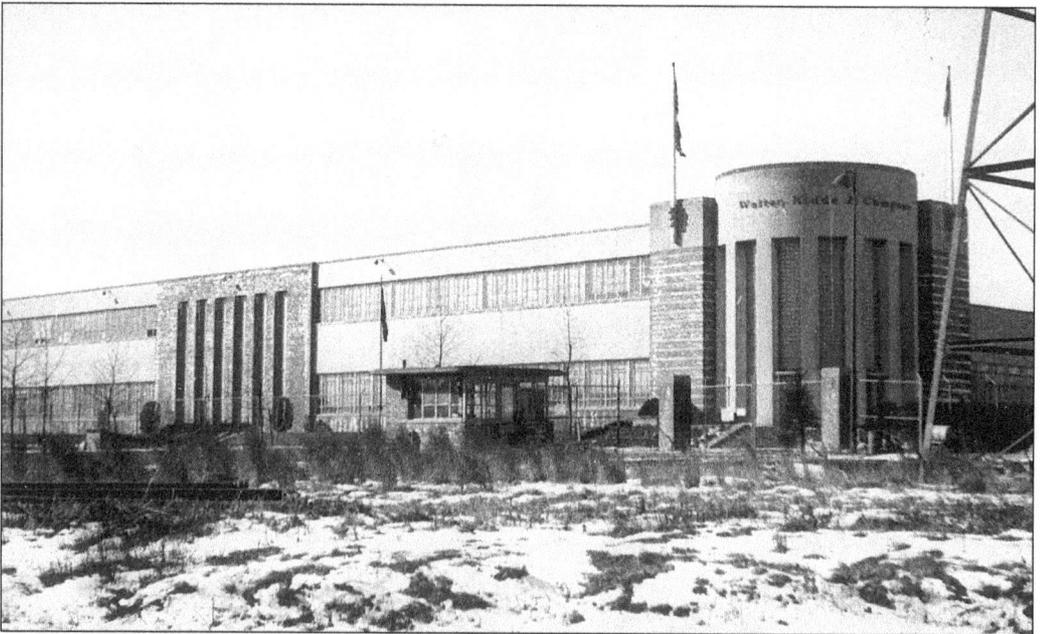

Walter Kidde & Company first began its business right in the heart of Belleville's industrial section, in the Valley, on Main Street near the Newark border. Walter Kidde went into business for himself as an engineer at the age of 23. Following years of success, he formed Walter Kidde & Company in 1917. Fire-protection products, such as portable fire extinguishers and sprinkler systems, were made at the Belleville plant.

Two

AROUND TOWN

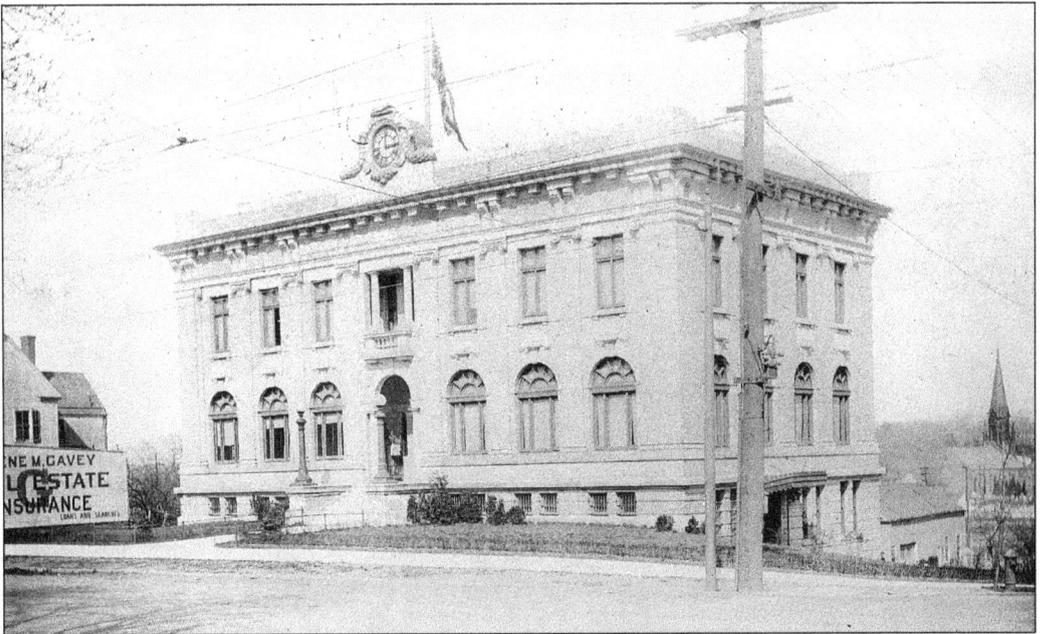

Belleville Town Hall, situated on the northeast corner of Washington Avenue at Belleville Avenue, was built in 1913 to house the municipal offices. Previously, the Belleville Hall, farther north on Washington Avenue, served as the town's headquarters. A small fire station was also situated at the rear. The building was later expanded to provide a home for the police department.

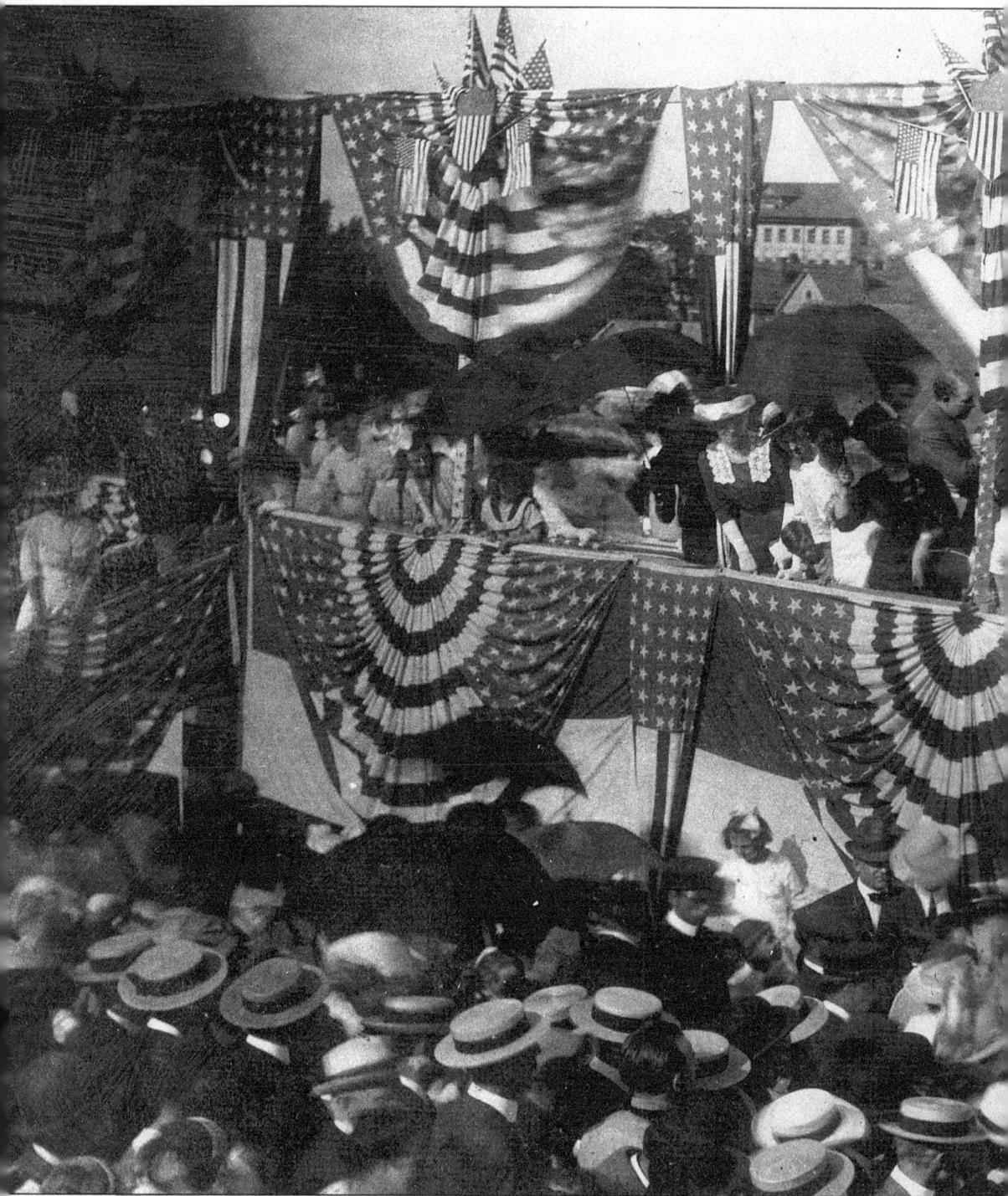

The dedication of the cornerstone for Belleville Town Hall brought a patriotic fever to the citizens, who turned out in droves to attend the event on July 19, 1913. Construction would not be completed until 1915, but the town council would hold its first meeting there on December 30, 1914. Belleville's first mayor, Charles Lyman Denison, convened a committee in

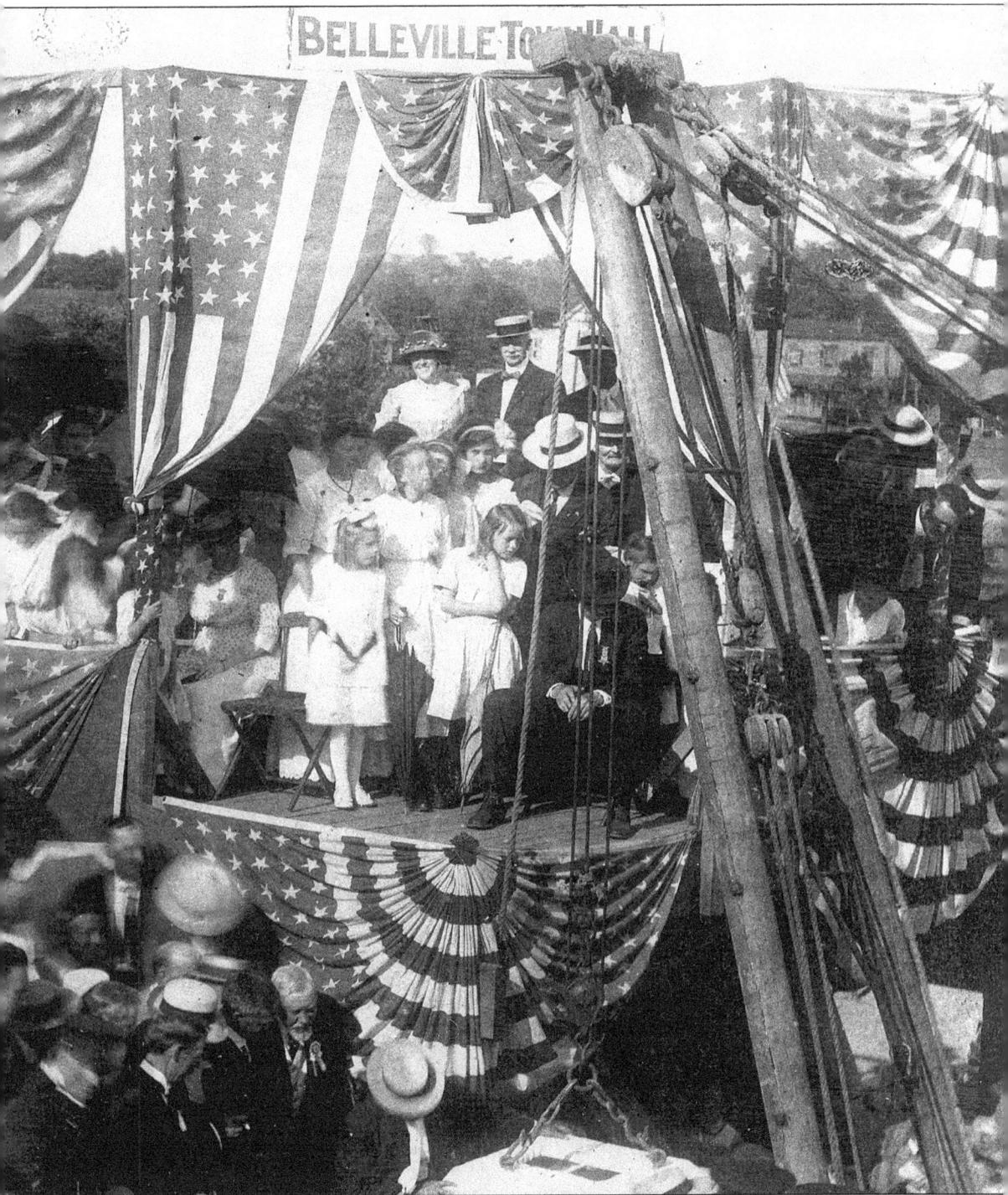

1912 to find a site for a new town hall, where all the town departments could be consolidated. At this time, all town agencies were located in numerous parts of the town, in schools and firehouses. A lot was purchased on Washington Avenue at what was then John Street for the price of $10,500, and then the town council appropriated $60,000 for construction costs.

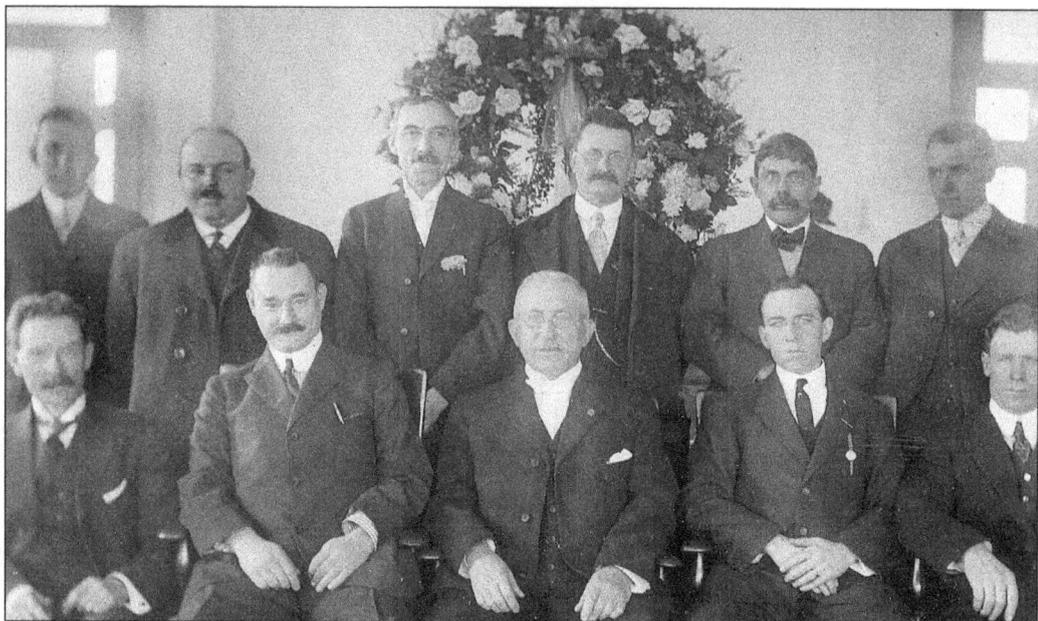

Two forms of government have overseen town business since its inception—commission and town manager–council. Pictured here are the town officials of 1908. From left to right are the following: (front row) Frank Carragher, unidentified, John C. La Fouchierie, unidentified, and John Waters; (back row) unidentified, Joseph A. Connolly, Edward E. Motbes, Edmund W. Bichtoldt, Edward Cyphers, and ? Manning.

RE-ELECT

WILLIAM D.

CLARK

Dependable Experienced

For Continued Good Government

This small pamphlet asks Bellevillites to reelect William D. Clark to the town council. What is unique is that the inside of the four-page brochure acts as a guide to the houses of worship and positioning of fire alarms within the town, along with important local phone numbers.

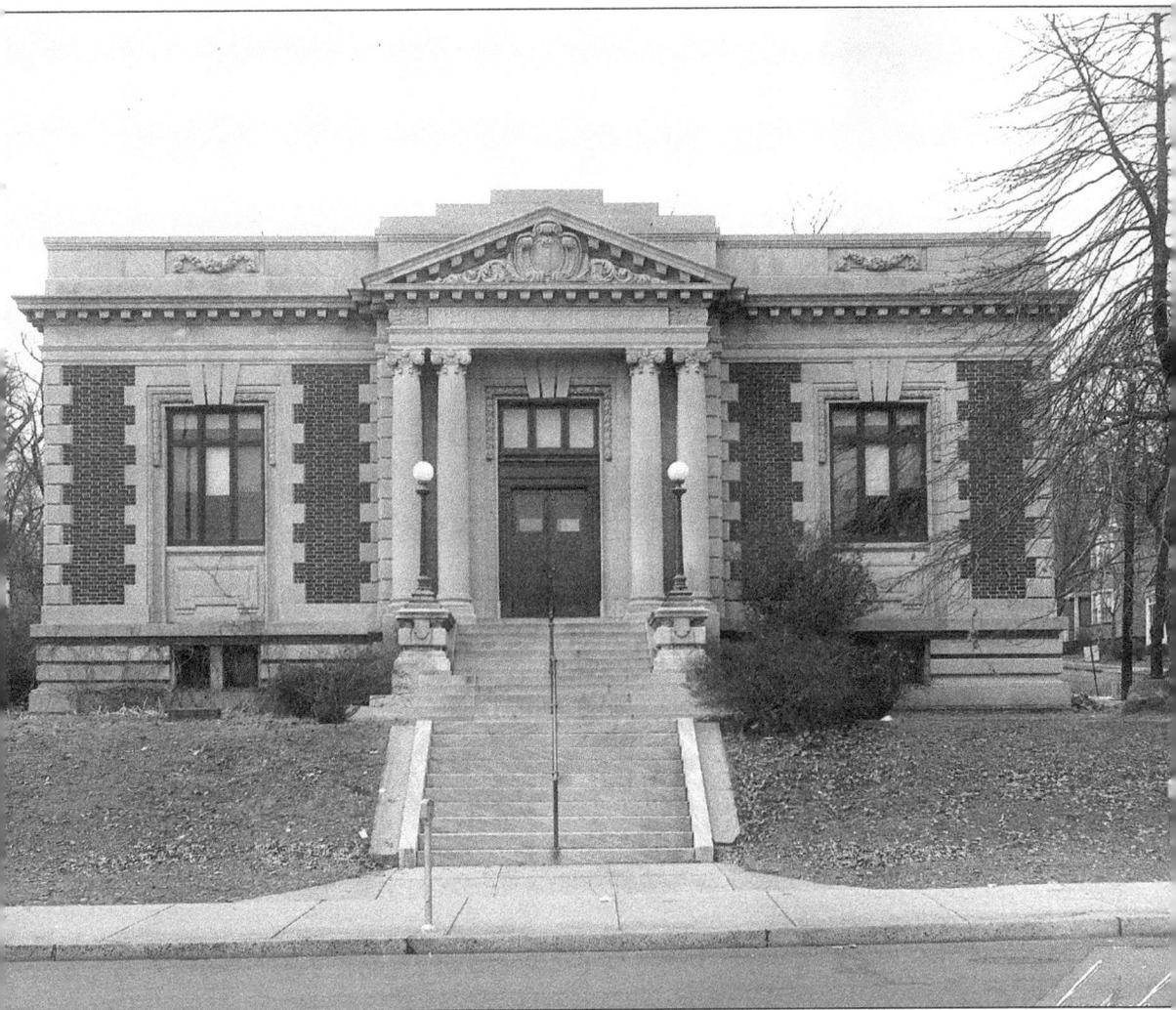

One of 1,681 libraries built across America, thanks to funding from philanthropist Andrew Carnegie, the Belleville Public Library was built in 1911 on Washington Avenue. The Carnegie room was added onto it in 1929 and currently houses the bulk of the book stacks. The original façade was obscured after an addition to the front in 1980 that enabled the library to expand its collection. This area has allowed for exhibits and programs to be held for the enrichment of the community. In the 1990s, the interior of the Carnegie room was completely renovated and restored to a style reminiscent of the original design, thanks to a bequest by Belleville resident Helen Van Brunt. New lighting, a ceiling mural, custom furnishings, and marbleized accents transformed the core of the primary building. The new Belleville Public Library and Information Center now provides not only books but also a state-of-the-art automated library system, CD and videotape loans, and audiobooks on cassette tape.

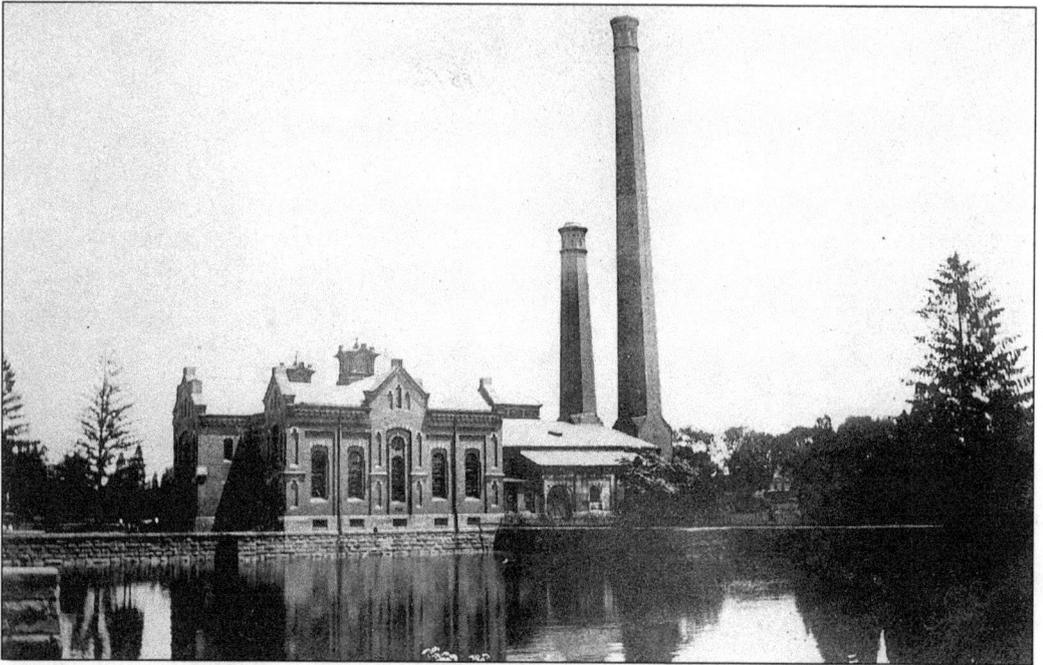

At its peak, more than 14 million gallons of water were held in the Newark Reservoir at Belleville on Joralemon Street opposite Reservoir Place. Built in 1869 to supply the citizens of Newark with water, the reservoir itself encompasses 11.5 acres and is a quarter of a mile long. The first chief engineer was George Bailey, and the superintendent was Thomas R. Williams.

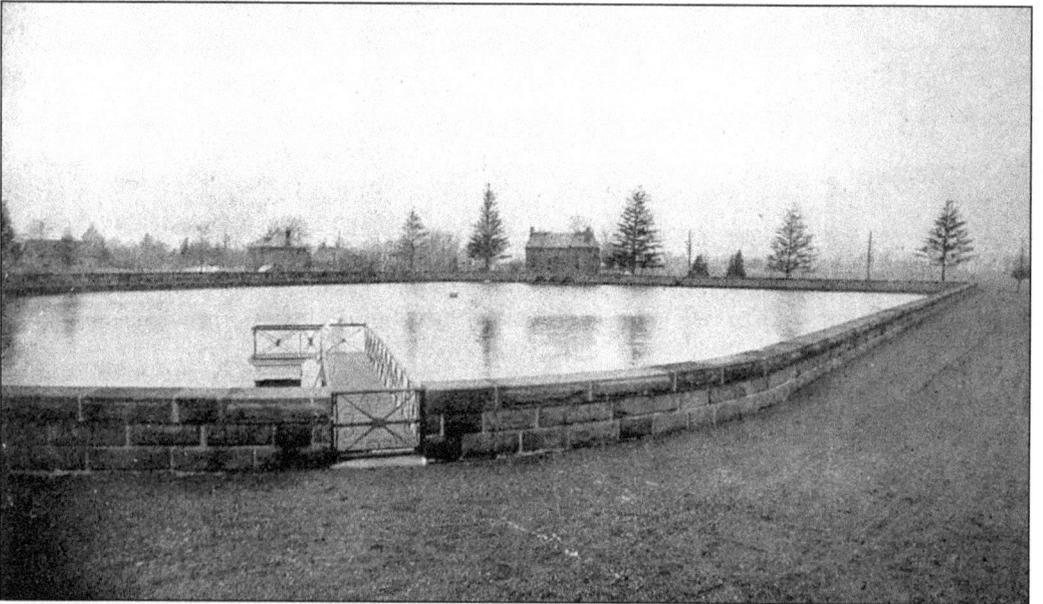

The reservoir was 165 feet above sea level. Originally, the water was pumped into it from the Passaic River via a pumping station on Main Street near Greylock Parkway. As river pollution increased in the 1880s, water was instead directed into the reservoir from the Pequannock watershed 21 miles away. It was drained in 1986, but the reservoir and its two stone gatehouses still stand. Its future is undecided.

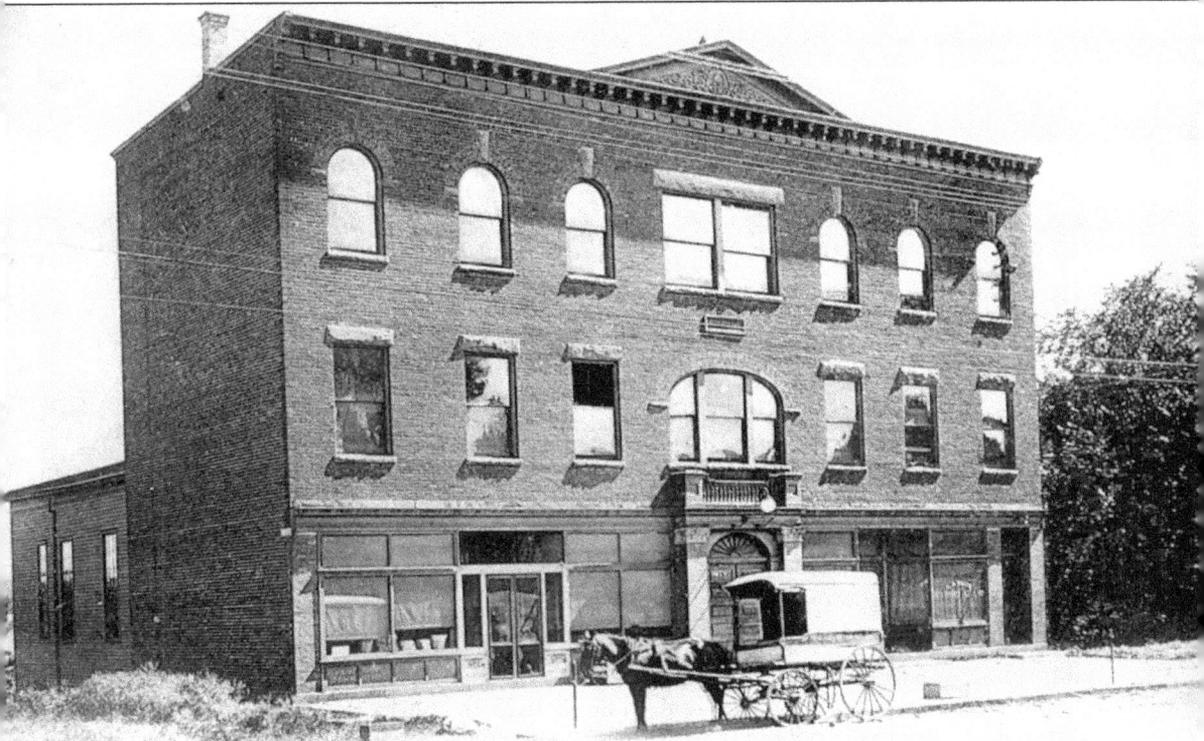

Belleville Hall, Belleville, N. J.

Thought to have been constructed *c.* 1850, Belleville Hall on Washington Avenue between Academy and Holmes Streets served as a meeting place for many civic and other local organizations. After the Civil War, Belleville war veterans' organizations sponsored plays at the hall. It served as Belleville's town hall before 1913, when the present building was erected farther south on Washington Avenue. During the Great Depression, it was used as a recreation center, where amateur boxing matches were held once a month. "Bun" Derbyshire, an old baseball umpire, would announce the contenders before each contest. Later, recreation basketball would be played, and on Friday and Saturday nights, a professional team made up of Belleville residents would play teams from neighboring towns. Dancing would be offered before and after these games. Eventually, the building was converted for commercial use and has been altered on the exterior over the years. The Belleville Hall Pharmacy was in one of the storefronts in the 1900s. The building still stands today.

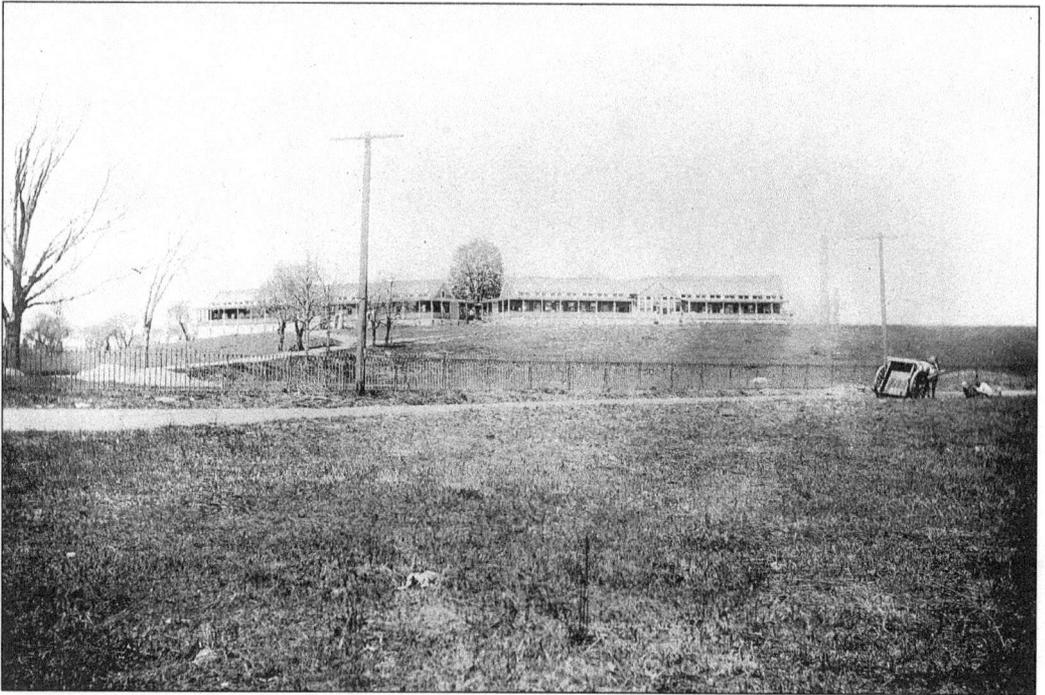

The Essex County Isolation Hospital, built in 1905 by the Essex County Board of Chosen Freeholders, originally housed patients with communicable and contagious diseases. Smaller outbuildings surrounded the main hospital, creating a complex so large that it needed its own power-generation facility. The smokestacks can be seen in the background.

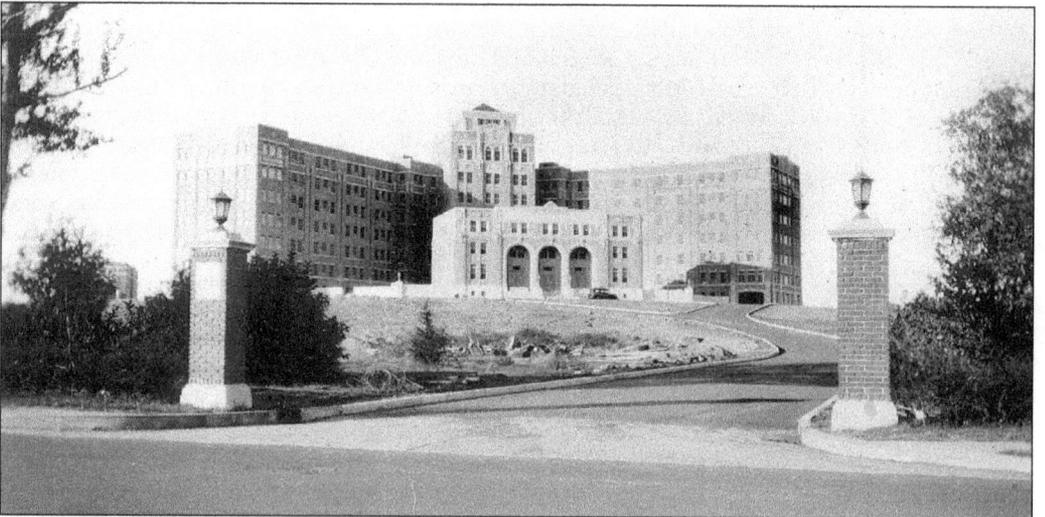

Many doctors and nurses received their training at the hospital, grandly situated atop a large parcel of land at the corner of Belleville and Franklin Avenues. It is rumored that there are catacombs and passages running between some of the smaller buildings and the larger hospital. Eventually, the hospital buildings would be used as a geriatric center and for county health services for children.

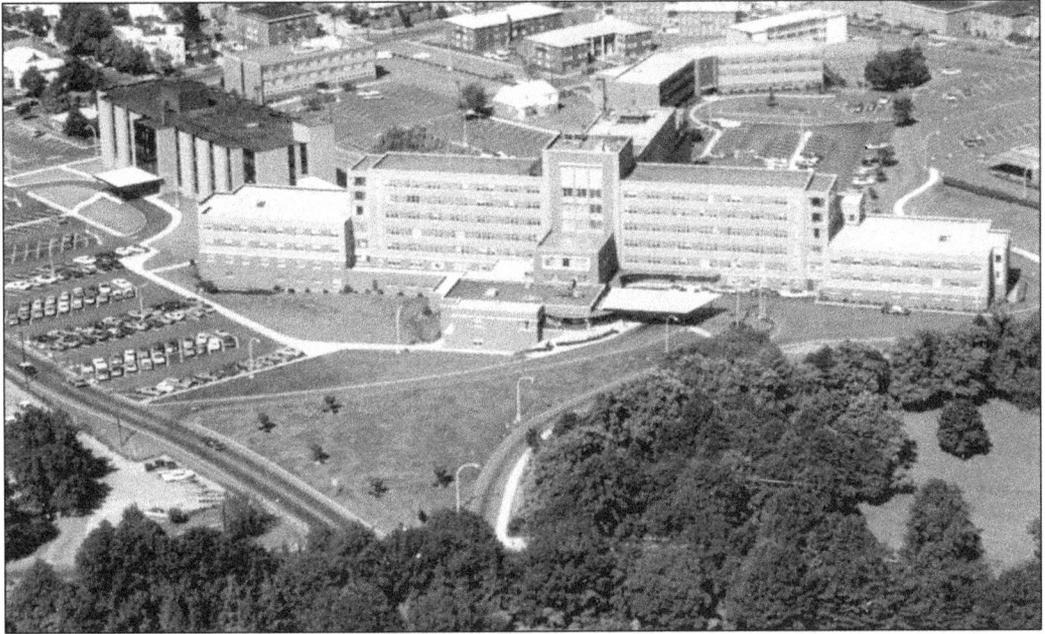

The Newark German Hospital moved to Belleville in 1957 with the construction of a new facility on Nanny Goat Hill on Franklin and Newark Avenues, previously owned by the Maioran family of Silver Lake. The hospital was renamed Clara Maass Memorial Hospital after the building's completion that same year. Clara Maass was a young nurse from East Orange who sacrificed her life during experimental treatment for yellow fever in Cuba.

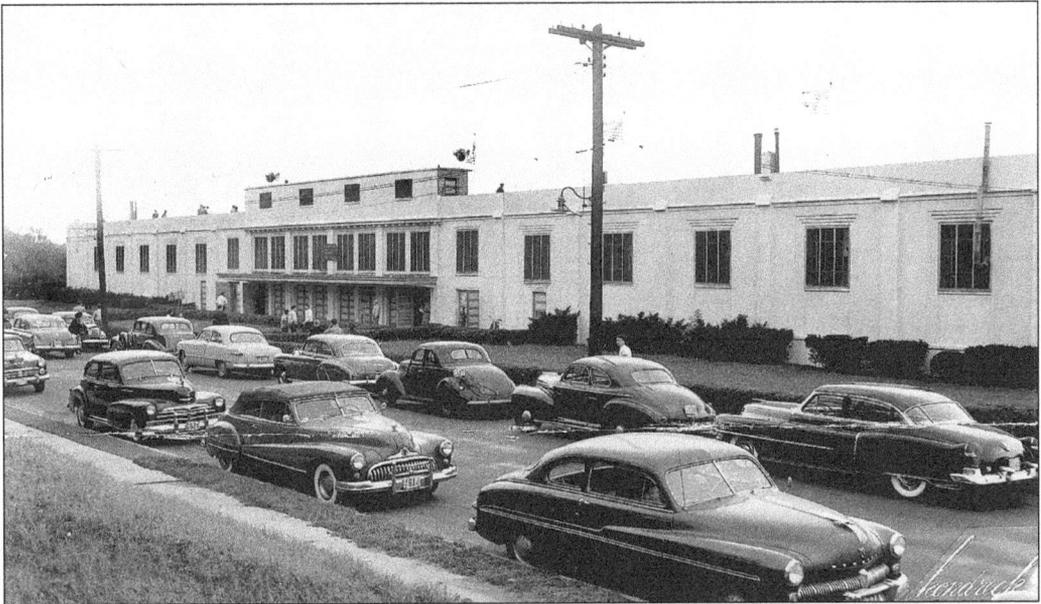

On Nolton Street behind the present Belleville High School is Municipal Stadium. Here, graduations, Fourth of July celebrations, and many sporting events have been held since its construction in the 1940s. The field is named after Doc Ellis, the football trainer for the high school whose career spanned three decades. There is also a concrete stadium and a running track, which are slated to undergo renovation.

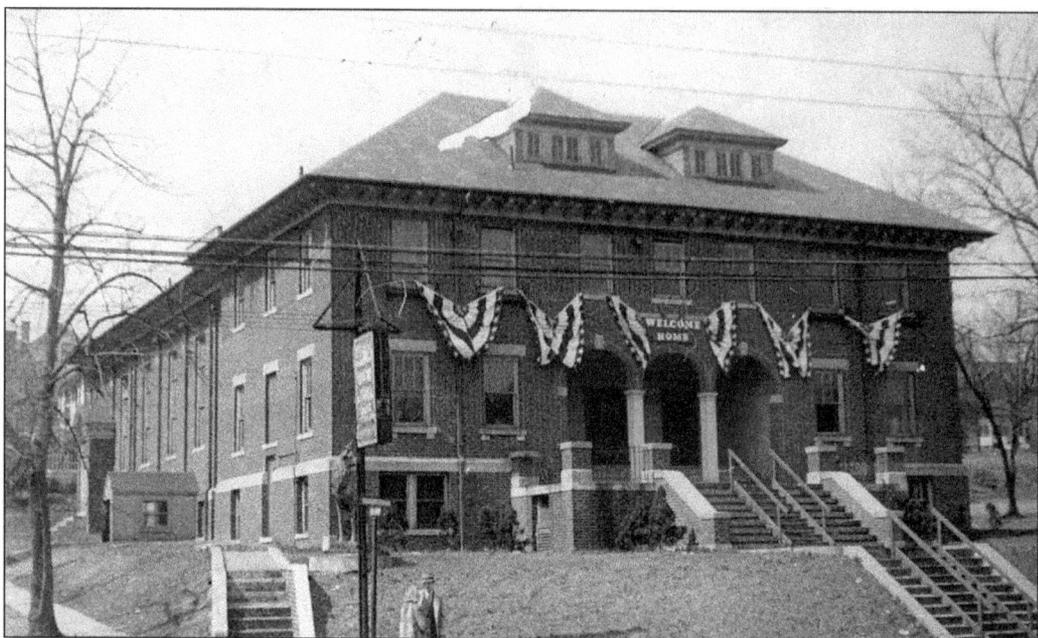

This photograph of the old Belleville Elks club's meeting place, taken in 1950, shows the large building at the corner of Washington Avenue and Van Houten Place. Built in 1925, the building was subsequently the home of the Disabled American Veterans organization. The Elks Lodge No. 1123 now has its headquarters at 254 Washington Avenue.

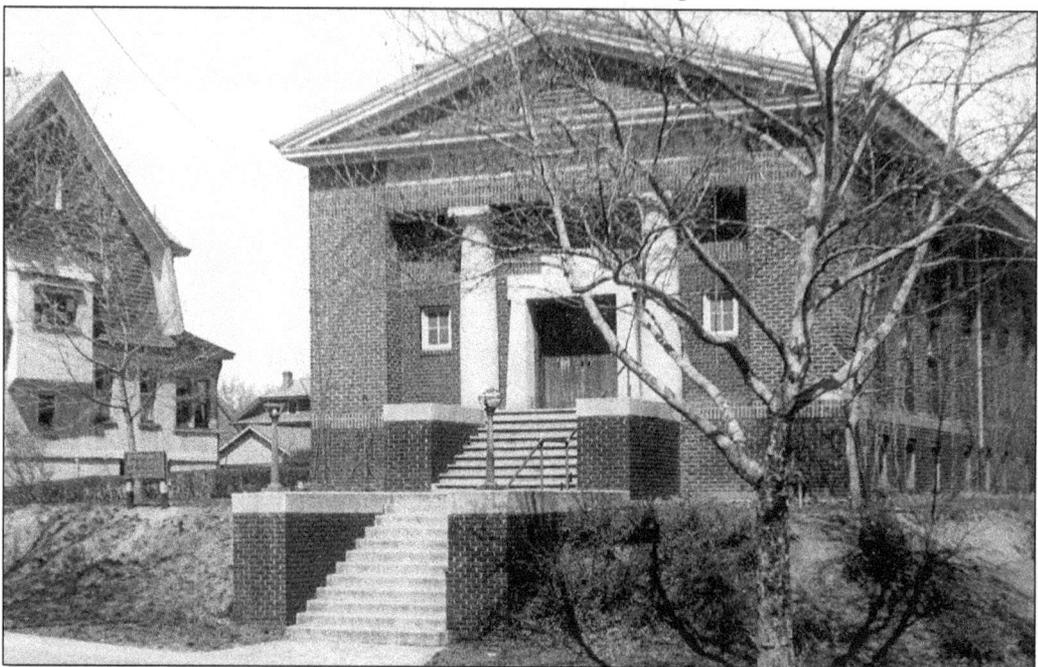

The Masonic Temple on Joralemon Street, west of Washington Avenue, has been home to the Free and Accepted Masons group since the 1920s. Previously, the fraternal organization met at the First National Bank on the second and fourth Wednesdays of the month. In 1909, the Belleville Free and Accepted Masons was led by Frank H. Wright.

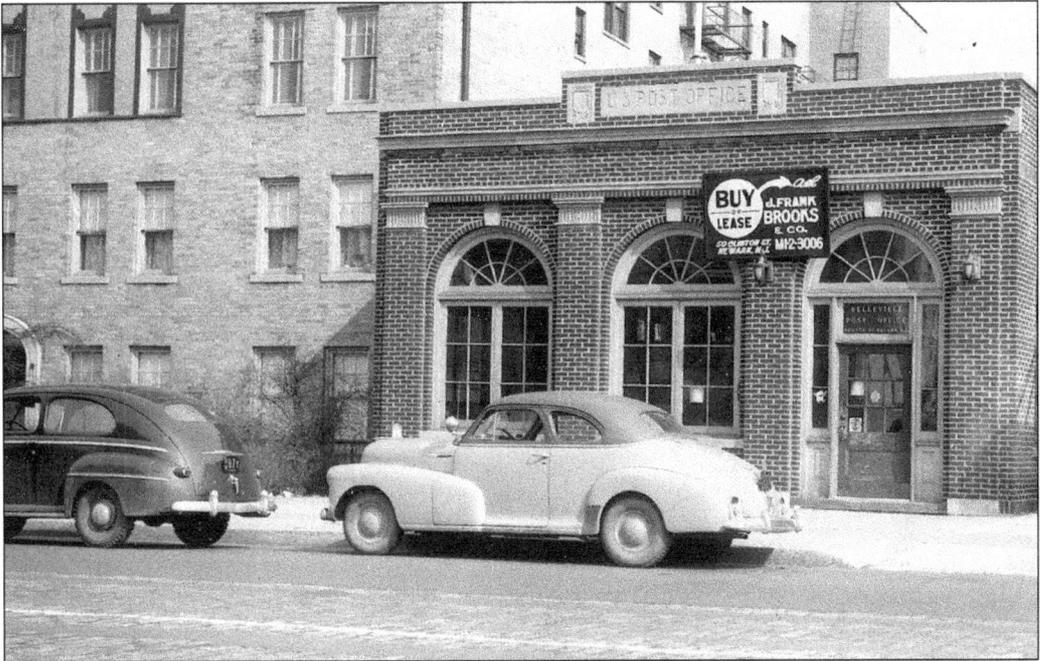

The old Belleville Post Office on Washington Avenue was closed in 1952 after a newer building was built on the opposite side of the street on the corner of New Street. Belleville's post office has been an annex branch of the Newark Post Office since its inception. At the time of the transfer, John J. Kant was superintendent.

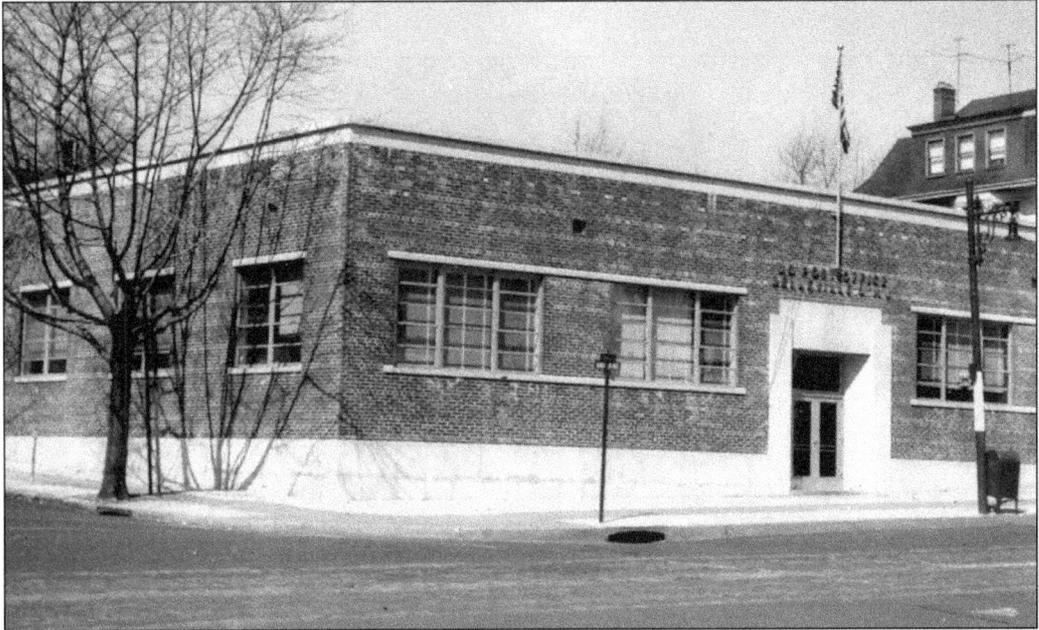

The new U.S. post office opened on December 31, 1951, with postmaster Louis A. Reilly in attendance. During its construction, local officials objected to its "industrial" exterior look, and face brick was substituted for the common red brick originally used on the outside. The new building would be three times as large as the old one, with twice as many post office boxes.

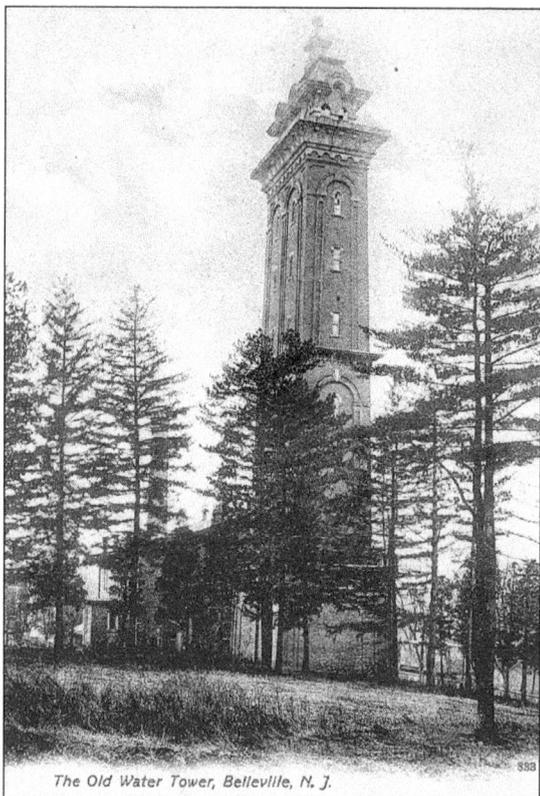

The author has not been able to find out the location of this water tower in Belleville but believes it could have been a part of the reservoir complex on Joralemon Street. The Newark Reservoir at Belleville provided cleansed groundwater to the townspeople and the residents of neighboring Newark. By the 1880s, however, 75 percent of the springs and wells in Belleville had been declared too polluted for consumption.

The Old Water Tower, Belleville, N. J.

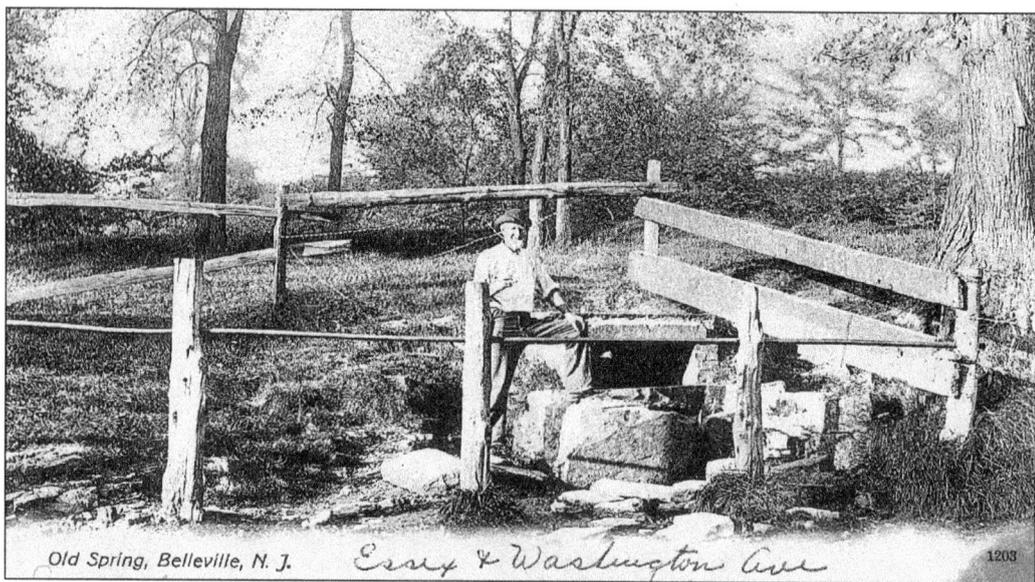

Old Spring, Belleville, N. J. Essex & Washington Ave

A spring was located at Essex Street and Washington Avenue in the late 19th century, a place where locals would come with their pails and fill up for free. At the time, only a few streets in town were piped for water. Pools of water filled with watercress, mint, and frogs fed into the spring.

Three

HOUSES OF WORSHIP

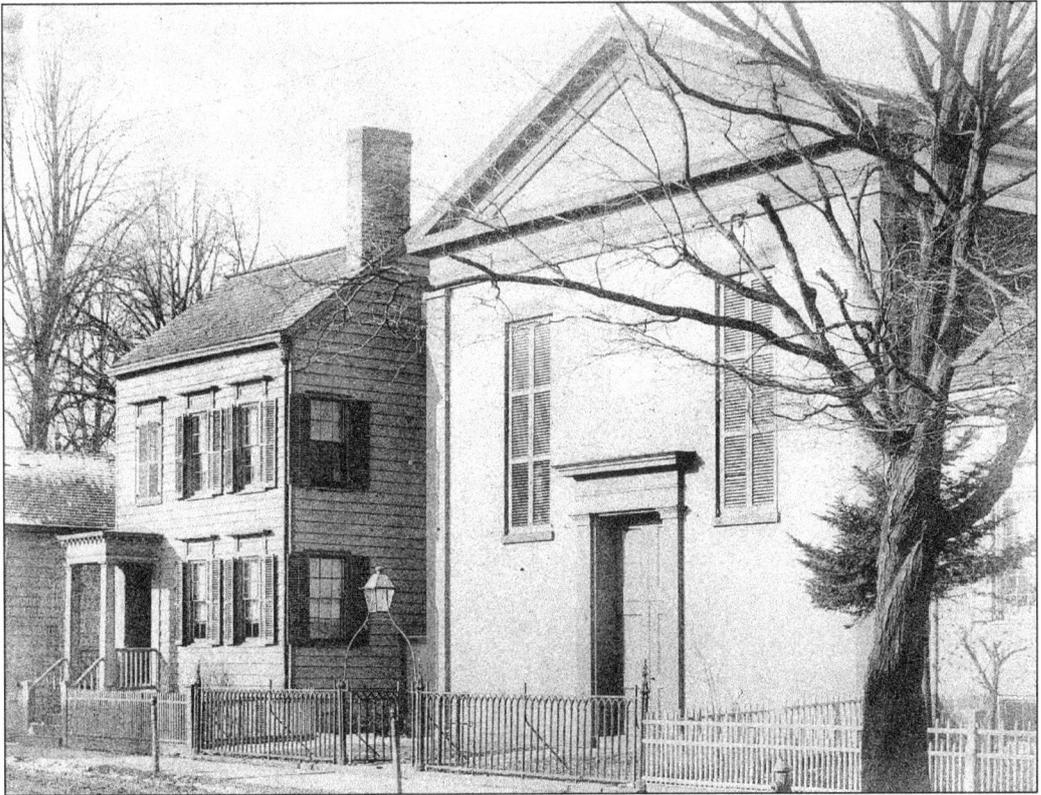

This 1889 photograph shows the first incarnation of Wesley United Methodist Church, constructed in 1803 on Main Street, south of Belleville Avenue. Begun in 1791, the church was organized by Margaret Dow and Mary Ann Stewart, and services were held in private homes. It is the oldest Methodist congregation in Essex County.

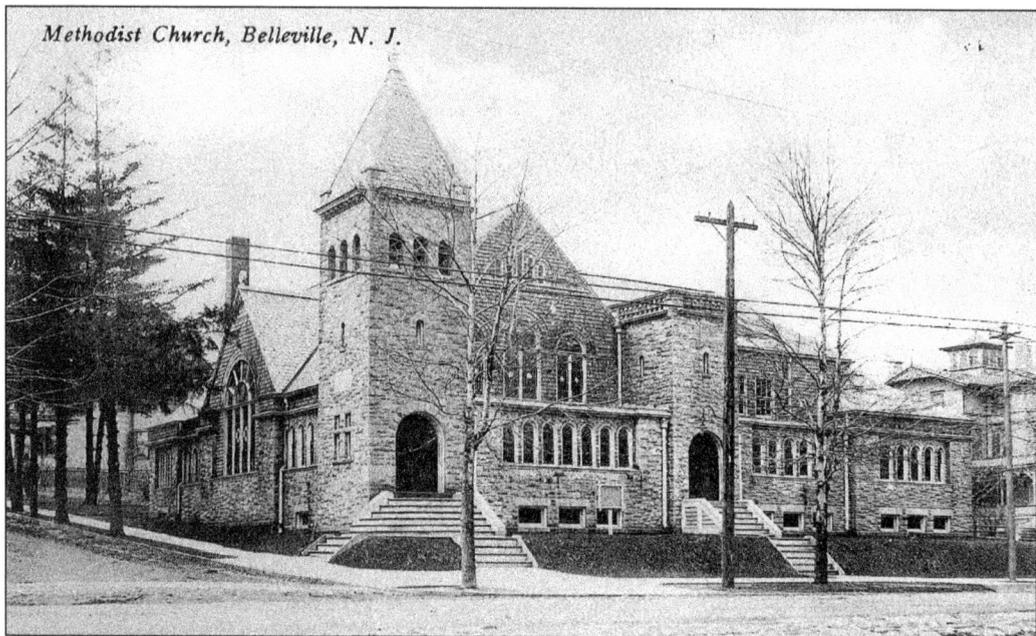

Methodist Church, Belleville, N. J.

As the number of congregants at Wesley United Methodist Church expanded, a new home was built at Academy Street on Washington Avenue to house them. This migration "up the hill" from the Passaic River mirrored the trend across Belleville as the population grew larger. Decades later, new stained-glass windows were added to the structure and an activities building was acquired.

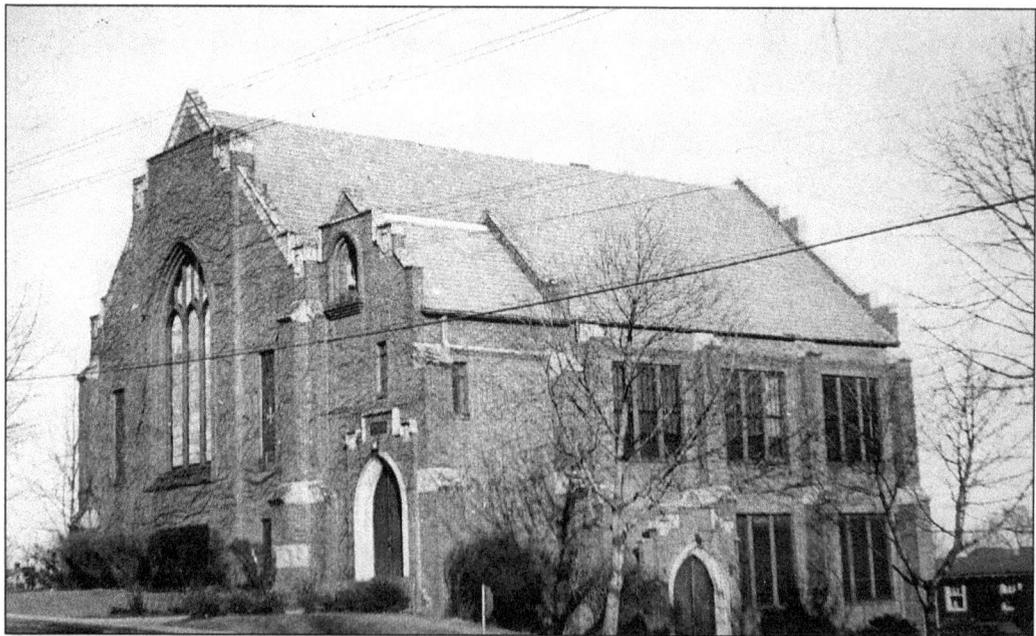

Fewsmith Memorial Presbyterian Church was dedicated in 1926 at its current location on Union Avenue at Little Street. Its name was taken from the church of the same name in Newark. In the past, Fewsmith had a popular youth program and Sunday school. Today, a preschool called Little Scholar Nursery School is run on the premises.

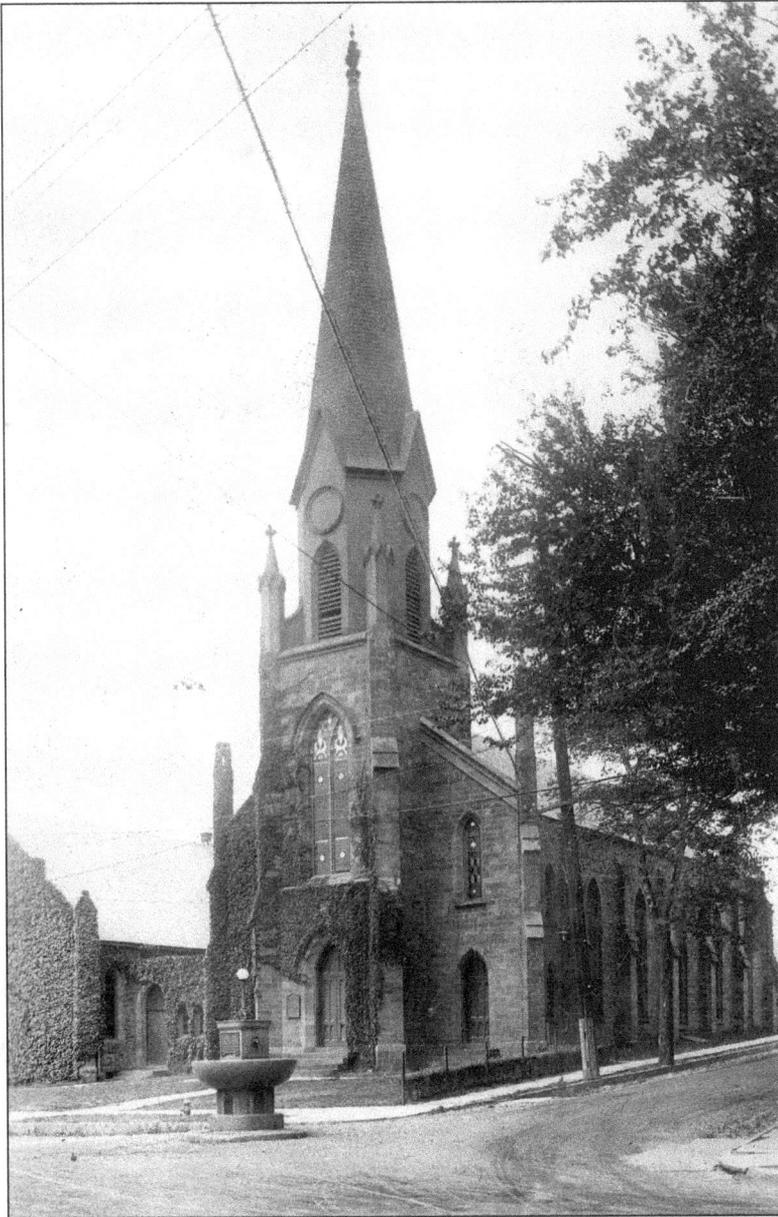

The original Dutch Reformed Church at the Belleville settlement of Second River was built in 1697 on the Passaic River waterfront and what is now Rutgers Street. It was rebuilt twice more atop the original foundation, in 1725 and 1807. Sixty-three Revolutionary War veterans, numerous town forefathers, and Henry Rutgers (for whom Rutgers University is named) are buried in its cemetery. During his retreat through New Jersey, on his way to the famous Delaware River crossing in 1775, it is said Gen. George Washington stopped in Belleville and worshiped at the Dutch Reformed Church. Although without concrete evidence, it is also said that there was once a tunnel from the church that led under the Passaic River into Kearny and was used during Revolutionary War skirmishes to battle with the British across the river. The present church was constructed and dedicated in 1853, using materials from Belleville's first school building, the Academy, which was located across the street.

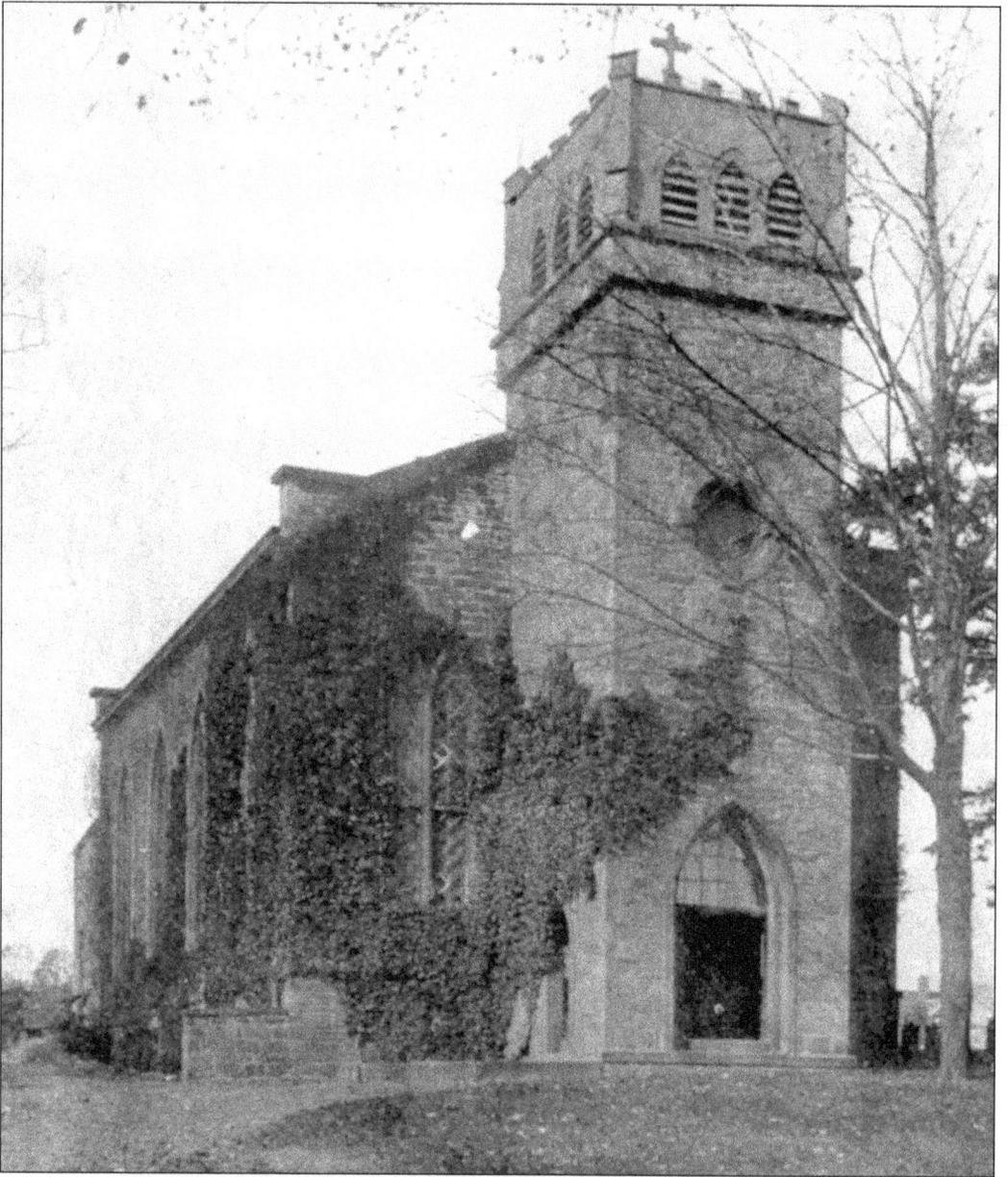

The charter for Christ Episcopal Church can be traced back to King George II of England, who authorized it in 1746, making the church a part of Trinity Church in Newark and providing another house of worship for Belleville's 300 inhabitants at the time. Early services predated the charter—in 1743, meetings were held at Bennett's mill house on the Passsaic River bank. Later, in 1774, services were moved into an old home called the Academy. Parishioners unsuccessfully tried to raise funds for a building, and it was not until 1836 that the cornerstone was laid for the church's first building on Main Street. Less than one year later, it burned to the ground. A stone church was rebuilt in the Georgian Gothic style in 1841 with cemetery grounds on either side. A Norman fortress tower was the focal point of this new building, and it held the church bell. Landscaped grounds surrounded the structure, and it was fronted by a circular drive. Buried on either side of the church were its early founders.

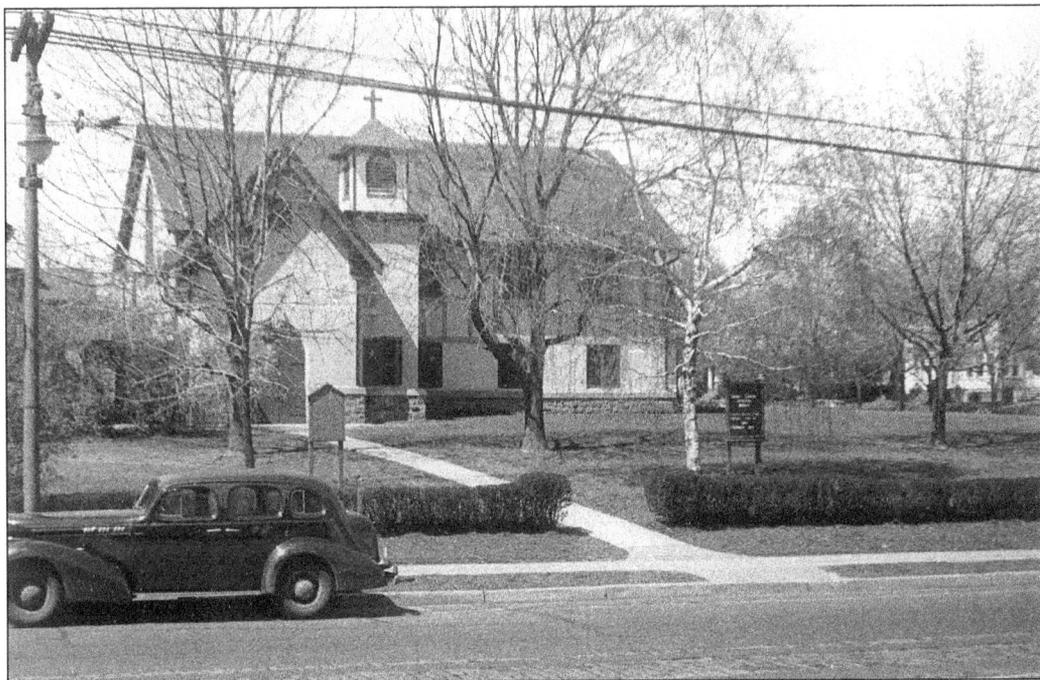

As the needs of its congregation changed, the leaders of Christ Episcopal Church purchased land on Washington Avenue and here built a parish house and rectory, which was completed in 1914. Following a campaign in 1928 to raise $50,000 for the purpose, land was purchased at Van Reyper Place with the intention of erecting a new church. As the nation entered the Great Depression, those plans fell through, and the property was sold in 1936.

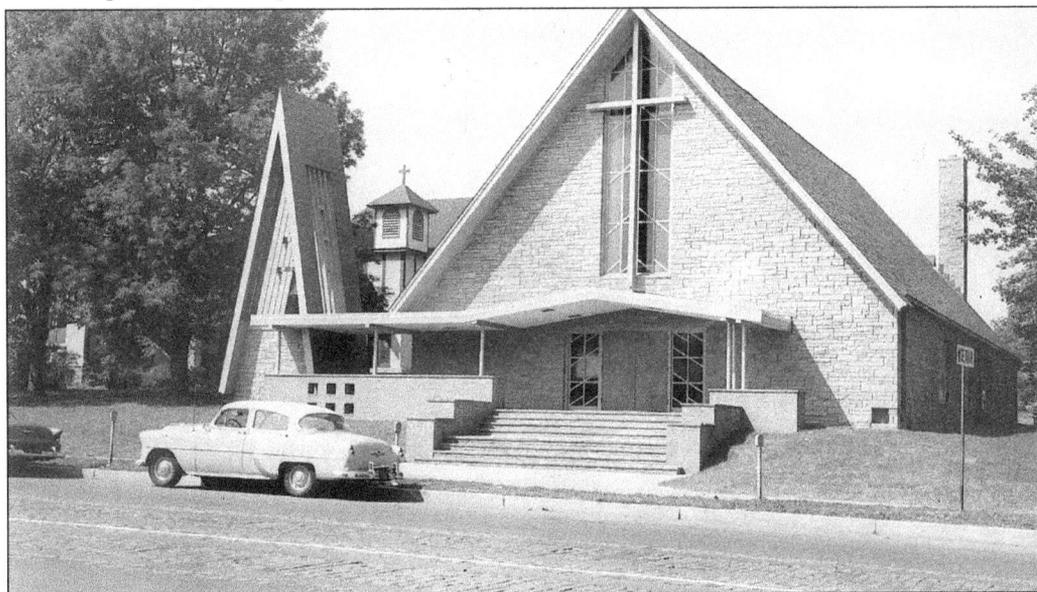

By the end of the 1940s, the consensus of the parishioners of Christ Episcopal Church was that it was more feasible to construct a new church rather than renovate the present building on Main Street. A groundbreaking ceremony was held in 1956 for the new, modernistic church building alongside the rectory on Washington Avenue.

43

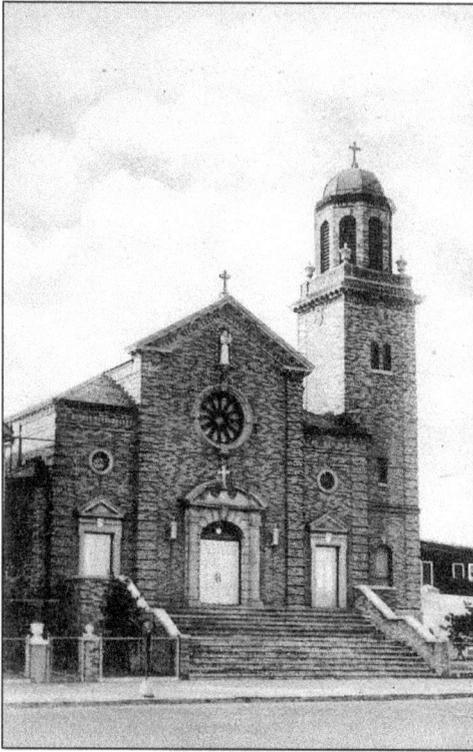

The large Italian immigrant community founded St. Anthony's Roman Catholic Church on Franklin Street in the Silver Lake section of town in 1901. Each August, the church is host to a festival commemorating the Feast of St. Bartholomew. The church's rectory and school are situated just over the Newark border off Franklin Street.

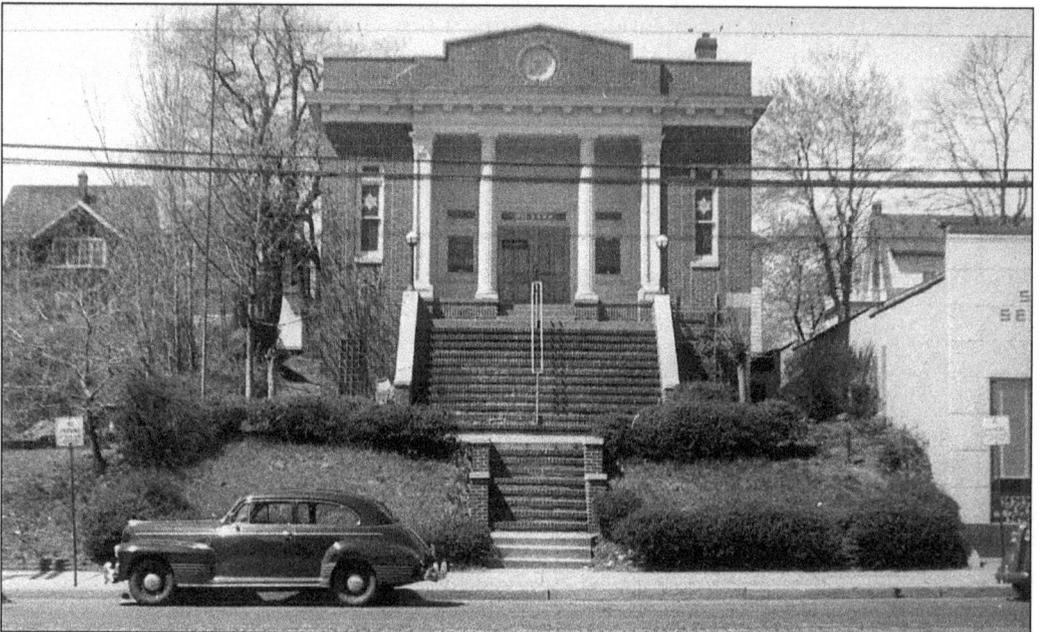

The variety of faiths and religions in Belleville expanded further in the 1870s, when a small community of Jewish immigrants arrived and conducted worship in their own homes. A dedicated synagogue was eventually built in 1924 on Washington Avenue near Holmes Street. Nathan Schwartz served as Congregation Ahavath Achim's first cantor, rabbi, and president until 1936. Schwartz was also a co-owner of Belleville's Hillside Pleasure Park.

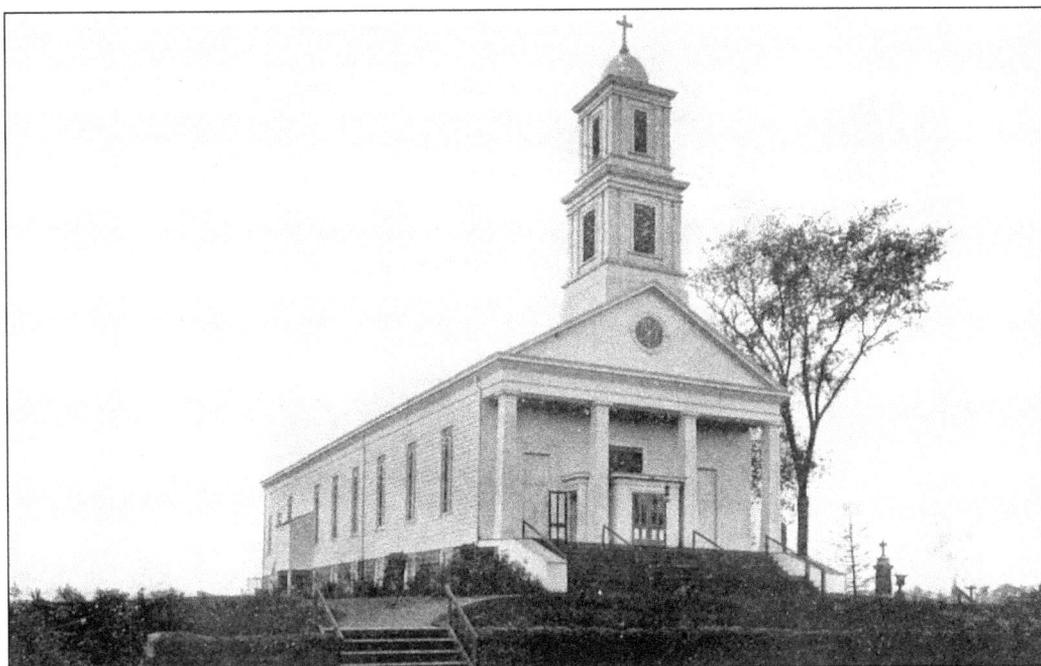

Here is St. Peter's Roman Catholic Church as it looked in 1882. The church building was raised in 1838 on property at William Street after years of holding services in private homes. People would row across the Passaic River to reach the Belleville side in order to attend Masses, since St. Peter's was the only Catholic church in the area at the time, outside of one located in New York City.

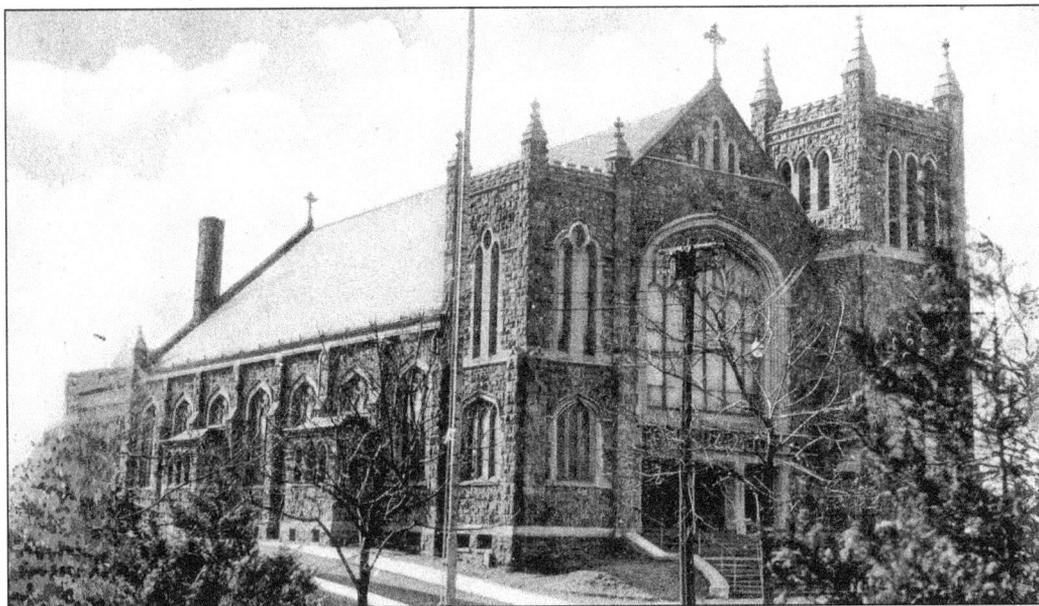

A new Gothic church was begun in 1924 to house the St. Peter's congregation, also on William Street. Rev. Edwin Field began the push for a new church after his appointment in 1923. The original church building had been renovated and enlarged many times, but it was decided it was time for a new home.

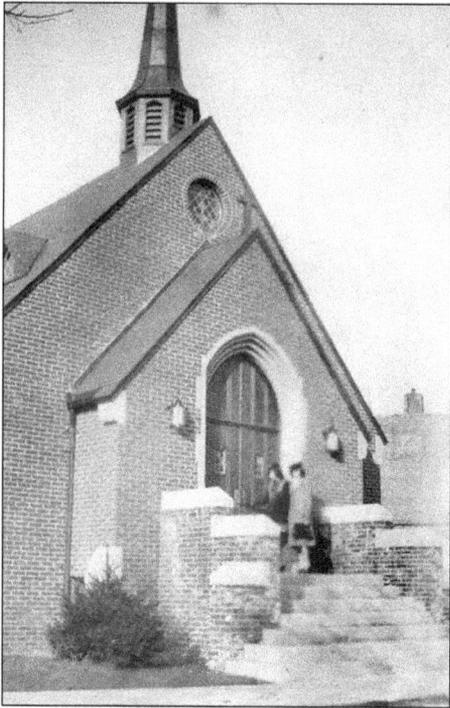

Bethany Lutheran Church was organized in 1931 with 22 charter members. Initially, services were held at the Masonic Temple, until the completion of a new church building in 1940 on Joralemon Street at New Street. Property for a parish hall and parsonage was purchased soon thereafter. Rev. Harry Pfunke served as Bethany's first pastor for eight years and has since been succeeded by eight pastors.

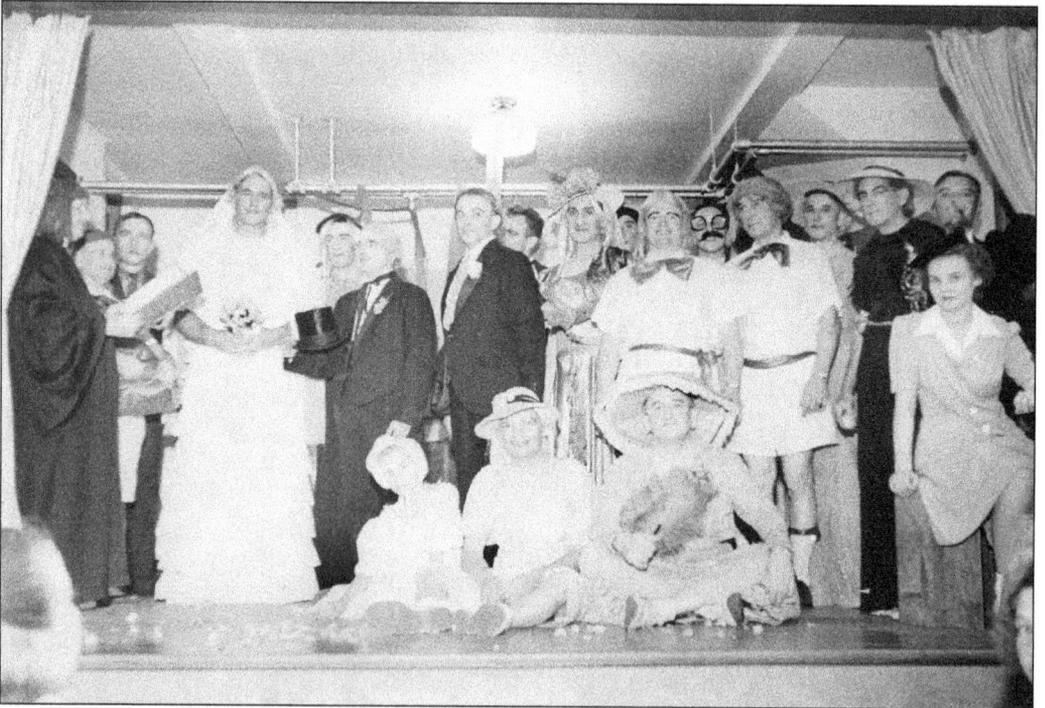

Many activities, such as this male revue, have been held at Bethany Lutheran over the years. There is a choir and a Sunday school program, along with numerous committees and organizations within the parish. The church's Chorus of Communities group has raised more than $10,000 for the Clara Maass Pastoral Care Center.

Four

EDUCATION

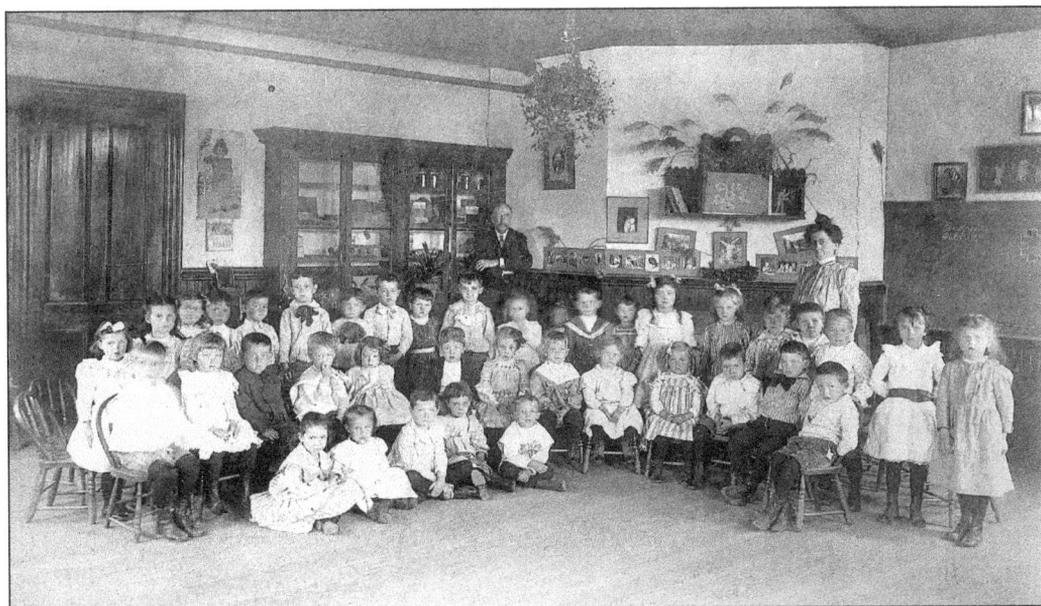

Education in Belleville was paramount even from the settlement's beginnings. Private schools and churches were the first to teach the younger citizens. The first public school in town would be built out of necessity when the property originally used for the previous nondenominational school was repossessed for a new Dutch Reformed Church. This class of grammar school students may have been located in School No. 1, the first modern school.

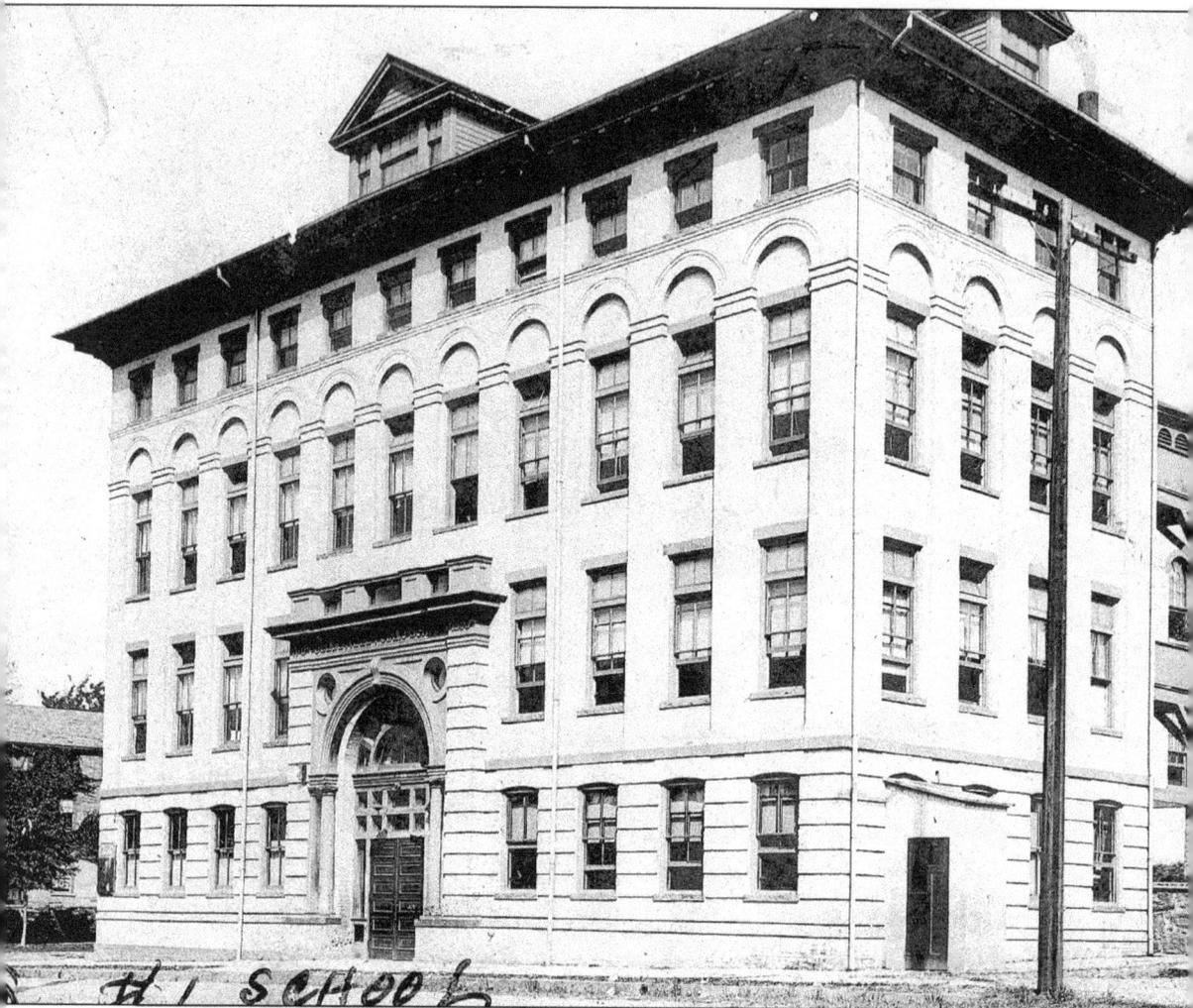

The original School No. 1 was built in 1853 to serve the students of Belleville. Two acres of land were purchased on Stephens Street for $700. On that land, a brick two-story building was built by Timothy Underwood and Hinman Lyon for $4,895.54 and called the Academy by the townspeople. The structure was 60 feet long by 32 feet wide with four rooms and a glass-enclosed cupola atop the roof. By 1890, another two-story building was constructed for $5,000. Two years after that, a four-story annex was constructed to accommodate the growing student population. This last annex, pictured here, faced Cortlandt Street. Classes were organized into kindergarten, primary, grammar, and high school classes according to ability and age. High school classes were first held in the basement and were then moved up to the second floor. The first high school class graduated in 1898, and the exercises were held in the Dutch Reformed Church.

Principal Alice Bricker and two faculty members appear in long skirts and white blouses in this 1901 photograph taken in front of School No. 1. At first, the school did not have much money, so pupils had to provide their own paper and pencils and, sometimes, textbooks. The school was not wired for electricity—teachers lit gaslights on darker days.

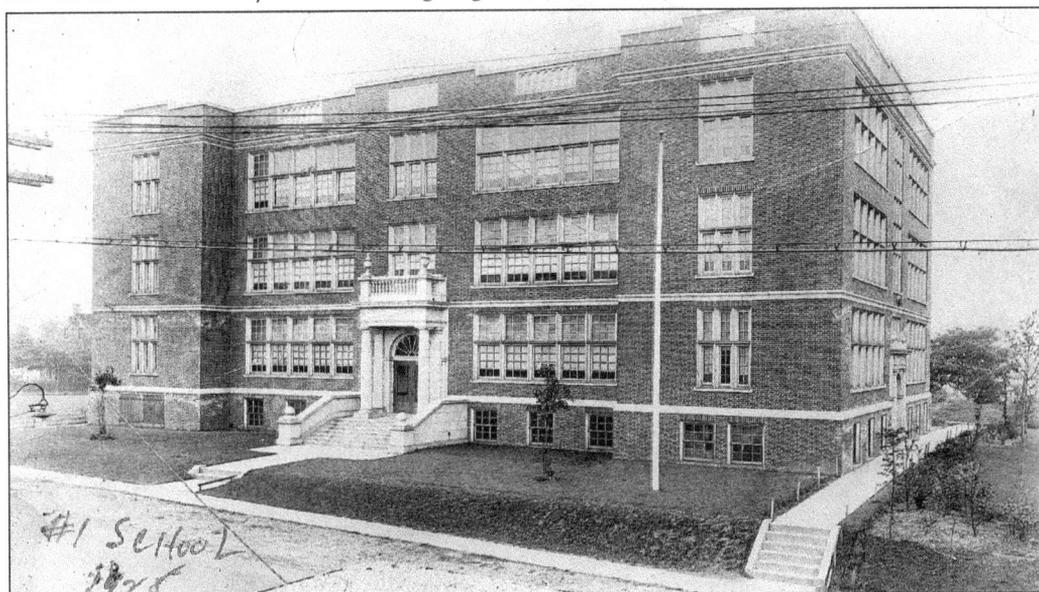

Here is School No. 1 as it looks today. The three-story building was constructed in 1919 and housed 16 classrooms and an auditorium, built on the third floor. Once the student population reached 700 children, the auditorium had to be divided into two additional classrooms.

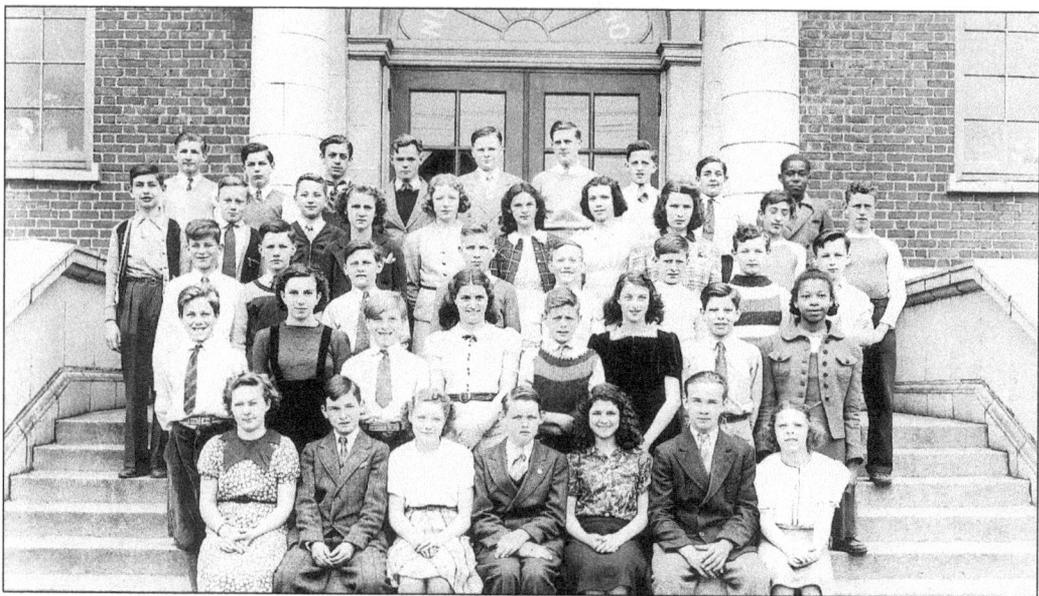

The graduating class of 1940 stands for its class picture in front of the newest School No. 1. A new auditorium was added onto the east side of the building for programs and graduations in 1965, and the old one was then converted into a library. Today, the building is used as the administrative offices of the Belleville Board of Education.

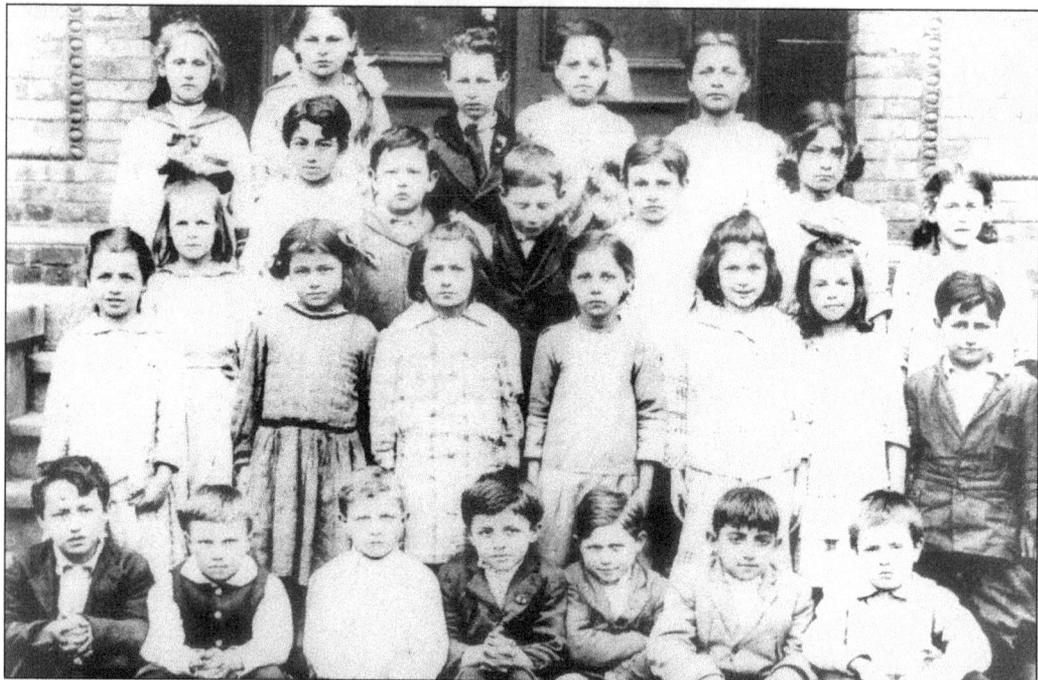

The Montgomery School was organized in 1838, and a small-frame building was set on the corner of Mill and Maple Streets, near Randolph's Mills. This building became School No. 2, and these children were its students. Architect Charles Granville Jones approved the plans for a more modern school to be built there during the 1920s. The school was later deemed unnecessary and was demolished.

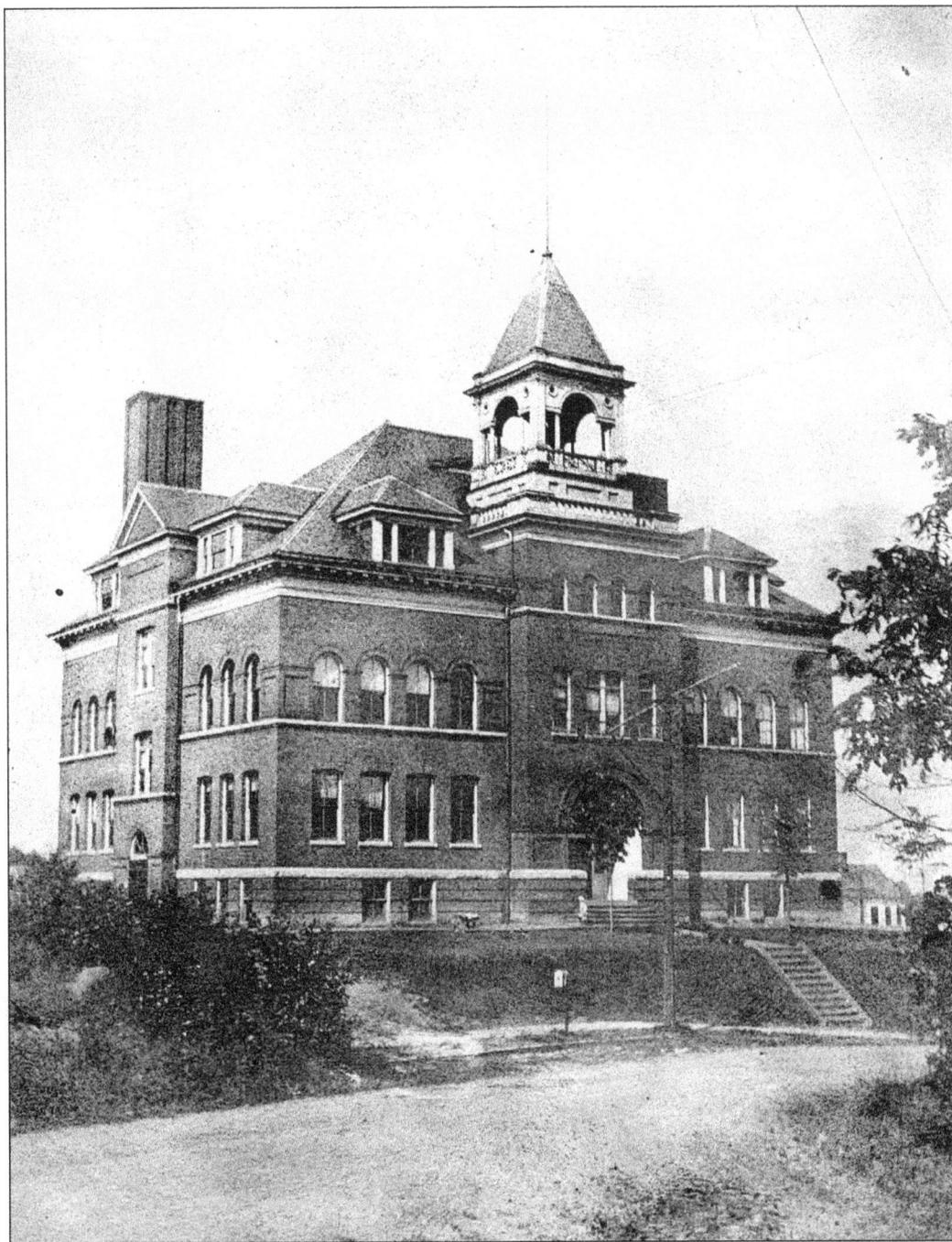

School No. 3 had its beginnings on the same property where it stands now, on the corner of Joralemon Street and Union Avenue. Built in 1897, it would take over the high school classes transferred from School No. 1. The eighth-graders in the 1920s were also brought over to School No. 3, creating more space for the lower grades in School No. 1. A bell tower sat atop the structure, but it was later removed.

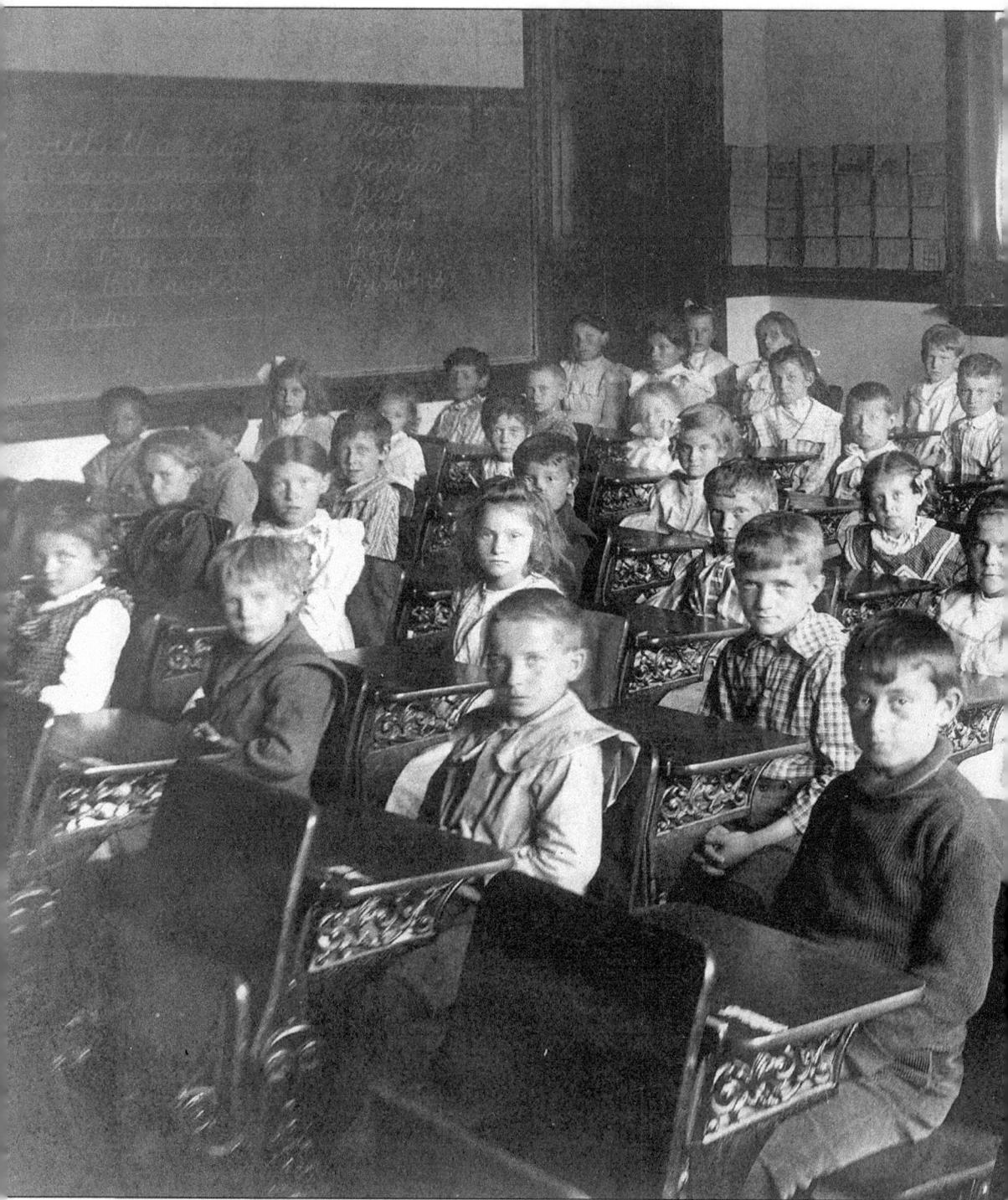

These students at the old School No. 3 sit at wooden desks with intricate iron scrollwork on the sides and legs. More than 60 students were in this one class alone. Enrollment in Belleville schools nearly doubled within a 10-year period, from 1,086 in 1903 to 2,144 c. 1910, creating a need for more schools within the township. To accommodate the burgeoning population,

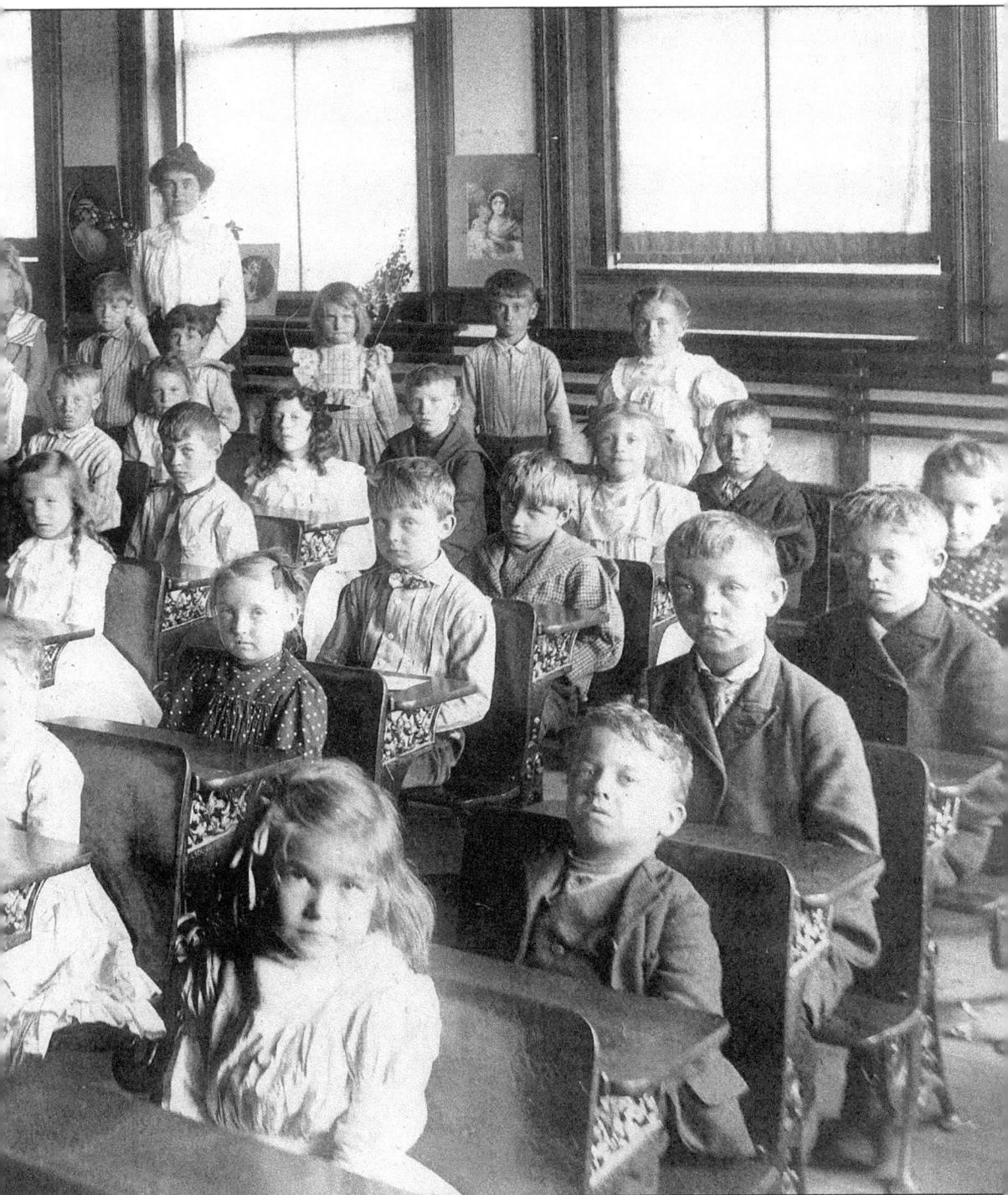

six more schools would open in a 20-year period from 1913 to the 1930s. A fatal blow against School No. 3 was dealt in January 1976, when the entire building was destroyed during a fast-moving fire. So much water was put on the fire in the cold temperatures that icicles formed and the ground became a sheet of ice.

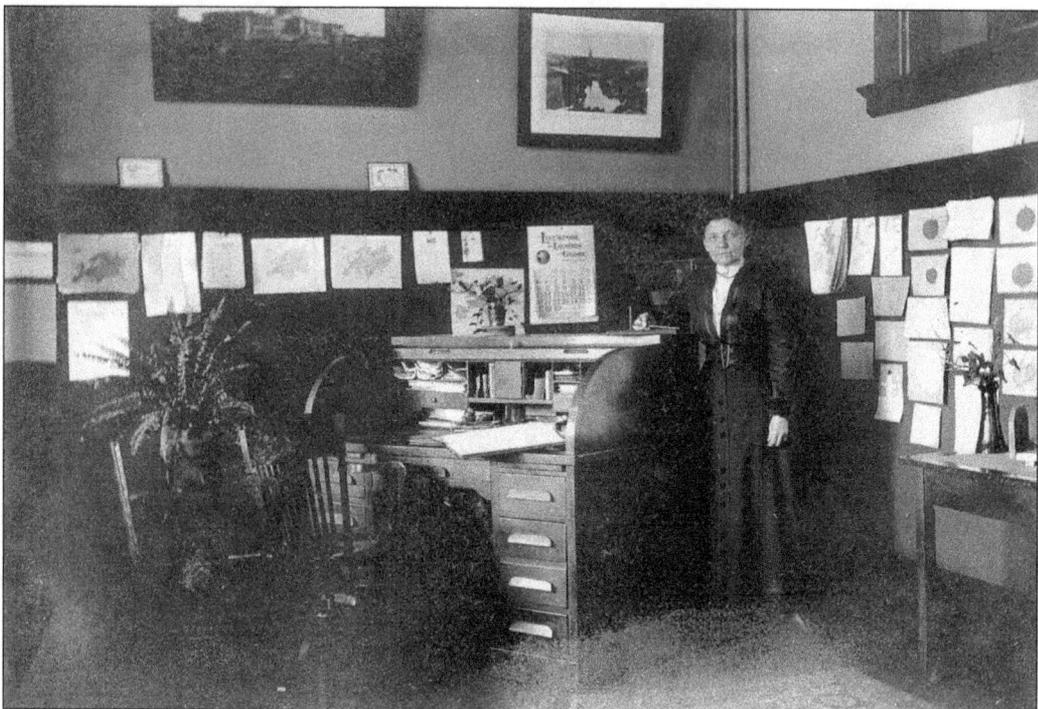

This stern-faced principal headed School No. 3 at the beginning of the 20th century. Her office was fairly large, furnished with a wooden roll desk, a chair, and even a fern plant. Pupils' artwork is posted across her walls, and an Oriental rug is on the floor.

School No. 5 was built in 1913 at Greylock Parkway and Adelaide Street to accommodate the children of the families who had built their homes on the Greylock Manor tract in the immediate area. Sixteen years earlier in Silver Lake, School No. 4 was built on Magnolia Street in response to a population increase in that area of town.

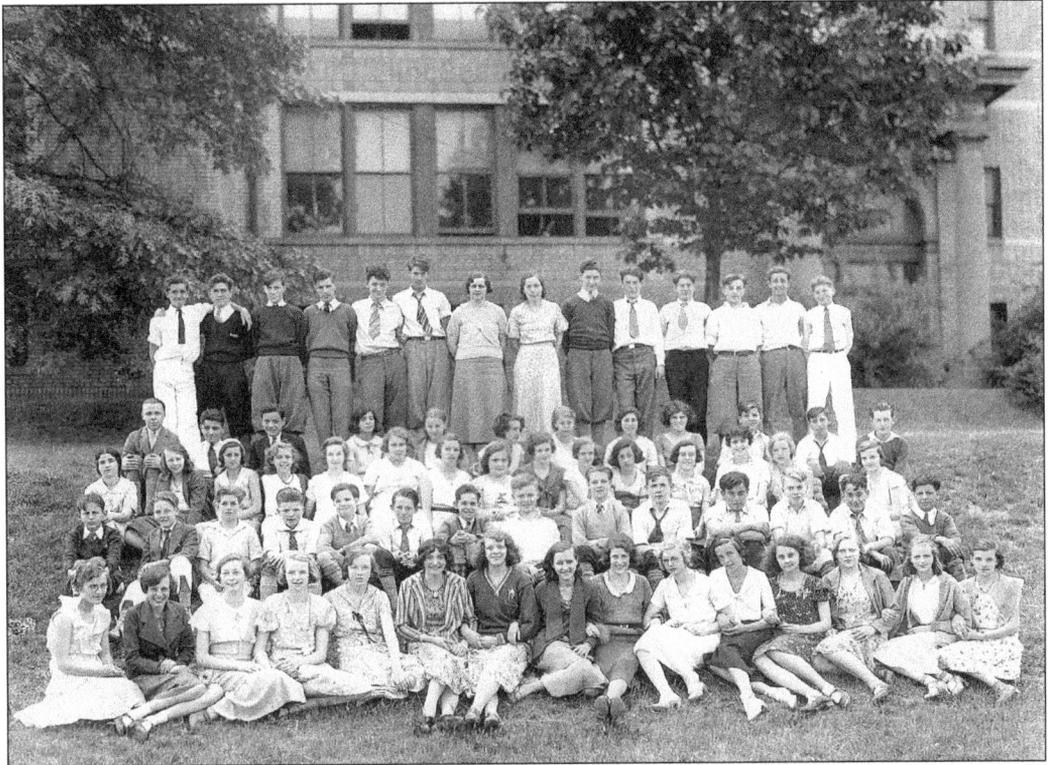

In the 1930s, School No. 5 held classes from kindergarten to eighth grade, instead of only to sixth grade as it does today. These students made up the school's graduating eighth-grade class in June 1932. Note how symmetrically the students were arranged, by gender.

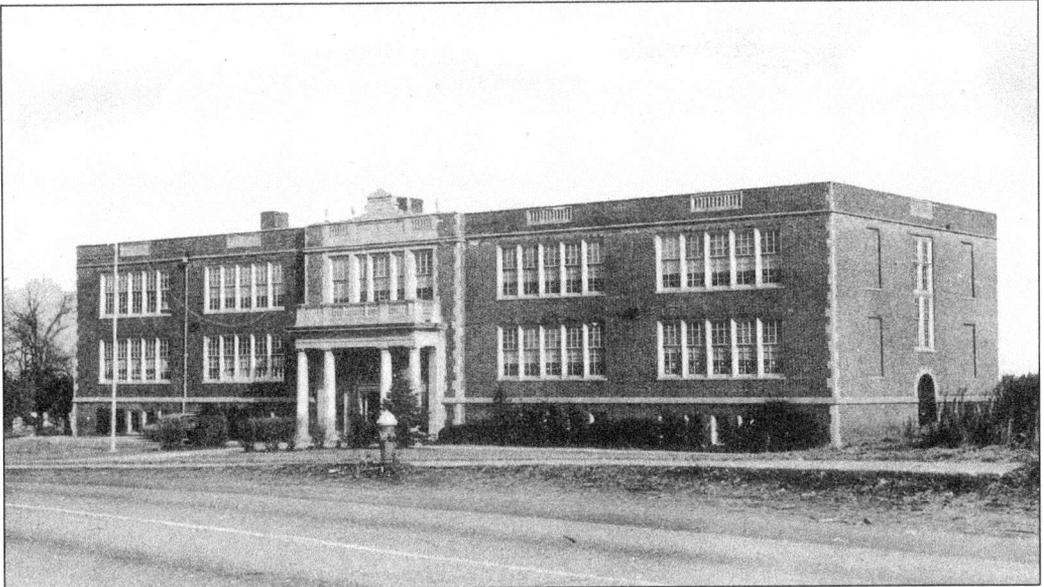

School No. 7 was built in 1921 on Joralemon Street near Passaic Avenue. The school houses kindergarten through sixth grade, as well as the Academically Talented classes for fourth-through sixth-grade students. Marilyn Hawthorne has been principal for the past 19 years.

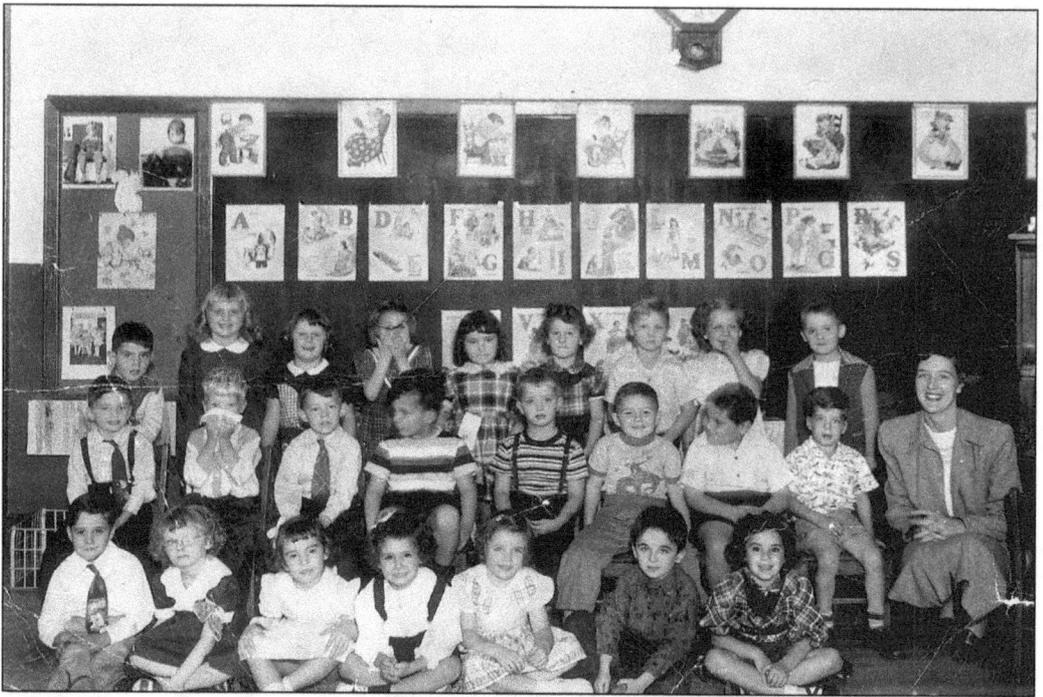

Keeping her kindergarten class focused on the camera does not appear to be an easy task for Helen Bauman, far right. The students attended School No. 8 on Union Avenue in 1950. The school property was expanded in 1926 when John C. Lloyd sold the land for Clearman Field to the town. The field was named for the board of education president at that time, David Clearman.

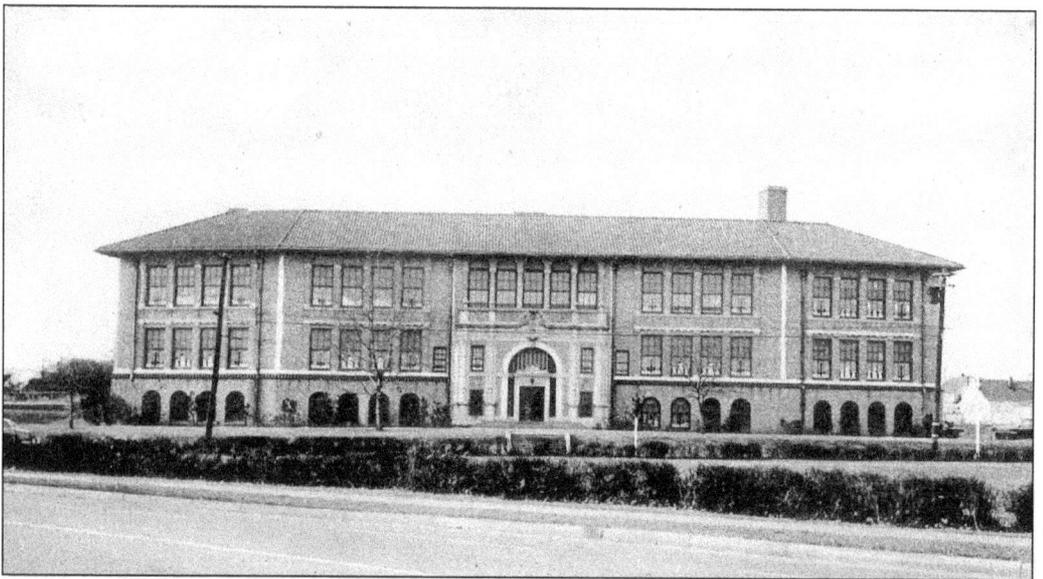

In the 1930s, it was necessary to add another school for children in the Soho section of town to attend. This school (School No. 10), located at the corner of Franklin and Belleville Avenues across from the old Soho Isolation Hospital, was faced with beige brick. By 1933, the student population had topped out at 6,000 pupils.

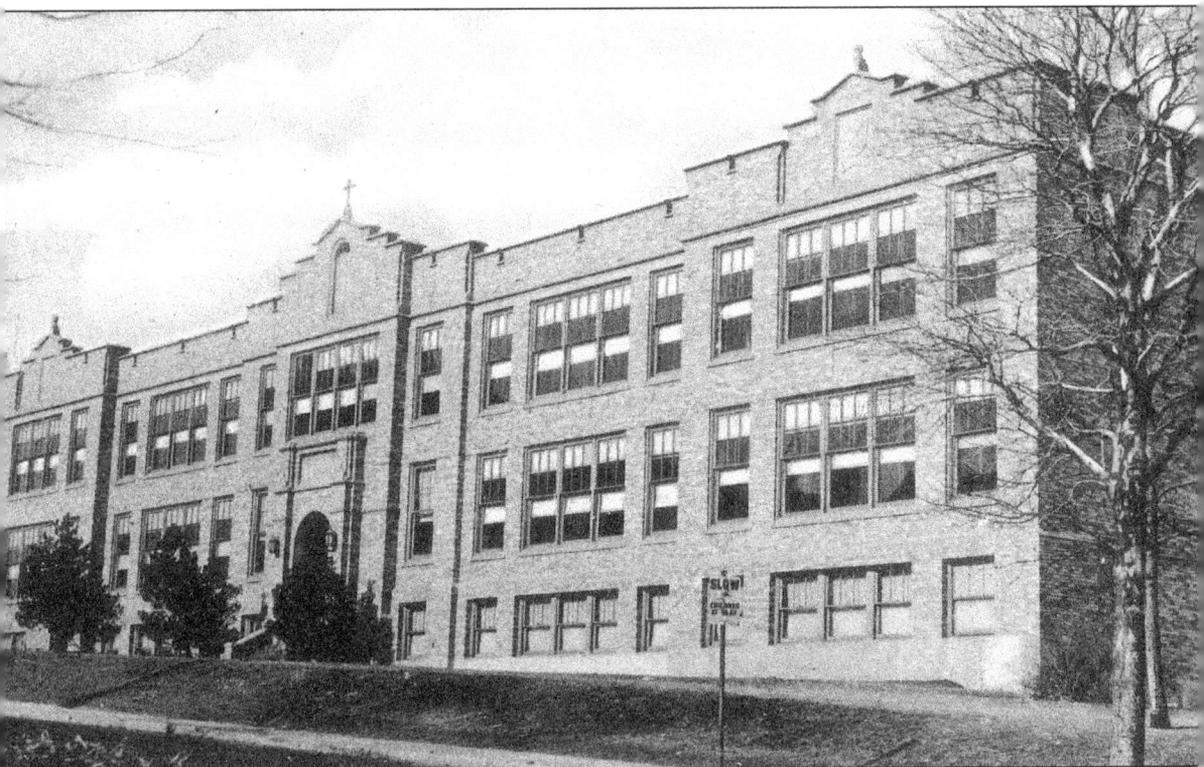

St. Peter's School was built next to the church on William and Dow Streets. In keeping with its Christian roots, the building was constructed in the shape of a cross. The parochial school had 225 students in 1884, many of whom were children of the church's parishioners. Several nuns taught the classes, under the direction of the pastor, who served in the role of principal. Also on the church property was a Catholic cemetery and a convent, and the total value of the two acres of property was estimated at $35,000. The church itself was enlarged more than once to accommodate the growing congregation, which numbered 400 at this time. As the only Roman Catholic church in the area, people from all over came to worship at its services. Extension parishes were then built in the neighboring Nutley, Bloomfield, and Montclair communities. The Belleville parish was originally begun by Irish immigrants in 1838. Many of these early settlers were buried in the church cemetery.

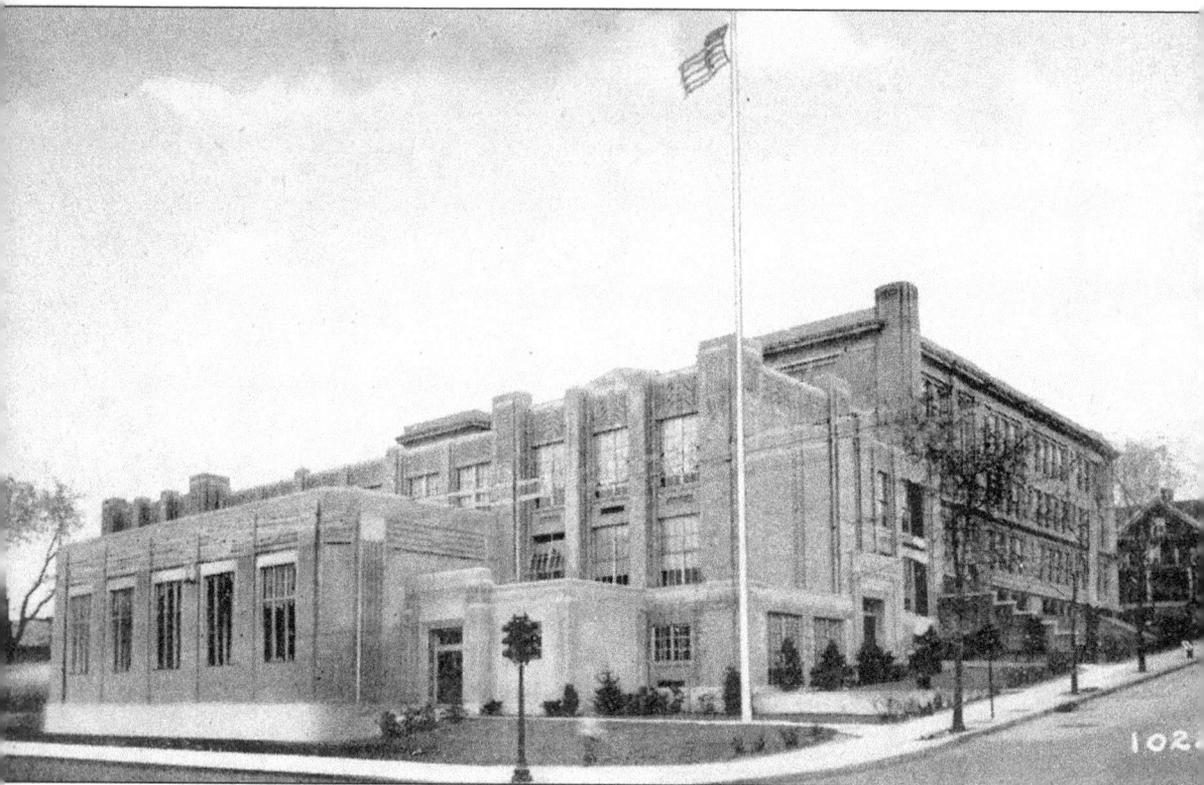

Charles Granville Jones was the architect of the original Belleville High School building, situated on the corner of Washington Avenue and Holmes Street. Built in 1915, it was enlarged by additions to the original structure in 1923 and 1936, giving it the capacity to hold 1,700 students. The building was at first 300 feet in from the road, and walkways in the shape of semicircles led up to the front doors of the school, which only seniors were able to use. Between the walkways stood a flagpole and a sundial. There were boys' and girls' gyms, a cafeteria, and many classrooms. Legend has it that there was once a swimming pool, which was covered over with concrete and made into the present lower gym after a student drowned in the water. A newer high school was built across from Municipal Stadium on Passaic Avenue and Division Street in 1964 to house the growing student population. The old high school was then turned into a middle school for grades 6 through 8. Today, the Belleville school system has kindergarten through grade 6 at its grammar schools, grades 7 and 8 at the middle school, and grades 9 through 12 at the present high school.

Five

TRANSPORTATION

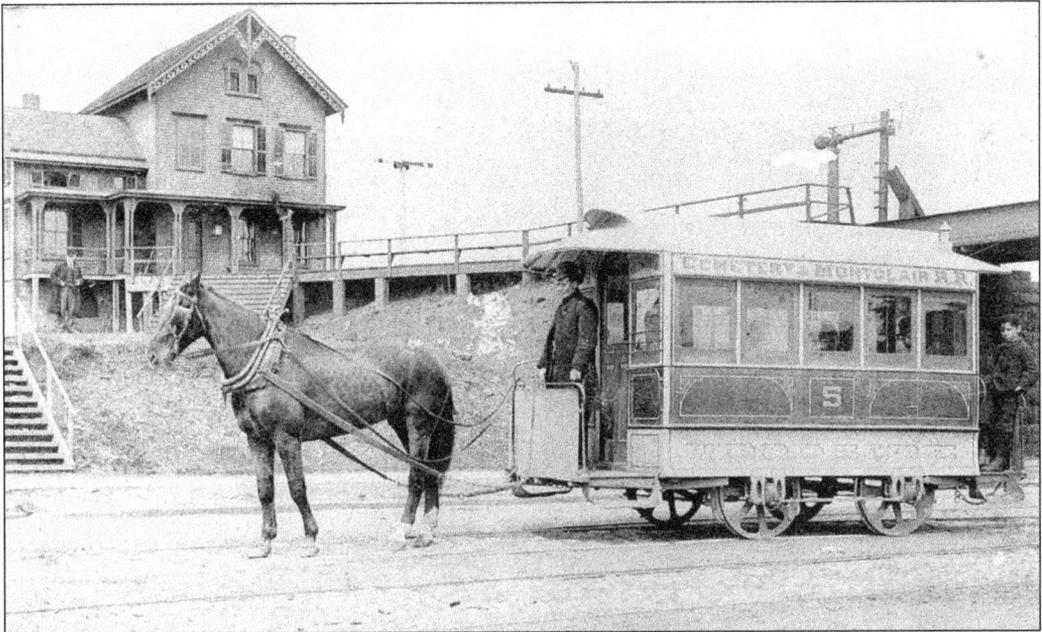

Horsecar trolleys once ran along Main Street to Mill Street and then traveled into the Woodside section of Newark. It was said that one horsecar driver, Jimmy Noonan, loved the game of baseball so much that he would stop in the middle of carting passengers to their destination to play a pickup game while his customers fumed.

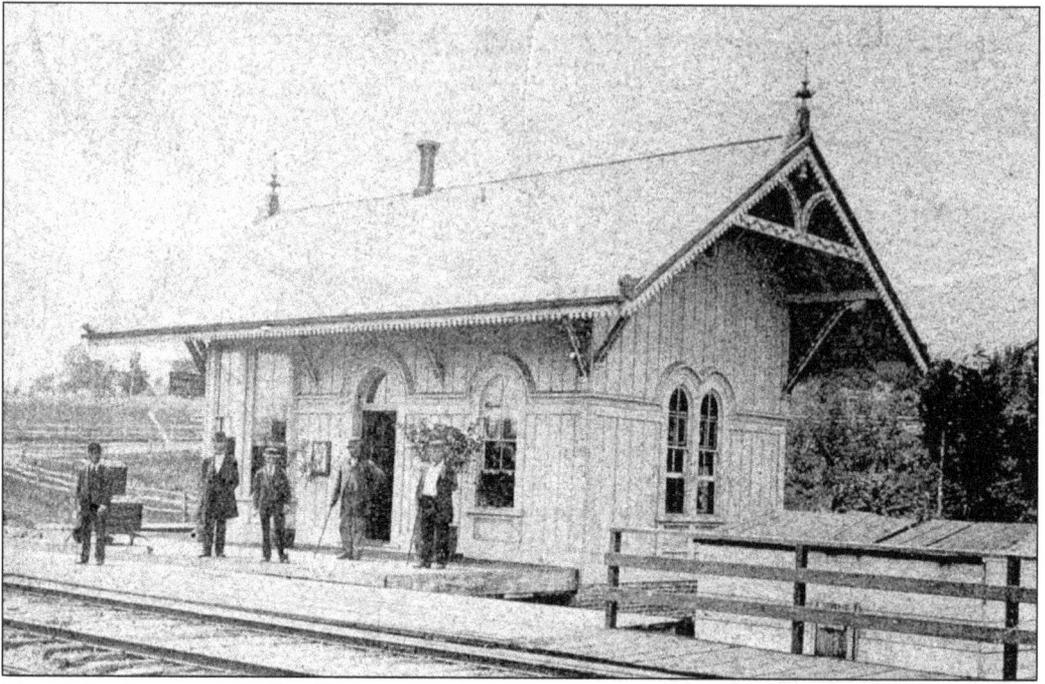

The Essex Station in Belleville at Essex Street was a stop on the Paterson–Newark branch of the Erie Railroad, which ran north and south between the two locations. One hundred twenty-two trains traveled weekly on this line. Today, there is no station left, just the railroad tracks.

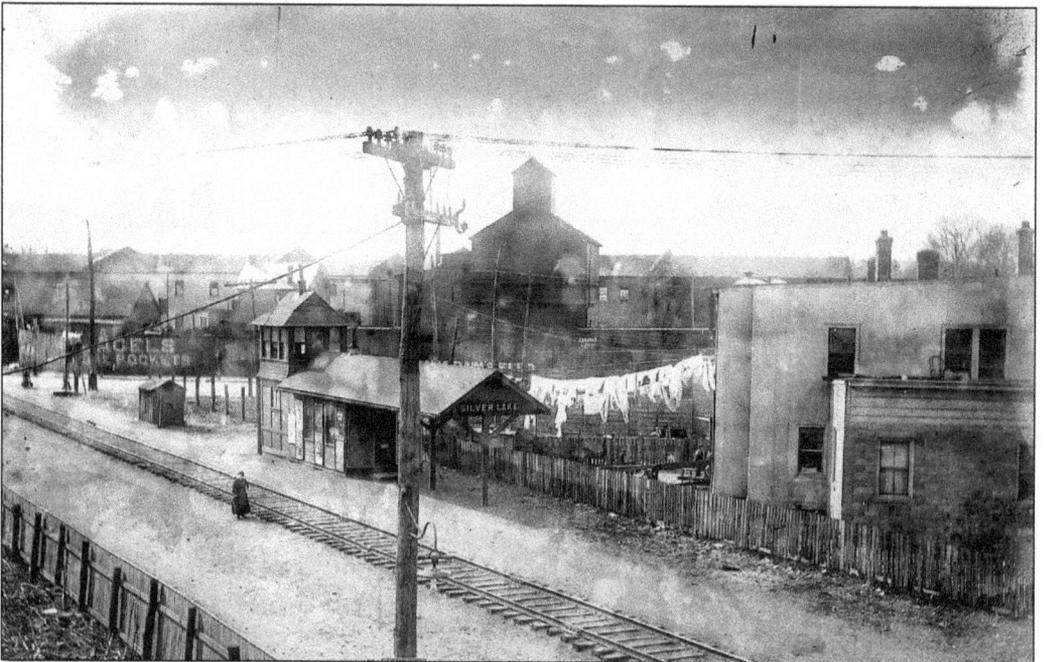

A train station was also built in the Silver Lake section of town, where today the railroad tracks have been converted into a light rail line. In the foreground on the electric pole is a marker for Heckel Street, and to the left of that is a livestock pen.

The "Mushroom Station" was merely a squared-off roof built around the trunk of a very old tree, used for shelter as passengers waited for the train to New York City. A wooden platform kept passengers' feet out of the mud during bad weather. The station was at the end of what is now the dead end of Mill Street in Belleville Park at the fork in the road.

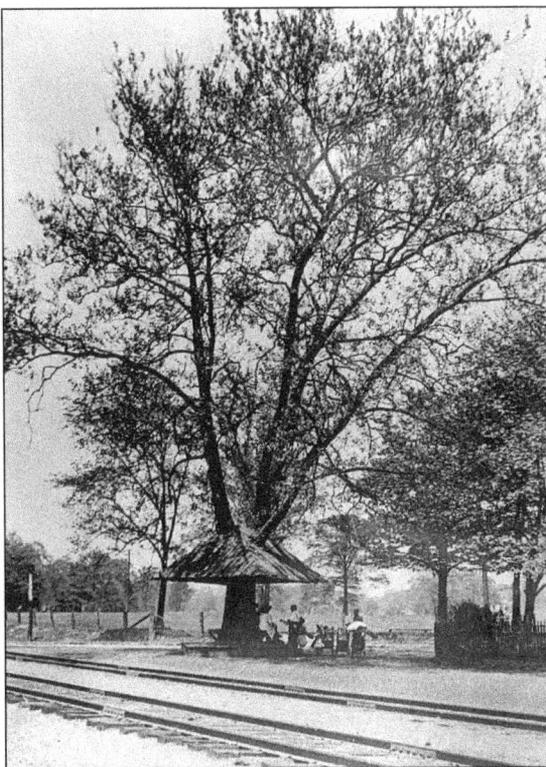

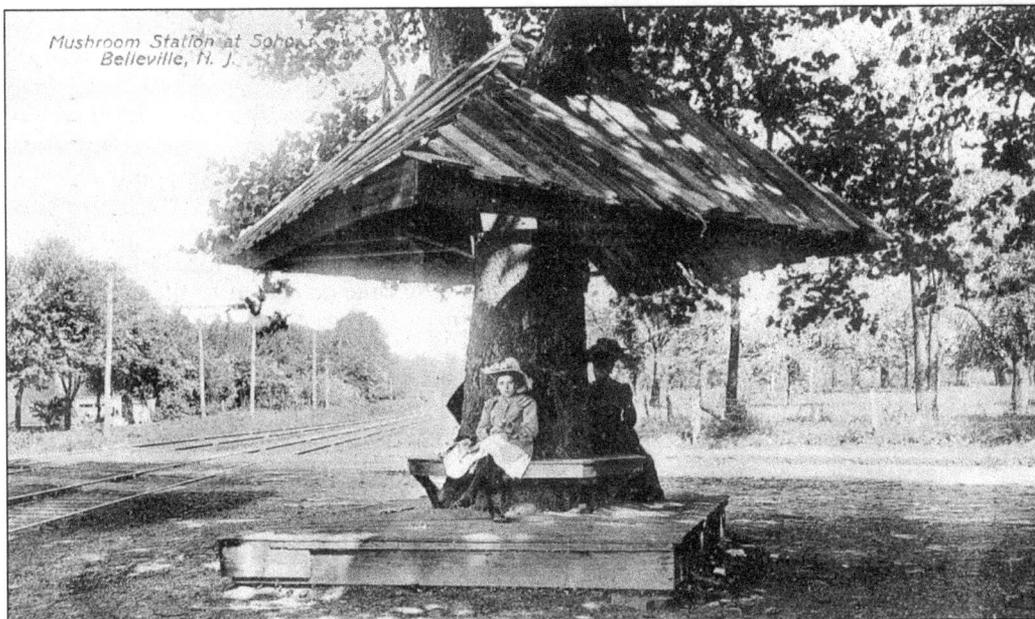

Mushroom Station at Soho, Belleville, N. J.

This 1907 postcard gives a closer look at the Mushroom Station in the Soho section of town, next to the Greenwood Lake branch of the Erie Railroad line. This Soho train station was on the Greenwood Lake railroad line, which took passengers east and west between Greenwood Lake and Jersey City. Its two stations, at Mill Street and Belwood Park (Hewitt Place), served 199 trains weekly.

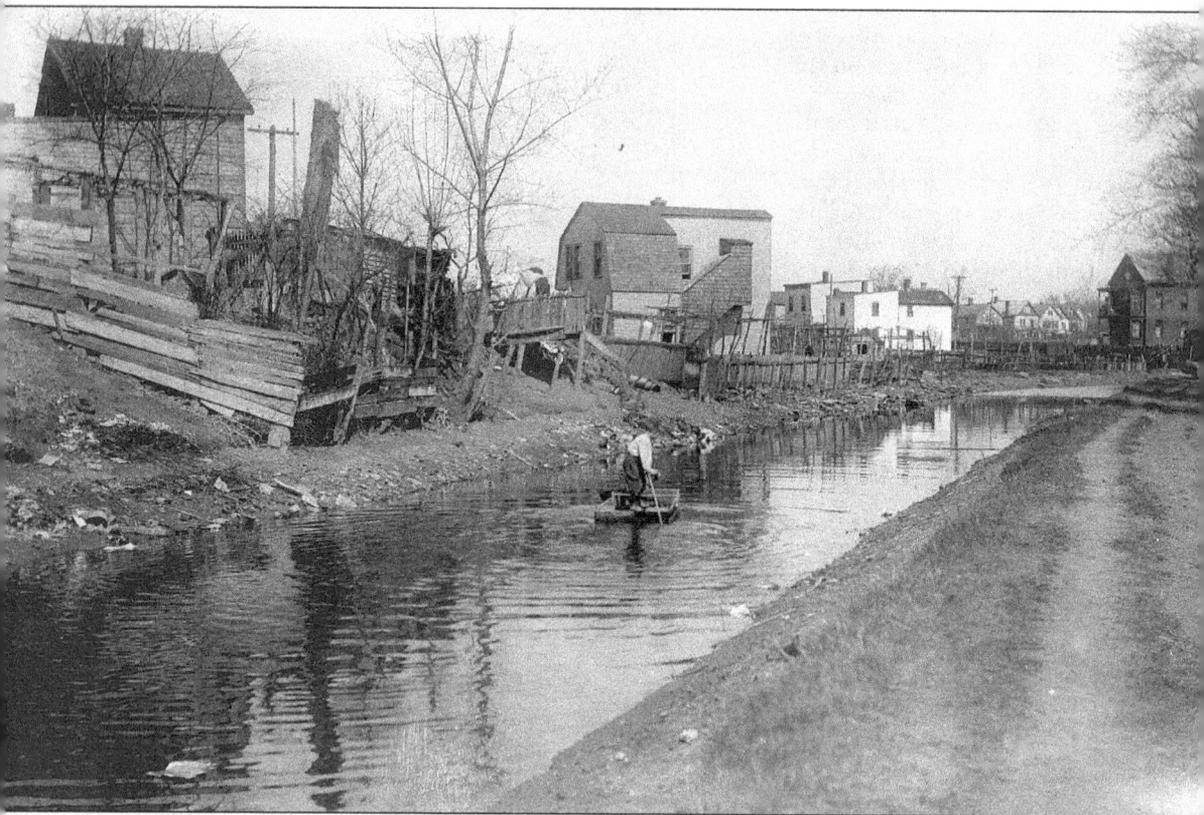

Opened in 1831, the Morris Canal allowed for boats to travel with their cargo from Newark to the Pennsylvania border. When finally finished in 1836, the canal spanned 102 miles from Jersey City to Phillipsburg. It was the main mode of goods transportation before the advent of the railroad. Farm products, manufactured goods, raw materials, and iron were moved along the canal system, aiding in the development of northern New Jersey. This way, bulk materials could be efficiently transported because, up until then, there was no other way to move large quantities. The canal would also connect the coal fields of Pennsylvania and open up new markets along the waterway. It would take five days to traverse the entire canal from one end of the state to the other, which seems like an awful long time compared to the speed of our transportation today. The idea for the canal came from George Macculloch, a Morristown businessman. This view shows what was left of the Morris Canal's trek through Belleville's Soho section in 1912, along present-day Mill Street.

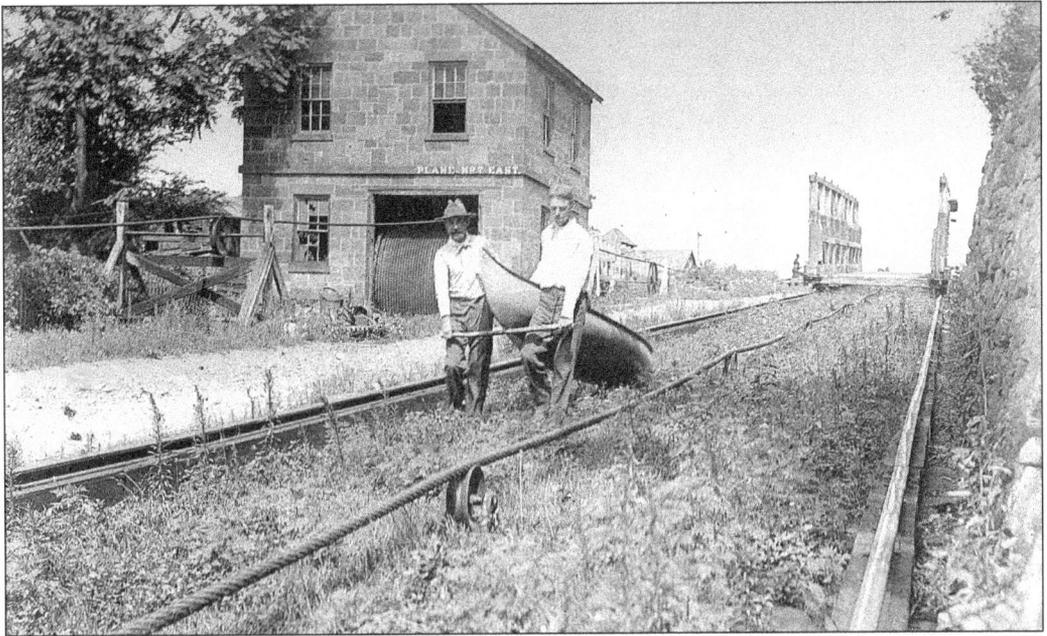

These two men are carrying a small boat over one of the inclined planes in Belleville built throughout the Morris Canal to bring larger ships over land at the higher elevations that did not allow for easy movement on the waters. Boats were placed in "plane cars" that moved up or down the plane on rails powered by water and underground Scotch turbines.

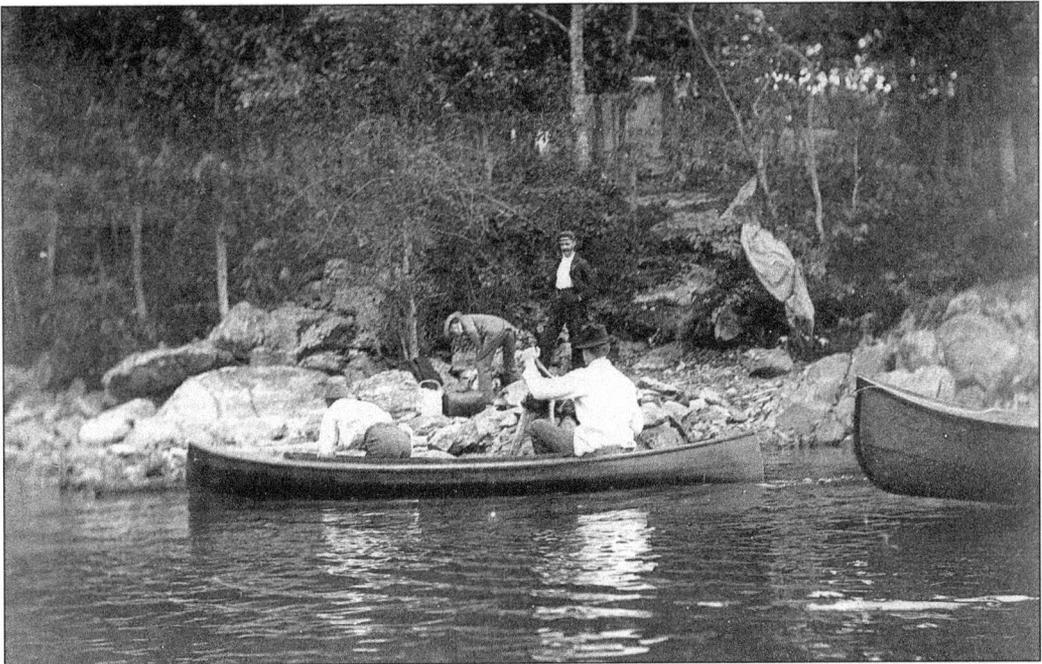

The Morris Canal was opened for its first full boating season in 1832, and many took advantage of the new waterway. Belleville afforded many places for boaters, including the Second, Third, and Passaic Rivers, in addition to the canal. Water travel was also an alternative to taking the stagecoach up the Belleville Turnpike to New York City.

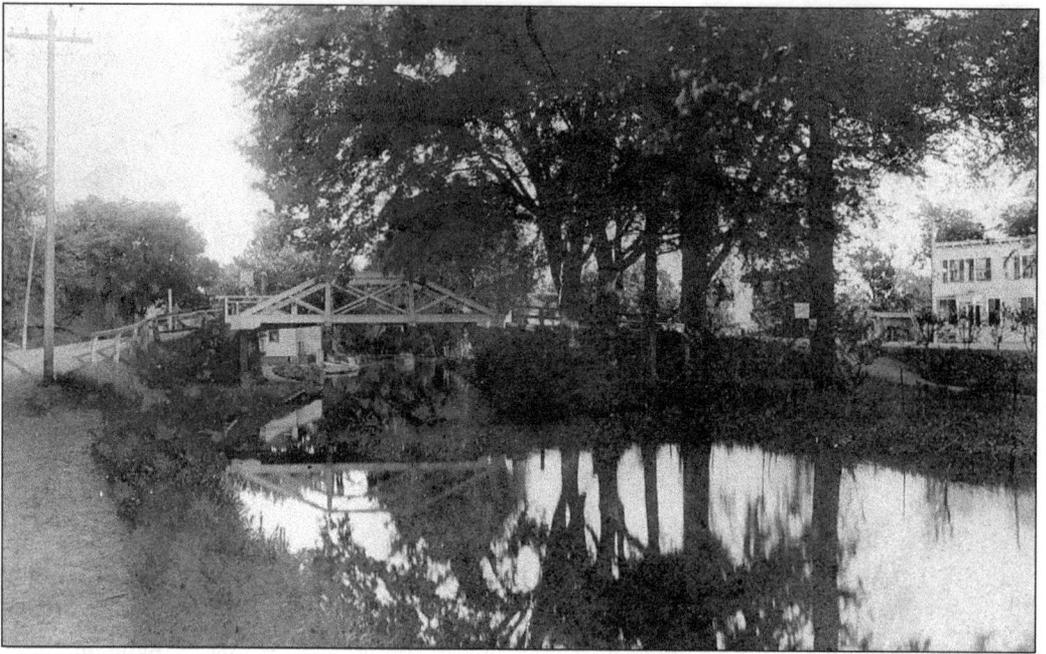

A bridge leads over the now defunct Morris Canal, at Harrison and Mill Streets. The Lehigh Valley Railroad signed a 99-year lease for the canal in 1871, but the original charter would expire in 1974. In November 1922, the state would take over administration of the canal. The canal was drained in 1924, put out of business by the increasing use of the railroads.

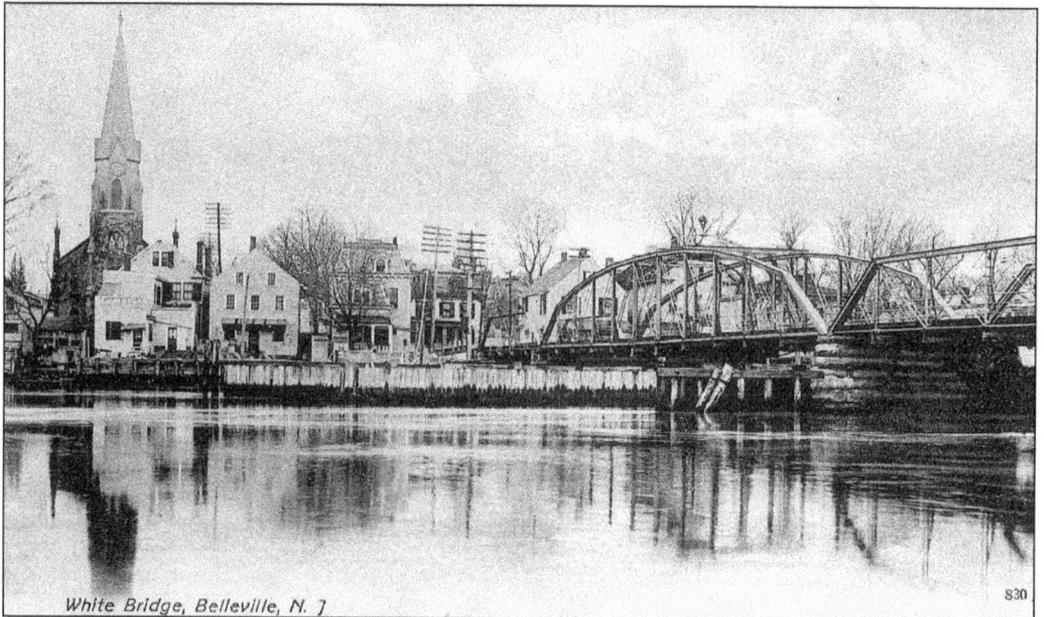

White Bridge, Belleville, N. J

The original bridge across the Passaic River at Rutgers Street was chartered in 1790. The strong wooden bridge was purchased by Anthony Rutgers and subsequently destroyed on February 4, 1841, by floodwaters reaching seven feet above the normal level. Rebuilt immediately, the new bridge lasted until 1879, when a symmetrical iron bridge was constructed and later sold to the counties of Essex, Hudson, and Bergen.

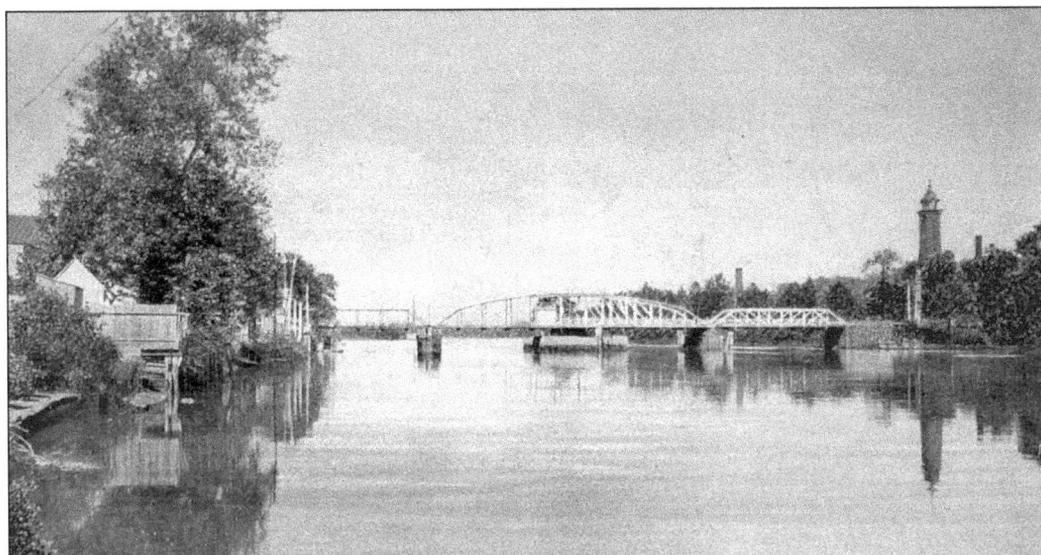

Belleville, N. J. 1906 Bridge over Passaic River
To Beatrice from Mamma

In 1906, the bridge stretching across the Passaic River at the Dutch Reformed Church was called the White Bridge, because of its whitewashed appearance. The Passaic Rolling Mill Company of Paterson supplied the iron for the structure. The White Bridge Inn flanked the Belleville entrance on one side, and an oyster bar run by Bill King was on the other.

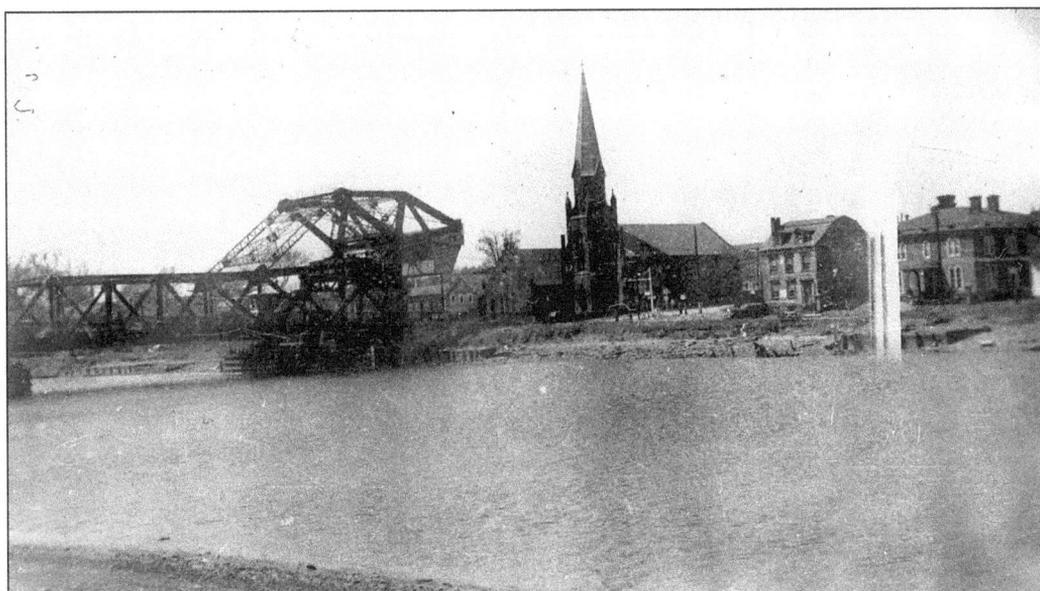

The latest incarnation of the Rutgers Street bridge came in 1910. Previously, it was a toll bridge. The bridge and street received their name from the Rutgers family, which had possession of the bridge from its inception until 1851. Rutgers University is named for Col. Henry Rutgers, a relative of the Belleville-based Rutgers family, many members of which are buried in the cemetery at the Dutch Reformed Church.

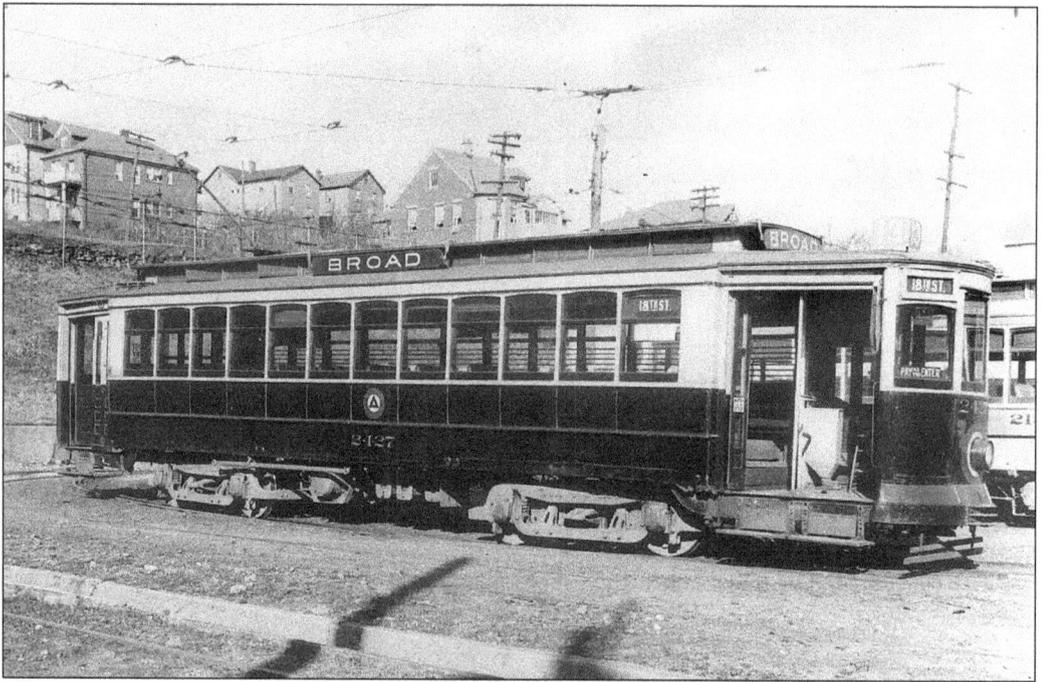

This is one of the Broad Street cars that traversed Public Service's street trolley lines in the first half of the 20th century. The tracks ran from Newark's Broad Street into Belleville, where the street changes to Washington Avenue, and continued up into Nutley on Centre Street, heading west. The line was instituted in 1898, and some of the cars were kept at the Big Tree Garage on the Belleville-Nutley border.

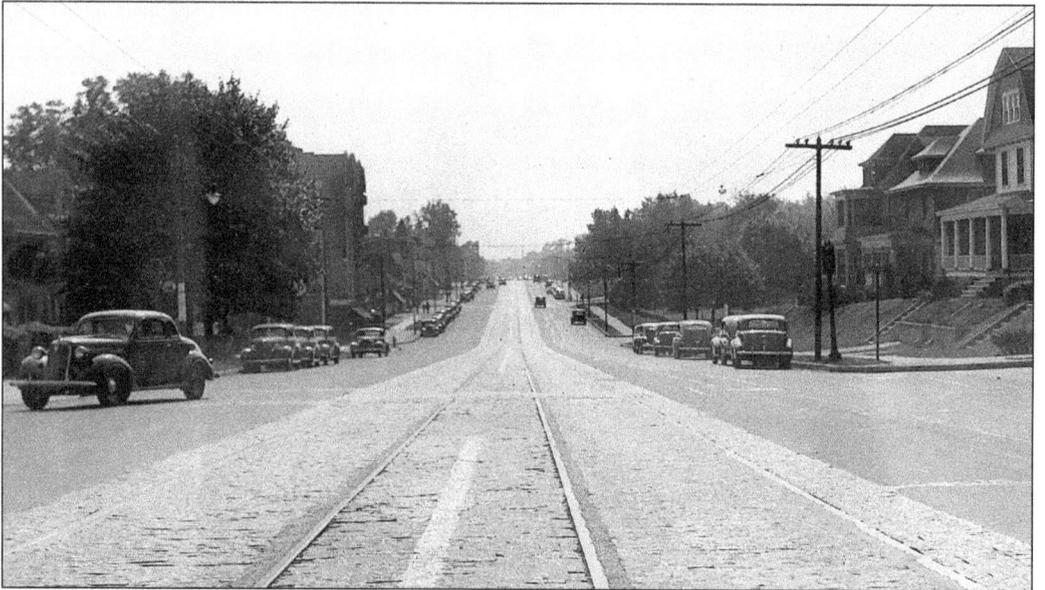

Here is a wide view of Washington Avenue, looking south toward Newark. By the 1940s, the street had been paved and the trolley line was moved to the center of the road and paved with cobblestone. Tracks for the trolley line were laid on the avenue in 1897, providing transportation to Newark and up into Bloomfield and locales farther west. The trolley service was ended in 1937.

Six

LANDSCAPES
AND STREETSCAPES

Rocks and trees jut out along the banks of the Second River, offering natural park scenery. The wide stream meanders along Belleville's border with Newark and empties into the Passaic River. Besides Belleville Park, adjacent to Branch Brook Park in Newark, there is little wooded land preserved for recreational purposes.

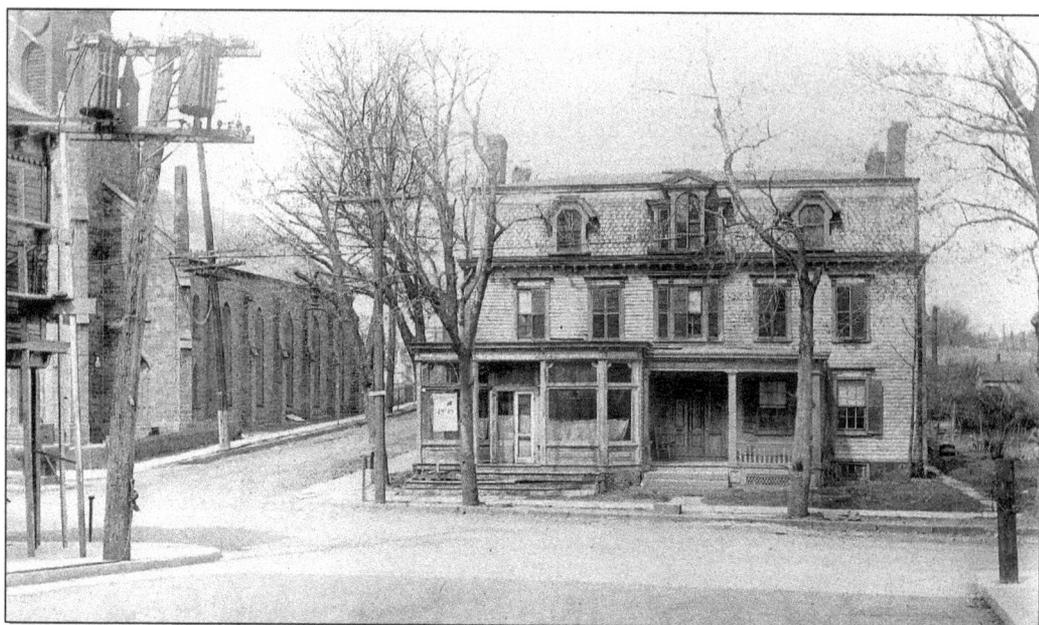

George Rademacher was the proprietor of the White Bridge Inn, which sat dead ahead of any traveler who came over the bridge from North Arlington into Belleville. Here, boats could be rented, and lunch was also provided to the hungry people. The irregular street pattern here at the intersection of Rutgers and Main Streets was rectified when a new bridge was built in line with the end of Rutgers Street.

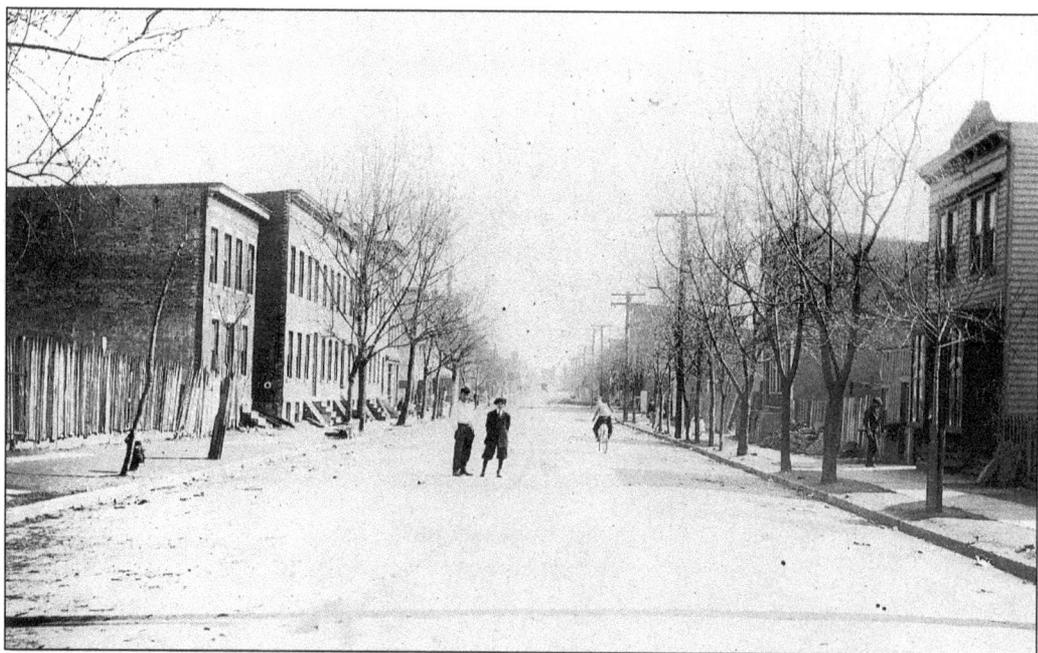

Two young boys stand in the middle of Belmont Avenue in the Silver Lake section of town. The street runs from Newark Avenue near the Clara Maass Medical Center and jags across Franklin Street down to Bloomfield Avenue in Newark. Many Italian immigrants settled in this area of town after coming through Ellis Island.

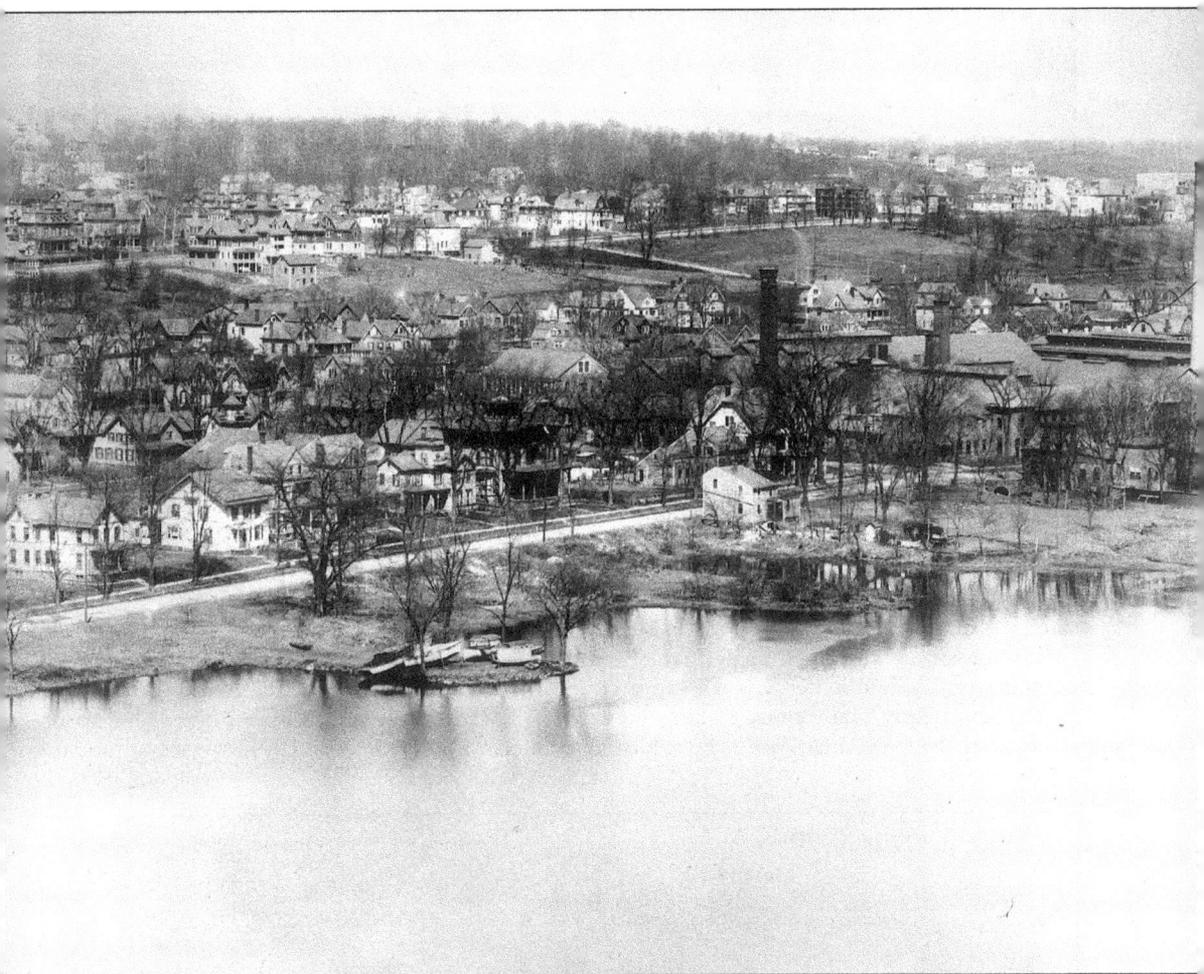

Belleville in 1900 shows a highly populated town surrounded by industry. The smokestacks of the Eastwood Wire Manufacturing Company are on the right, near Nutley. Much of the land between this area and Washington Avenue, seen toward the top of the photograph, was still vacant and somewhat treed. In this area of Main Street, closest to the river, lived Abe "Brunny" Joralemon, who had a reputation as the strongest man in Belleville at the time. He was a football player with a local team, playing the fullback position. He was not unaccustomed to playing two games a day—one in the morning and another in the afternoon. Former town commissioner R.G. Minion lived in the lone house on the banks of the Passaic River shown here.

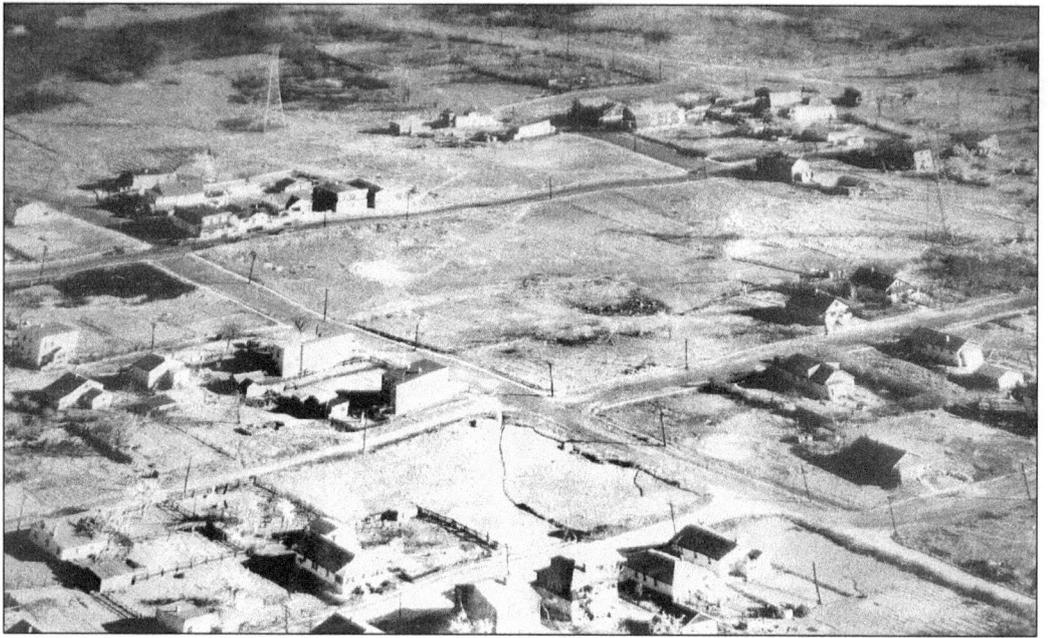

This photograph was taken from a larger 36-by-24-inch photograph showing an aerial view of northeastern Belleville between Passaic Avenue and Meacham Street at the Nutley borderline. Notice the nearly open block of land between Passaic Avenue and Moore Place. This space once again became clear with the addition of a parking lot in the 1990s to accommodate a local business.

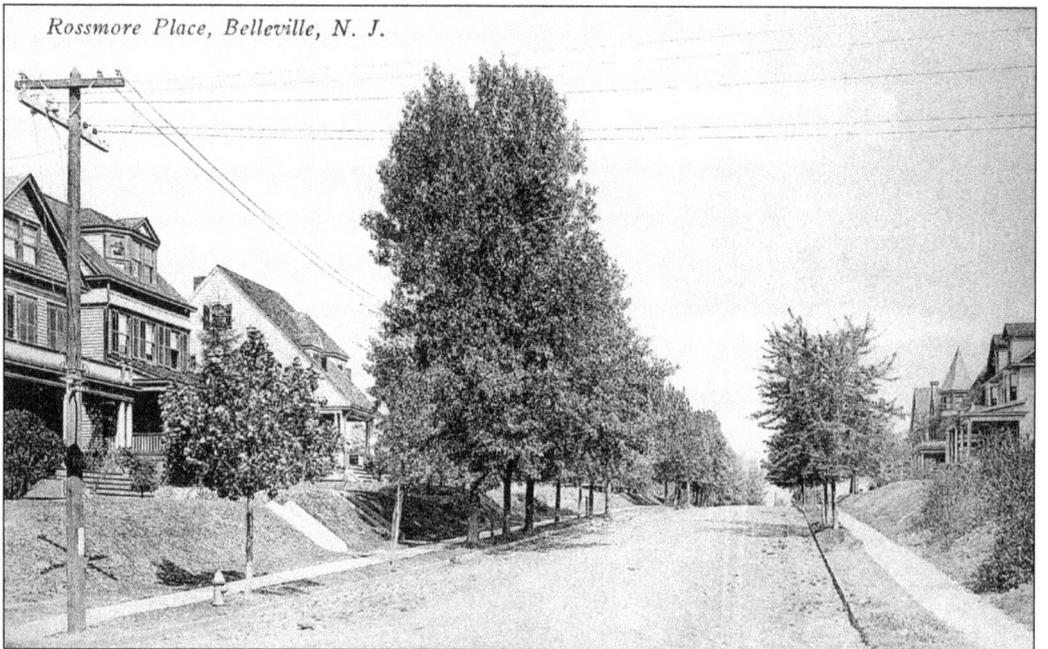

Rossmore Place, Belleville, N. J.

One of the residences on the street of Rossmore Place is now the meeting place of the Woman's Club of Belleville. On Washington Avenue across from the east end of Rossmore Place is the Rossmore Pharmacy, in business for many decades.

70

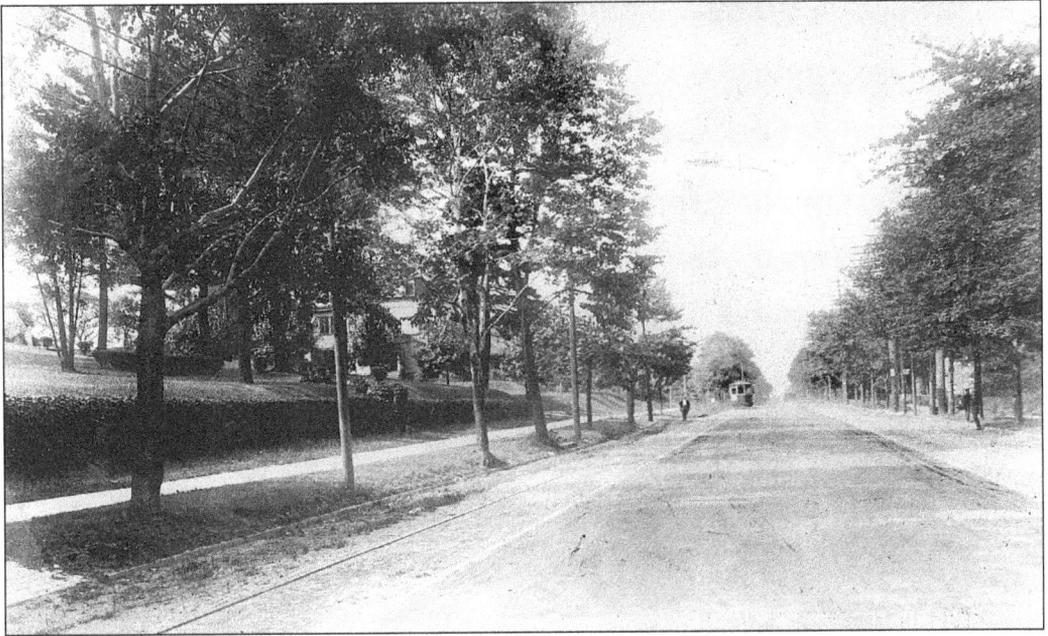

Washington Avenue was widened to its present breadth in the 1870s, thanks to an act passed calling for a system of main boulevards. The Telford paving method called for a foundation of large stone blocks, followed by a layer of smaller stones and a scattering of chippings on top. The avenue was later paved with cobblestones. In this view, men can be seen waiting for the trolley that followed the tracks into Belleville from Newark.

Many of these homes on Linden Avenue off Joralemon Street are still standing, and many were converted into multifamily homes. It was said that this was an example of a poorly developed residential street because of the narrowness of the street and the lack of trees for shade. Trees were eventually planted and now line the street.

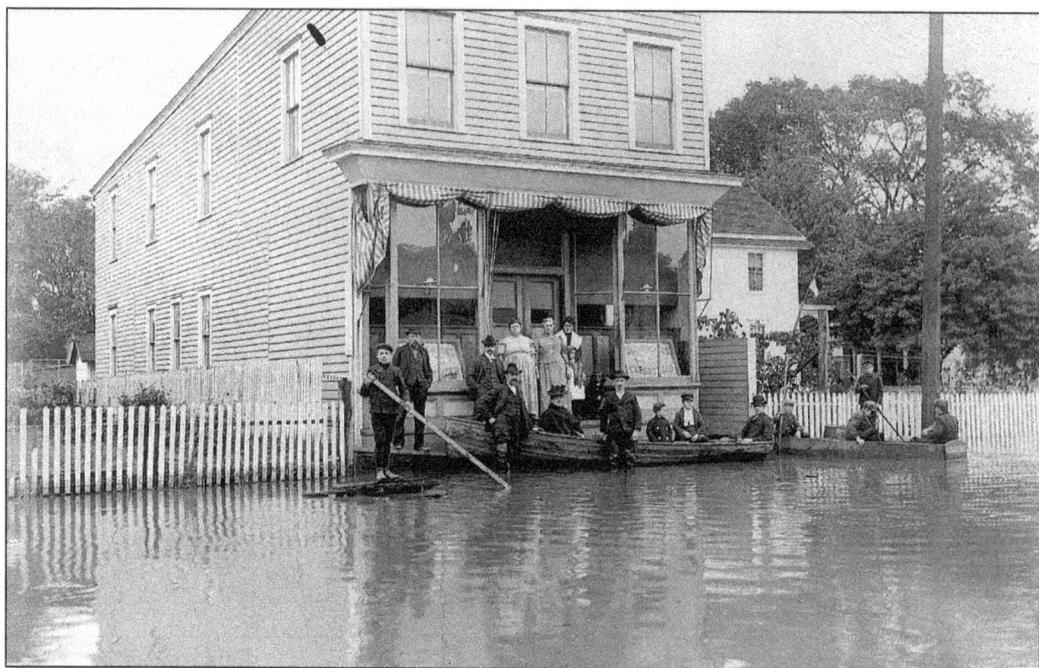

The Ziegler Tavern on Holmes Street was an unfortunate victim of the Main Street flood of March 1902, when the Passaic River overflowed its banks. The flood routed families out of their homes by boat and caused chaos in the communities all along the Passaic River. Andrew Ziegler owned the saloon.

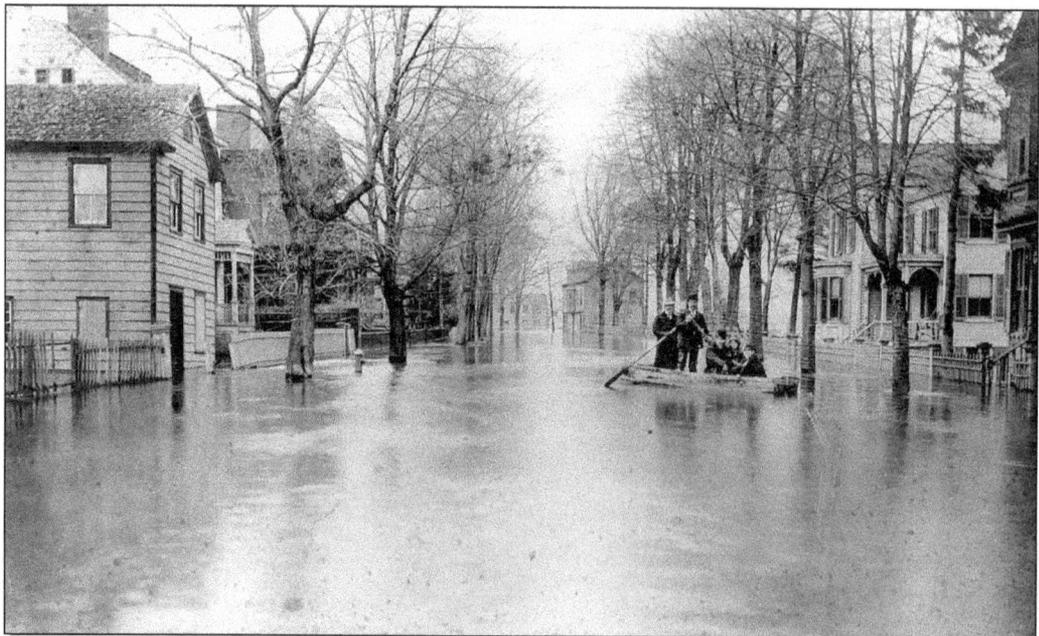

Another unfortunate group travels in the floodwaters on a small wooden boat. Two men are holding the paddling oars while a man, woman, and child look at the photographer capturing their plight. Many families with homes on Main Street escaped the raging waters of the Passaic River at the height of the storm by boat.

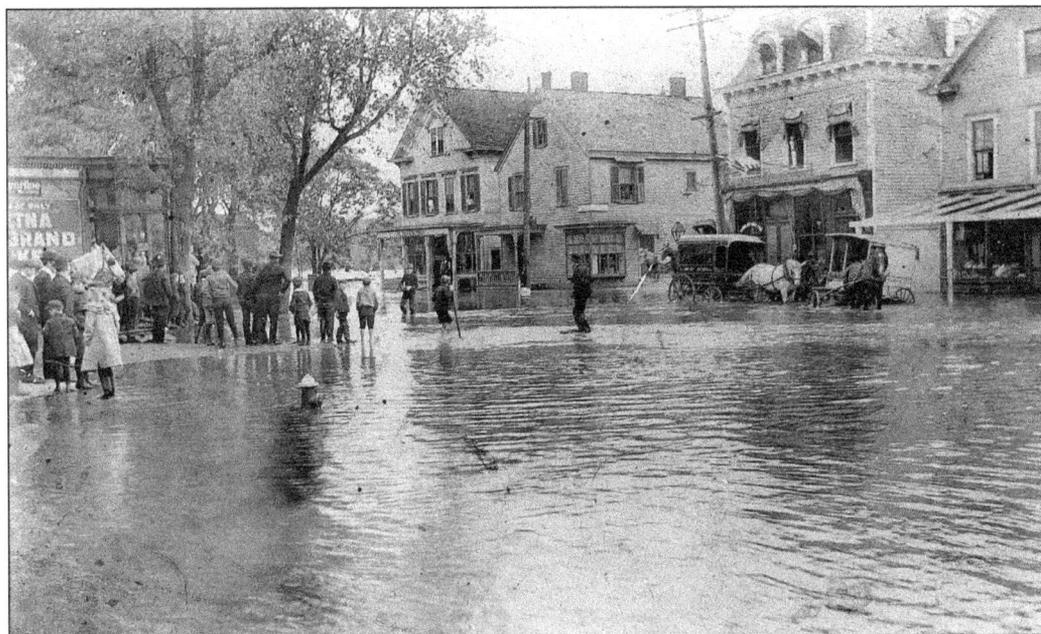

The great flood of March 1902 caused the Passaic River to overflow its banks and caused millions of dollars in damage. Floodwaters inundated Main Street, the town's main thoroughfare, to a depth of seven feet. Here, the townsfolk gather on what little dry land there was to get a good view of the stranded horses still tethered to their carriages.

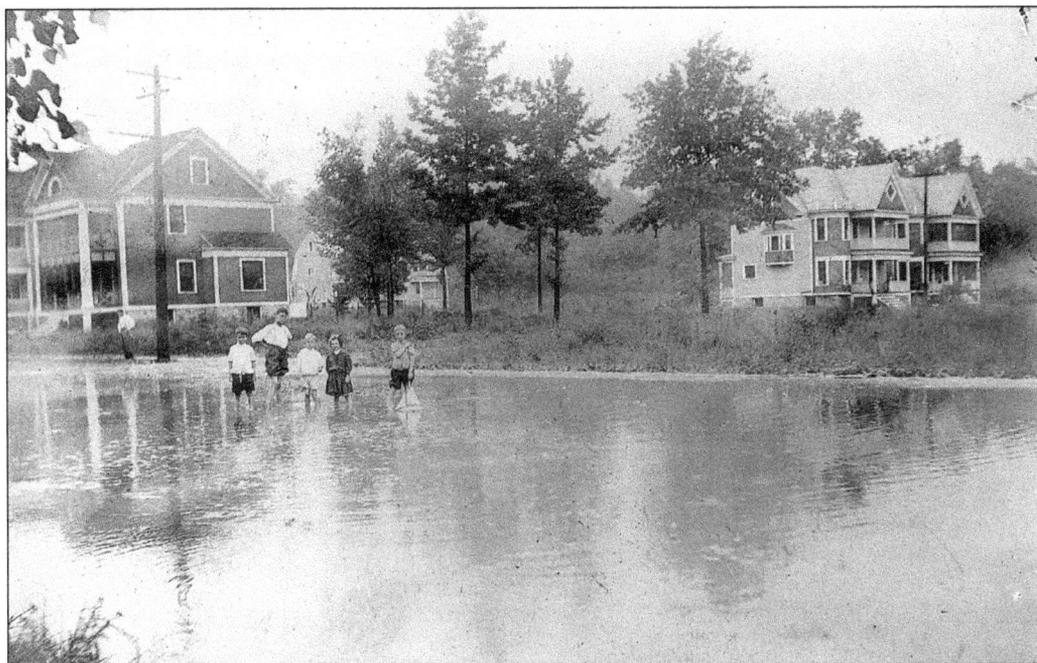

These children took advantage of the floodwaters during the great flood of 1902 to wade out into the middle of Greylock Avenue and play with their sailboat. The Passaic River sent water hurtling throughout the eastern half of the town, forcing many families to evacuate their homes. Hopefully, the weather was warm, since these children are knee-deep in the water.

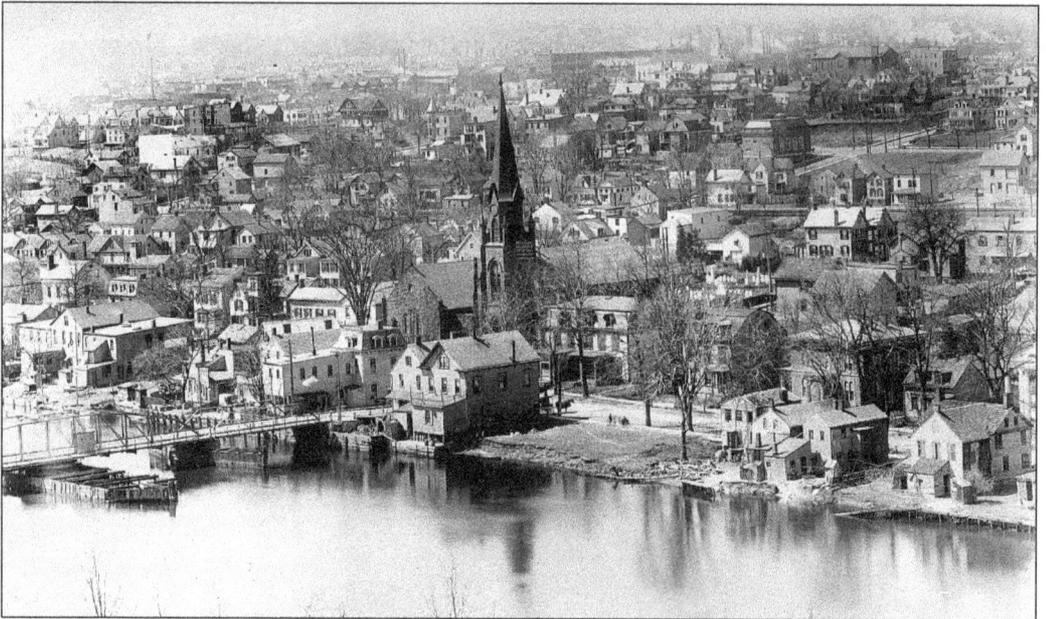

This photograph offers a wonderful view of the expansion the town saw at the beginning of the 20th century, as seen from the North Arlington side of the Passaic River. In the center foreground is the Dutch Reformed Church and its cemetery. In the background are the smokestacks along the Second River, where industry had resettled at this time.

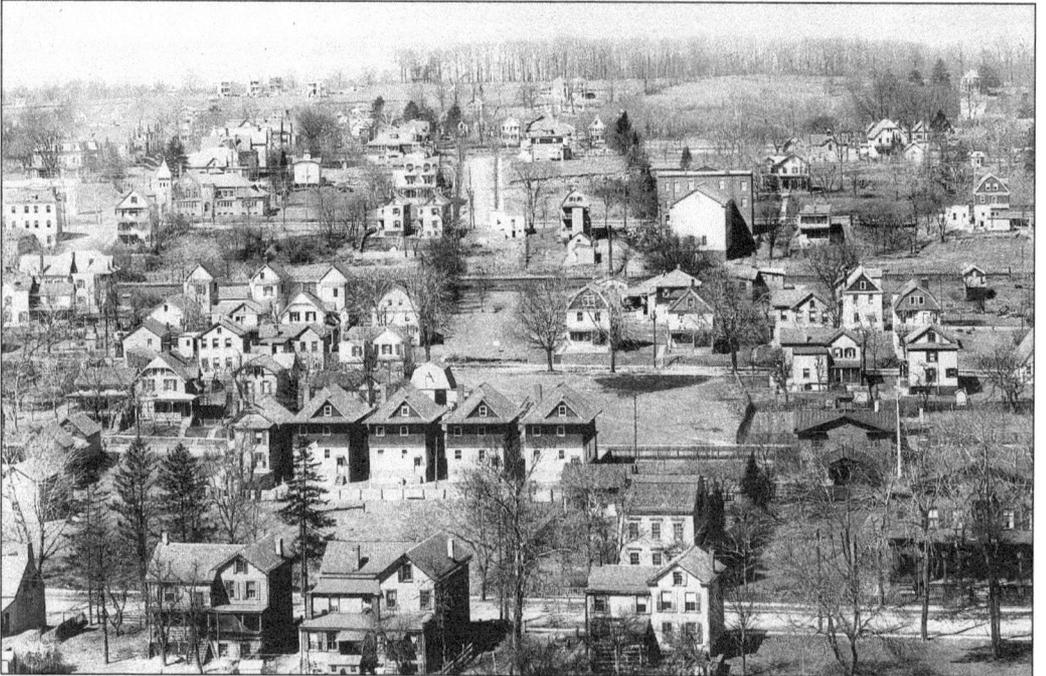

This is another aerial scene of Belleville, this time farther north toward Nutley. The current building of the Wesley Methodist Church can be seen on Washington Avenue, where it was built in 1900. The original Belleville Public Library is to the left, but another building obscures its view.

74

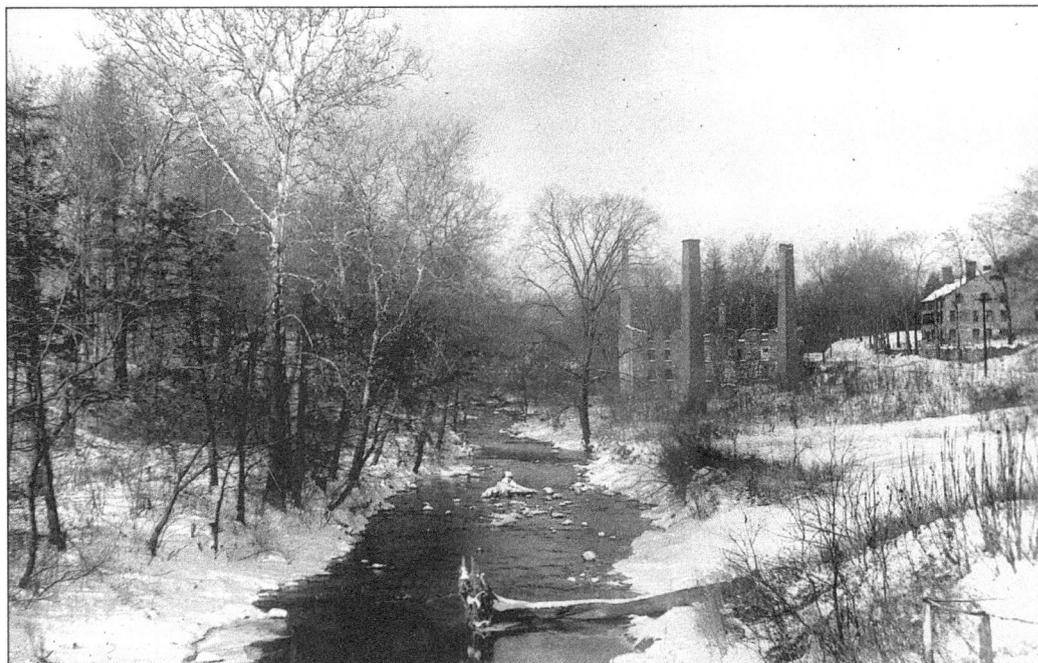

A beautiful view of the Second River behind Mill Street in what is now Belleville Park shows the ruins of one of the factories owned by copper manufacturer Harmon Hendricks. The Hendricks mansion, which served as the family's summer home, can be seen on the right.

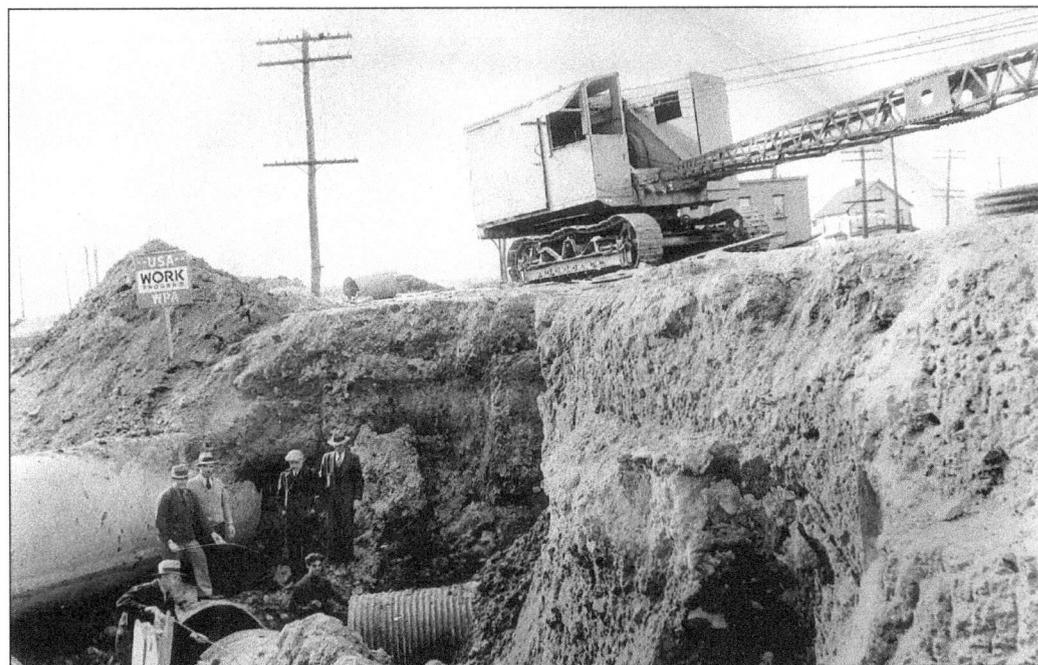

During the Great Depression, Pres. Franklin Delano Roosevelt implemented the Works Progress Administration (WPA). Here are local Belleville men installing water pipes to connect homes in the Washington Avenue, Belwood Park, Soho, and Greylock sections of town to Newark's 36-inch water supply main at Belleville and Garden Avenues.

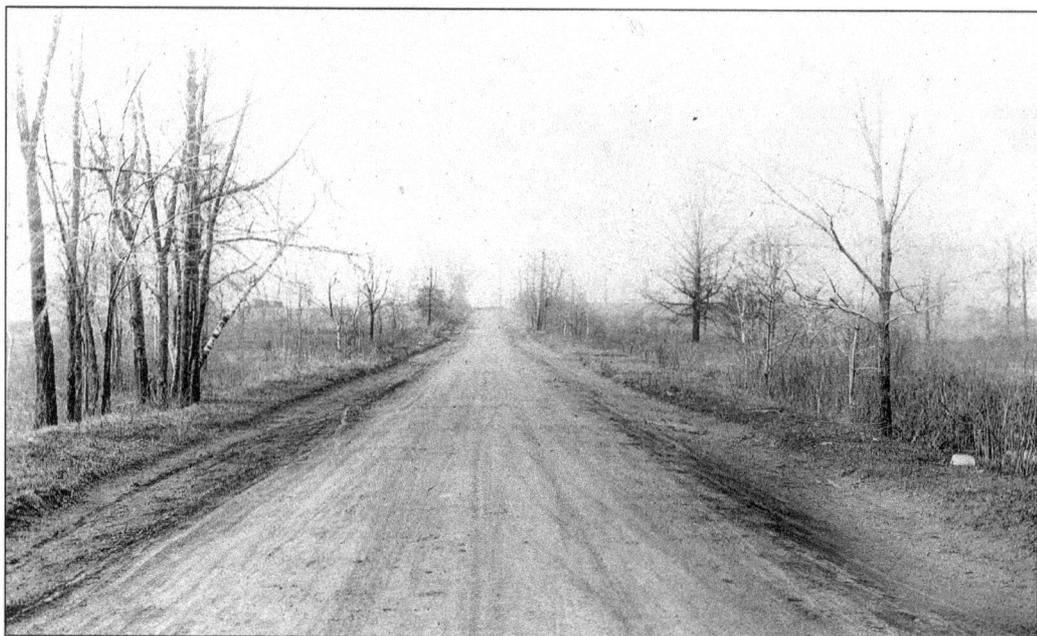

This view of Franklin Avenue, looking north toward Nutley, shows a dirt road and little else. From its terminus at the Newark border on the south to the railroad bridge near Nanina's Restaurant, there is still today little development. It is bordered on the east side by Branch Brook Park and the Hendricks Golf Course and on the west side by the Clara Maass Medical Center and small commercial buildings.

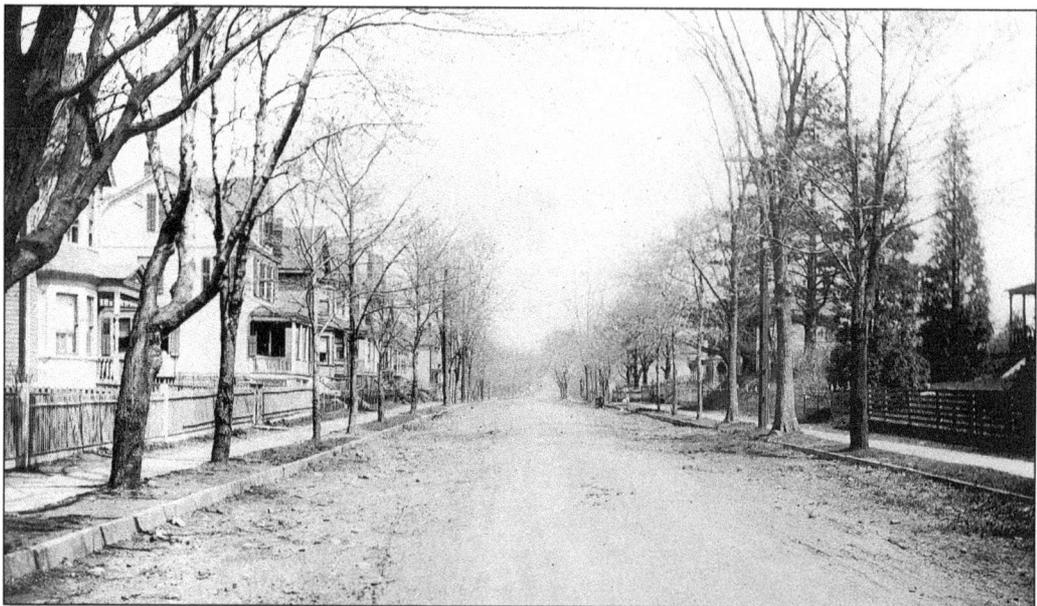

Union Avenue is another main boulevard in town filled with residential homes. School No. 3 is located on the avenue at Joralemon Street, and School No. 8 (with Clearman Field) is at Holmes Street. A small commercial district can be found farther north of Division Avenue and into the Greylock section of town. The street was widened to 80 feet to accommodate the increased traffic in the first half of the 20th century.

A smaller residential street with shade trees is Wilson Place, located north of Mill Street off Union Avenue. At the end of the street (as seen in this *c.* 1910 photograph) is Belleville Park. There is a small mailbox at the bottom right corner, used to collect the mail in that community.

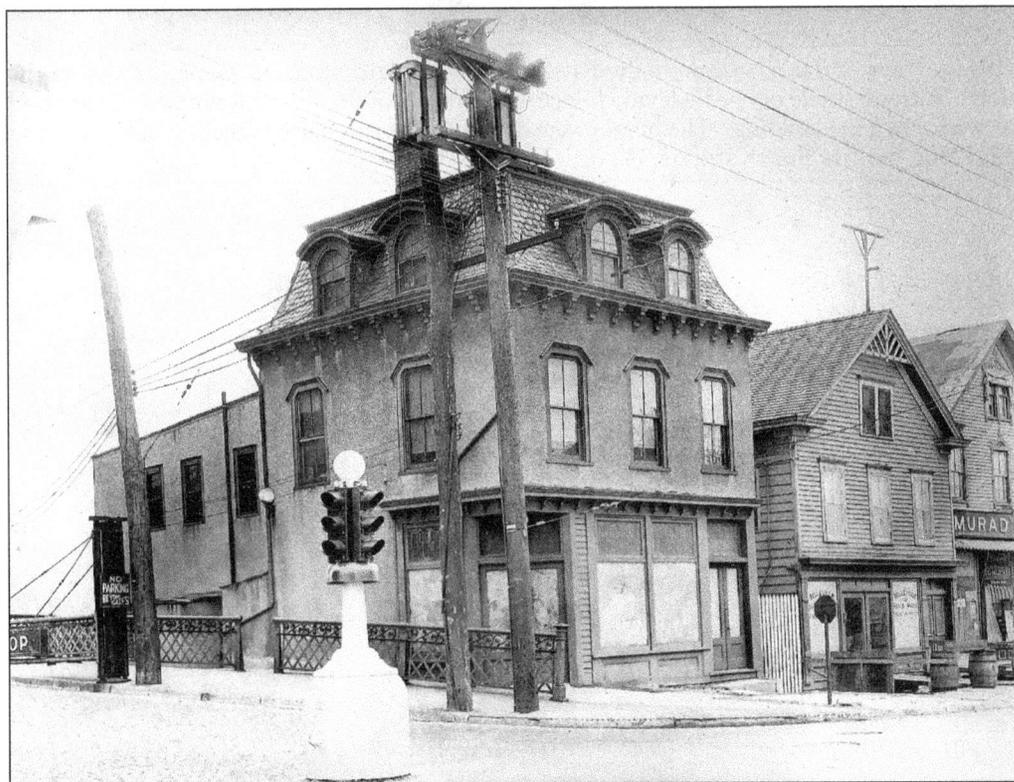

An early traffic light directs traffic in all four directions at the intersection of Main and Rutgers Streets at the bridge. Cobblestone streets, as those shown here, eventually replaced the dirt roads. The corner building looks to be in the style of local architect Charles Granville Jones, with its dormered square roof and rounded-arch windows.

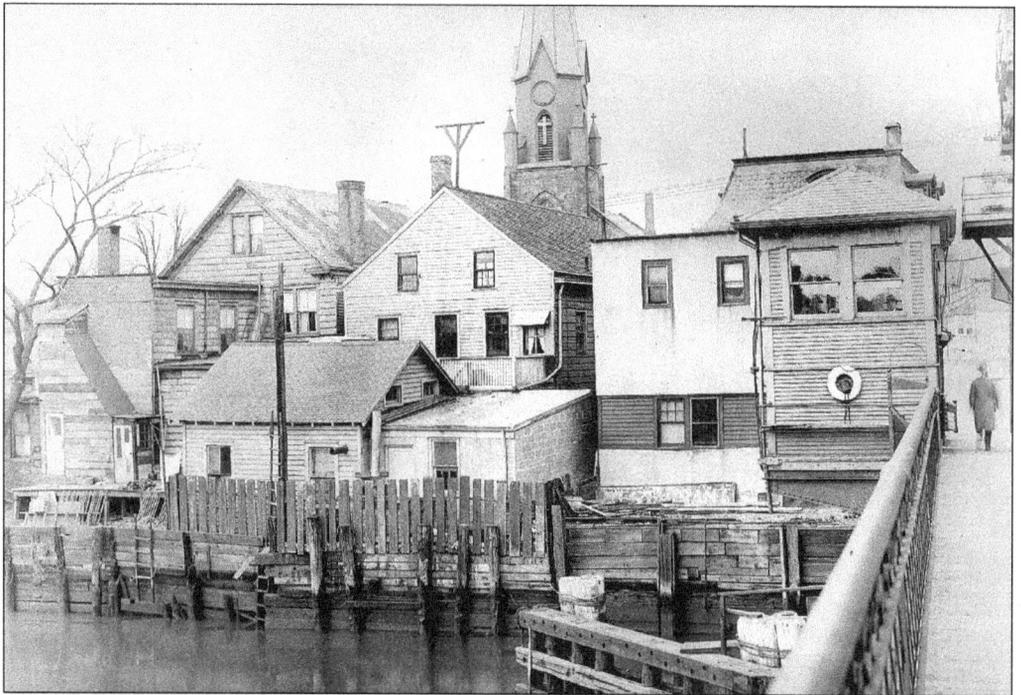

This is a view of the homes along the Passaic River on Main Street as seen c. 1930 from the North Arlington side of the Belleville bridge. The steeple of the Dutch Reformed Church can be seen above the buildings. The homes were demolished with the construction of Route 21 in the 1950s, but the church still stands.

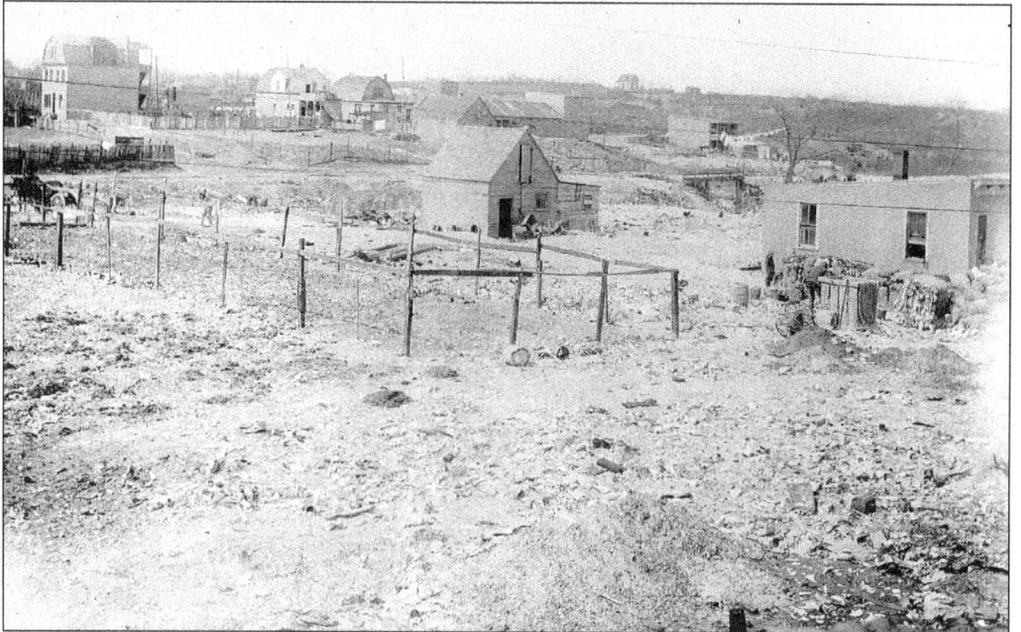

The local townspeople unfortunately used the barren land that divided Belleville proper from the Silver Lake district as a dumping ground c. 1910. A survey of the land at that time deemed it only suitable for industrial use because of its proximity to the Erie Railroad.

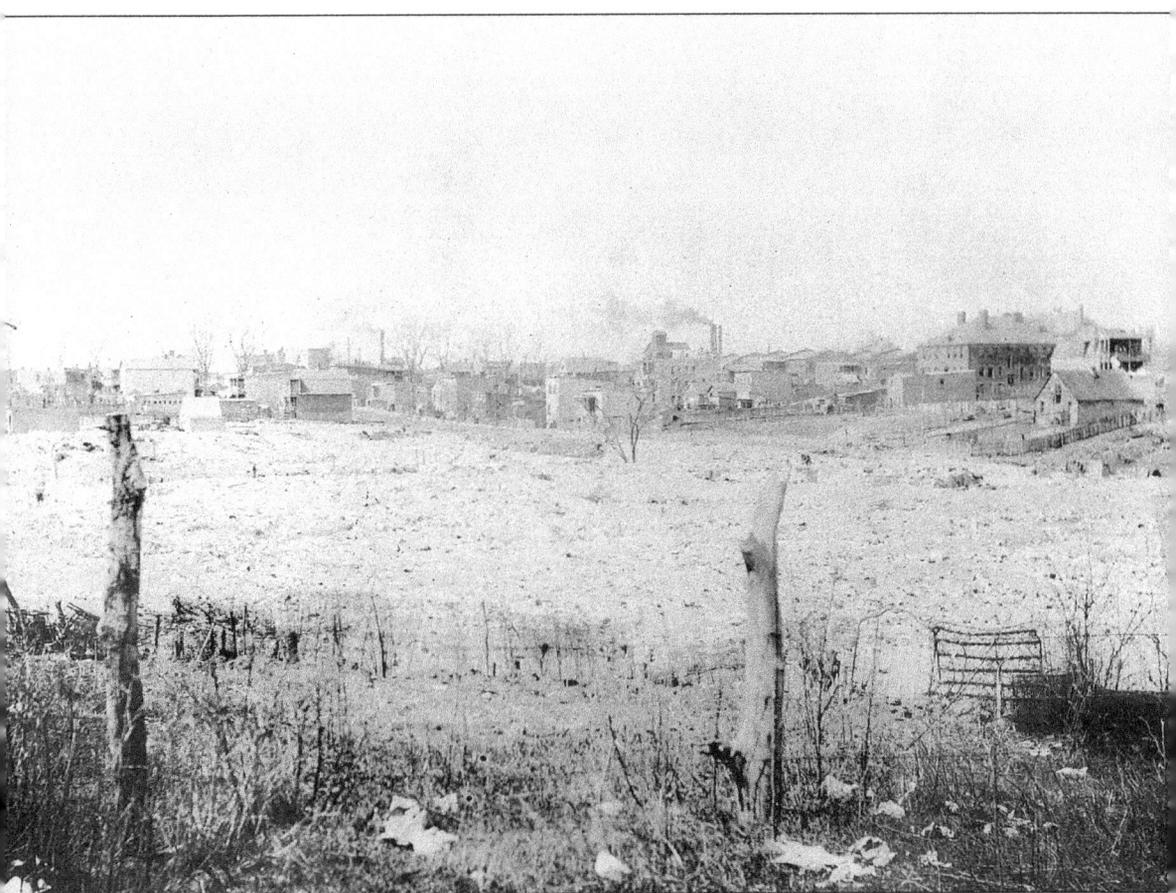

Beyond the garbage-strewn land is the Silver Lake community. Many of the Italian immigrants here owned livestock, such as chickens, goats, and even horses, which were kept on their properties. In the background are the smokestacks of the old Edison Manufacturing Company, built in 1890 by famous inventor Thomas Alva Edison on property along Belmont Avenue and Franklin Street. It was this subsidiary company that released *The Great Train Robbery*, the first silent movie filmed in America. It was directed by Edwin S. Porter. Edison would establish another plant in Silver Lake for the manufacture of carbolic acid and other chemicals. Carbolic acid was used in making phonograph records. The streets of Edison and Alva in Silver Lake are named after the inventor.

Rock gutters line a dirt-paved William Street in this view looking west toward Washington Avenue. The railroad tracks still cross over the road at Valley Street. There were crossing gates at the intersection, but they were not in operation during the early-morning hours of 2 a.m. and 6 a.m. It is uncertain if the gates were opened and closed by hand or by electricity.

John Street (now Belleville Avenue) was a busy roadway, but one survey showed the street was not sufficiently wide enough for the amount of horsecar traffic it carried. Eighty feet of width for the street was recommended to accommodate the travelers headed toward the bridge at the river.

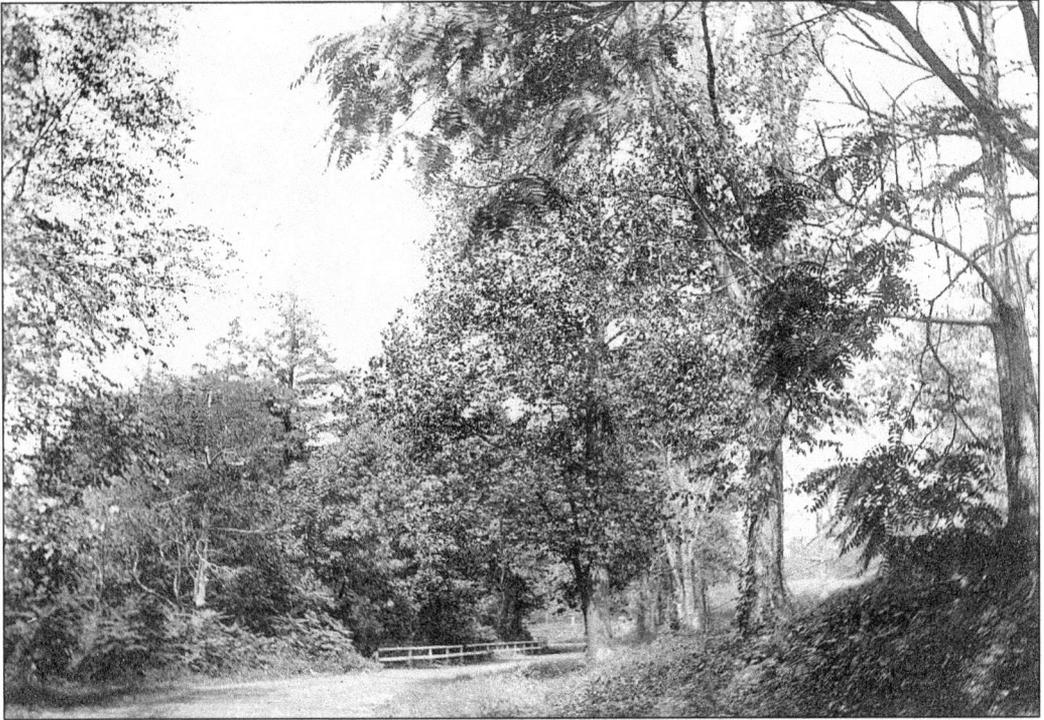

Mill Street was a nice road through the wooded areas that served as a thoroughfare between the Soho and Valley sections of town. The street was later intersected by railroad tracks and split in half when the railroad crossing was closed to traffic. Mill Street runs westward from the tracks up to Montgomery Place and east from the tracks down to Main Street.

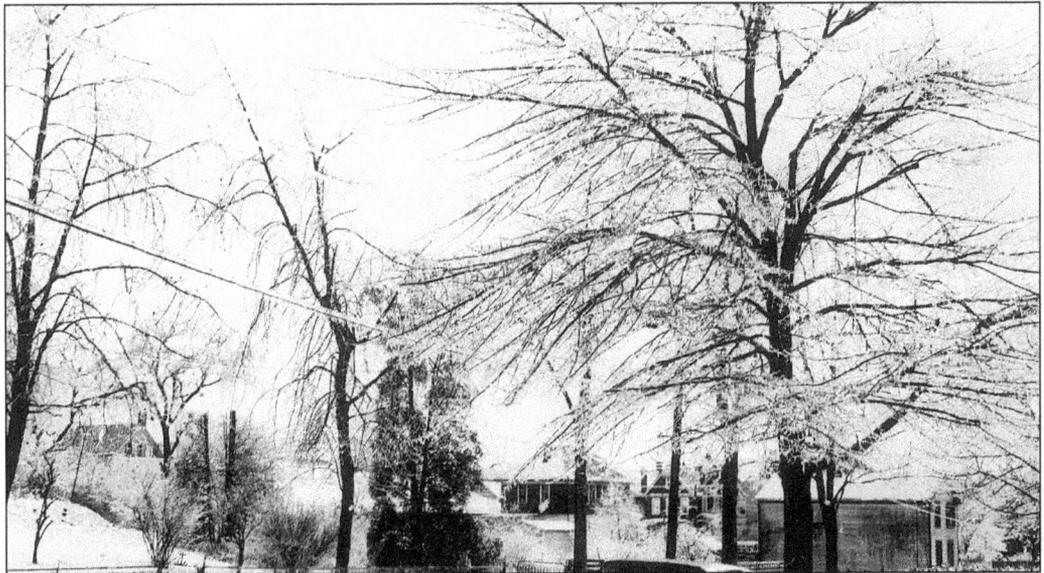

An ice storm in 1929 left much of the town coated with fine icicles. Electricity was briefly knocked out in some areas because of the weight of the ice on the power lines. This view shows the east side of Union Avenue, closer to the river. The building in the lower right side of the image was later demolished.

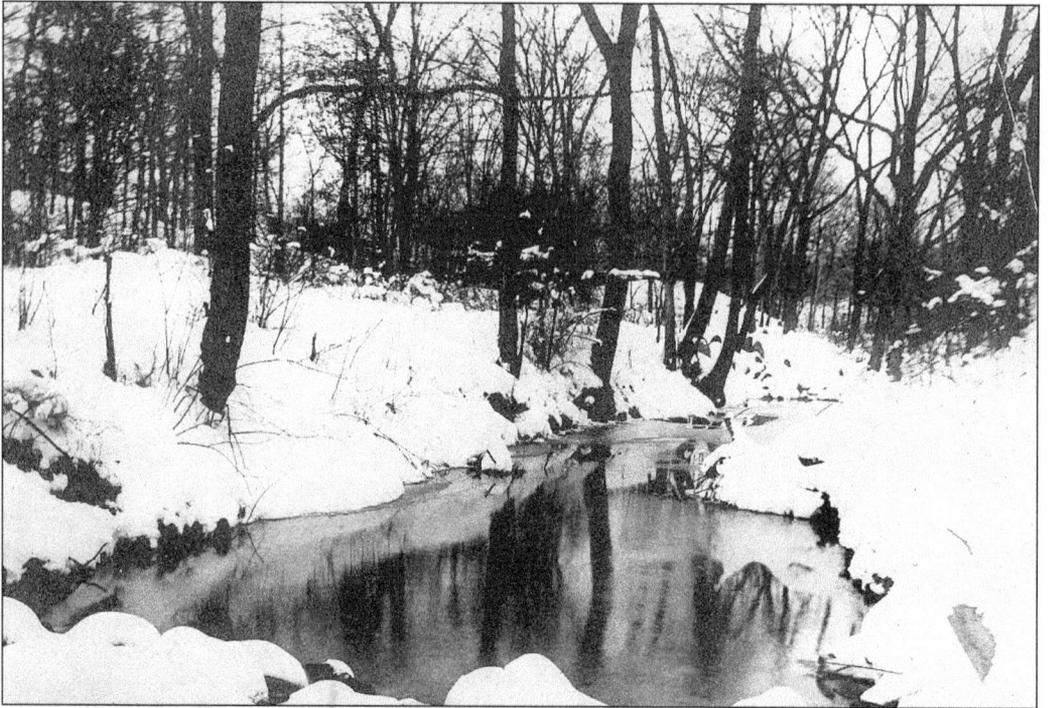

The narrow Third River, a tributary of the Second River, runs from the Passaic River, winds its way under Joralemon Street in Belleville up near the Glendale Cemetery, and over into neighboring Nutley. The river continues throughout Nutley's park system and ends at Kingsland Falls at the Clifton city border.

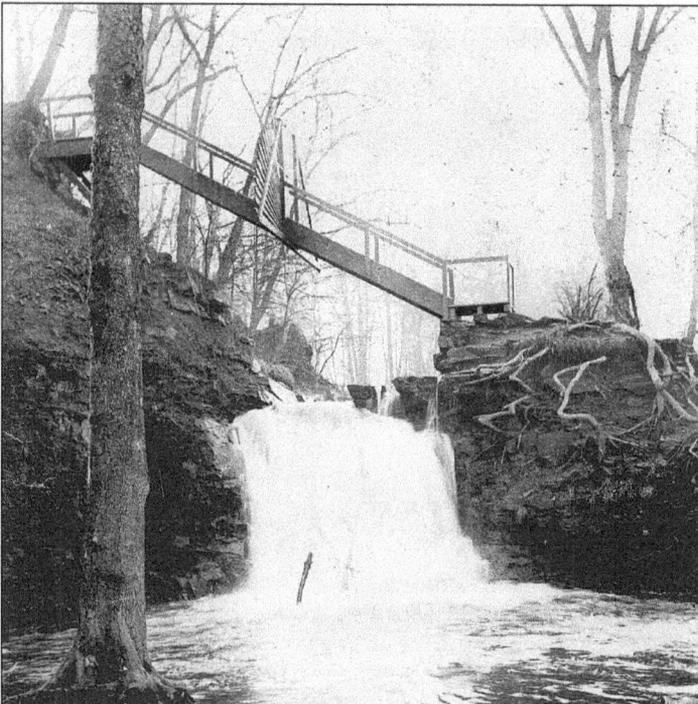

The small waterfall in this 1906 photograph was next to the Tiffany & Company factory in North Newark at the Belleville border at Union Avenue and the Second River. The factory was built in 1892 and was turned into loft apartments after it closed in 1985. Tiffany's was well known for its jewelry, silver, and glassmaking.

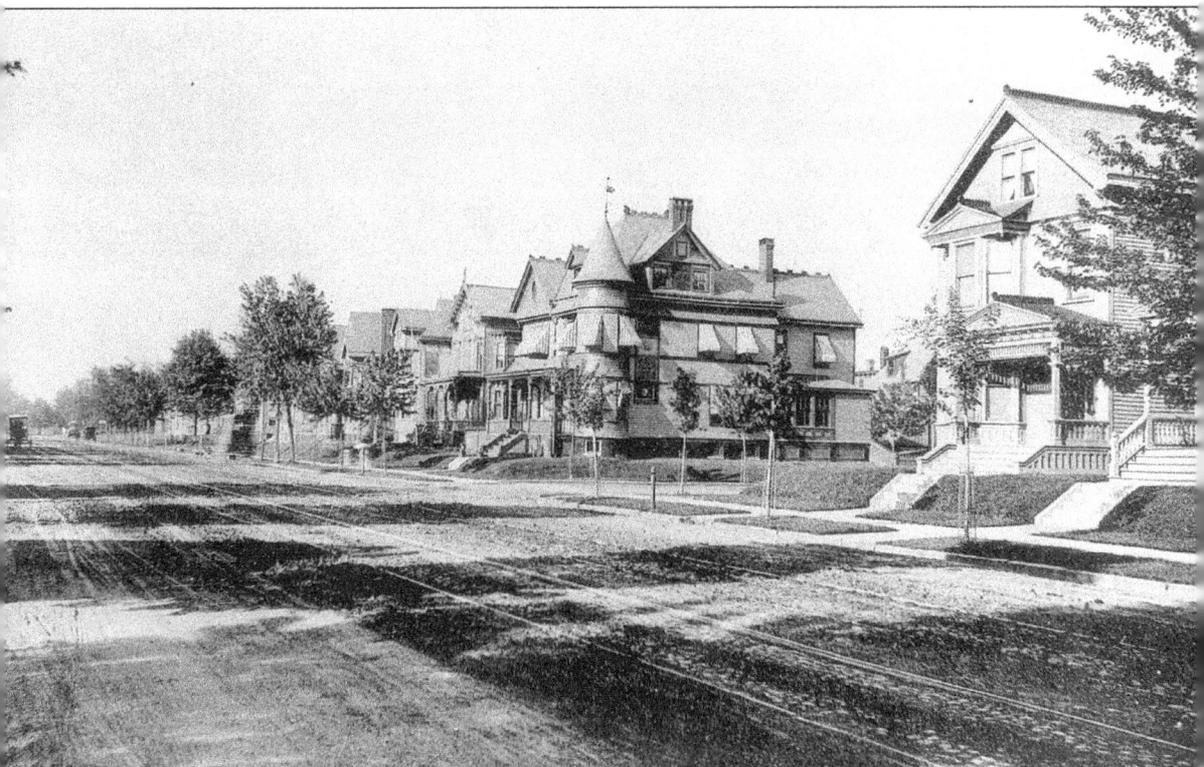

Many grand residences were built on Washington Avenue. This postcard view shows the street in 1892 with its dirt road and horse-drawn buggies. The homes here were built in the Victorian fashion, with ornate woodworking and trim inside and out. The striped awnings over the windows of the one home were a rarity. Most of these homes no longer exist, and still others were converted into storefronts for businesses. There are few trees left along the avenue as well. Most of Washington Avenue encompassed the main retail center of town, where larger department stores were located at one time. The homes may have been part of the Greylock Manor real estate tracts, sold from the late 1800s into the 1900s. These estate homes were popular because of the property's proximity to public transportation and New York City.

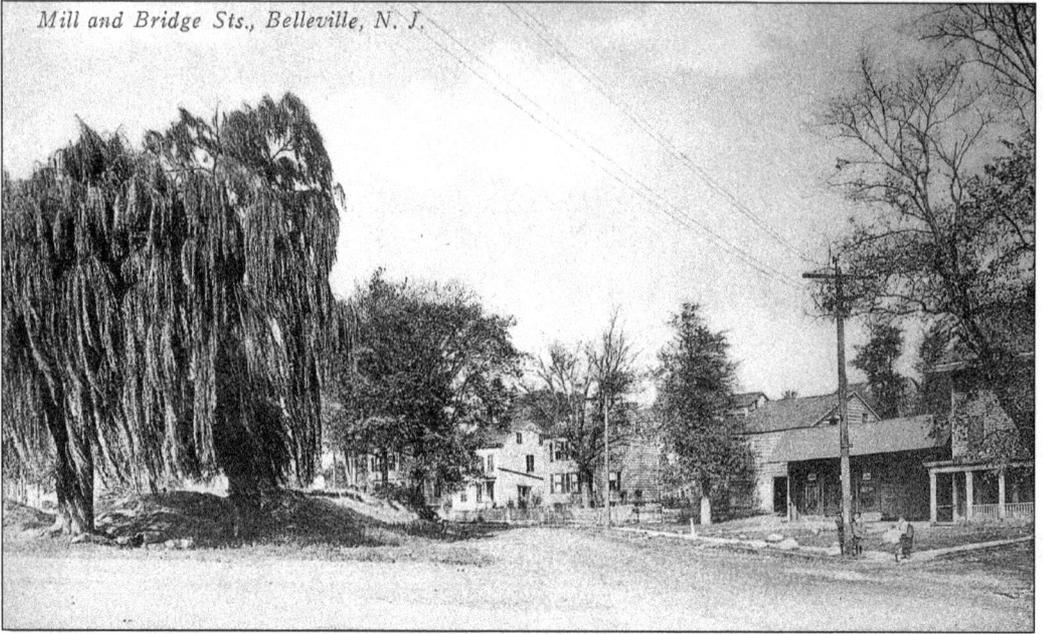

Mill and Bridge Sts., Belleville, N. J.

This postcard illustrates the corner of Mill and Bridge Streets as it appeared in the mid-1900s, when it was just beginning to develop into a residential street. Poles carried electrical lines to power the local homes. Today, the Knights of Columbus Council No. 835, founded in 1904, meets at its headquarters on Bridge Street.

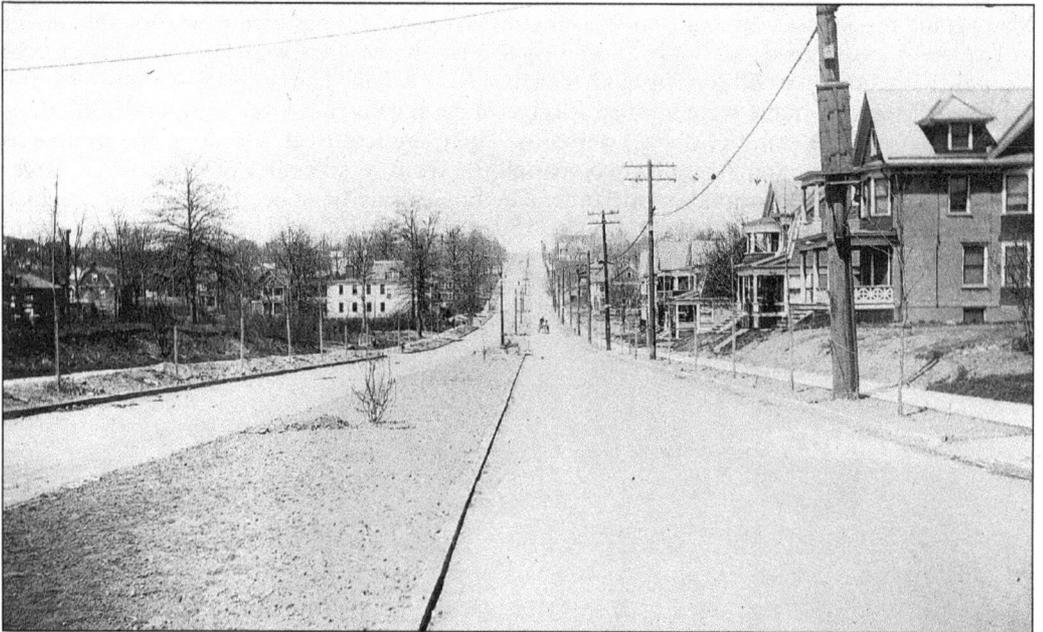

Greylock Parkway was constructed as a wide boulevard for the Greylock Manor real estate development built at the beginning of the 20th century. Vacant lots were priced from $200 to $500. The main selling point was the proximity to the Erie Railroad and New York City. More than 1,400 lots were divided from the land between present-day Washington Avenue and Hauck Street, bordered north and south by Overlook Avenue and Campbell Street.

Seven

RESIDENCES

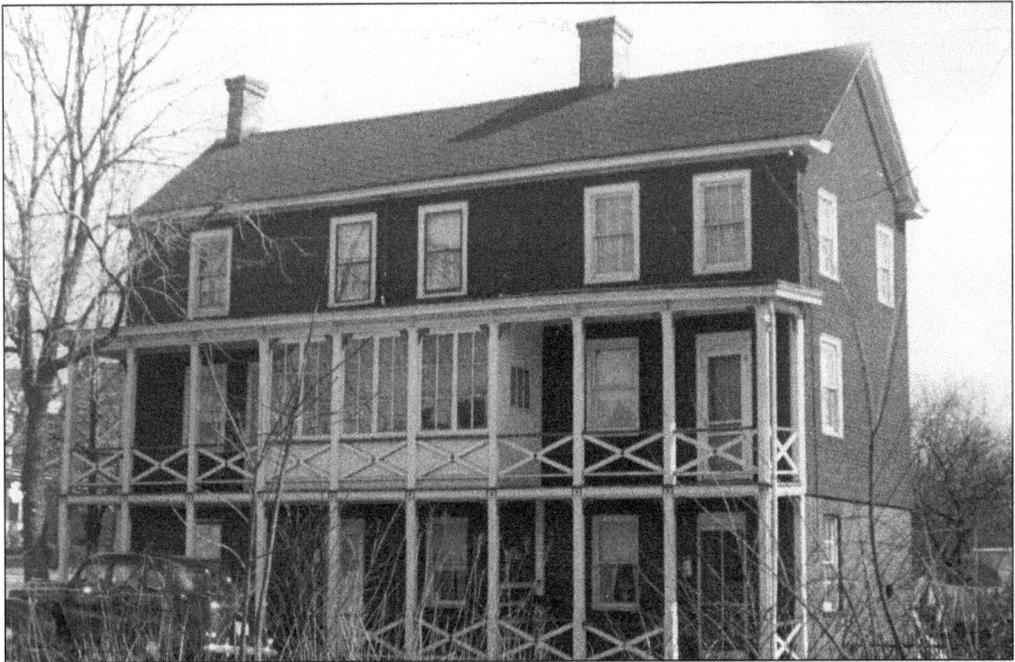

A unique double porch adorns this home on Dow Street, one of many historical residences that can no longer be found in the town. This double porch idea was also seen on a smaller scale on the side of the Macomb home, built in 1798 at 125 Main Street and demolished in March 1940 because of tax liens.

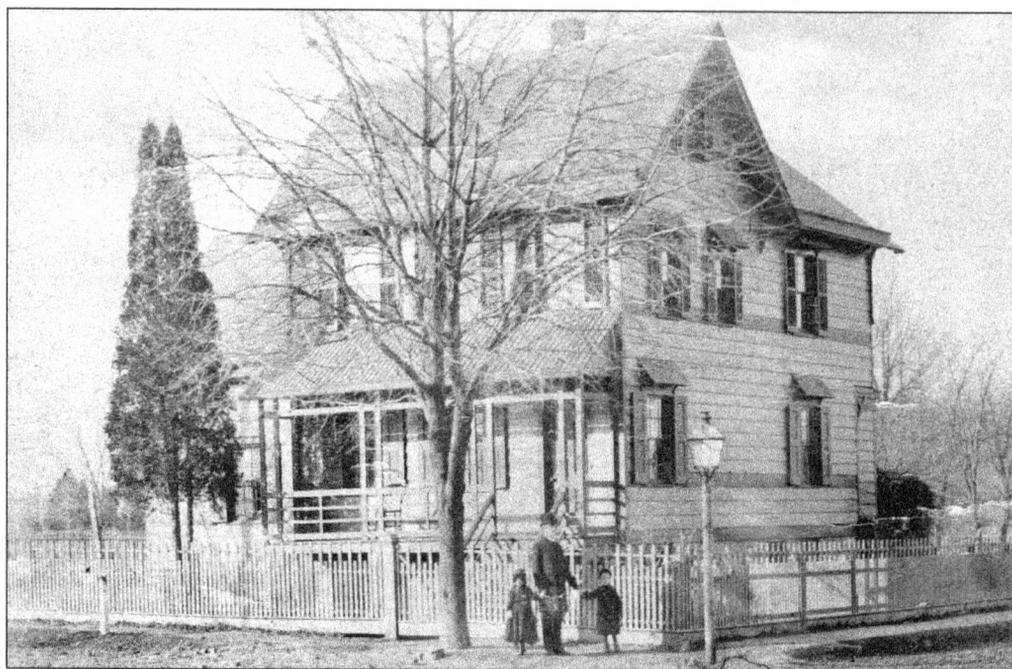

Famed Belleville architect Charles Granville Jones moved into this home on Holmes and Prospect Streets with his parents in 1879. Jones stands here with possibly a younger brother and another little friend, Robert Crisp. Jones would later study architecture with his father and open an office in Brooklyn, New York.

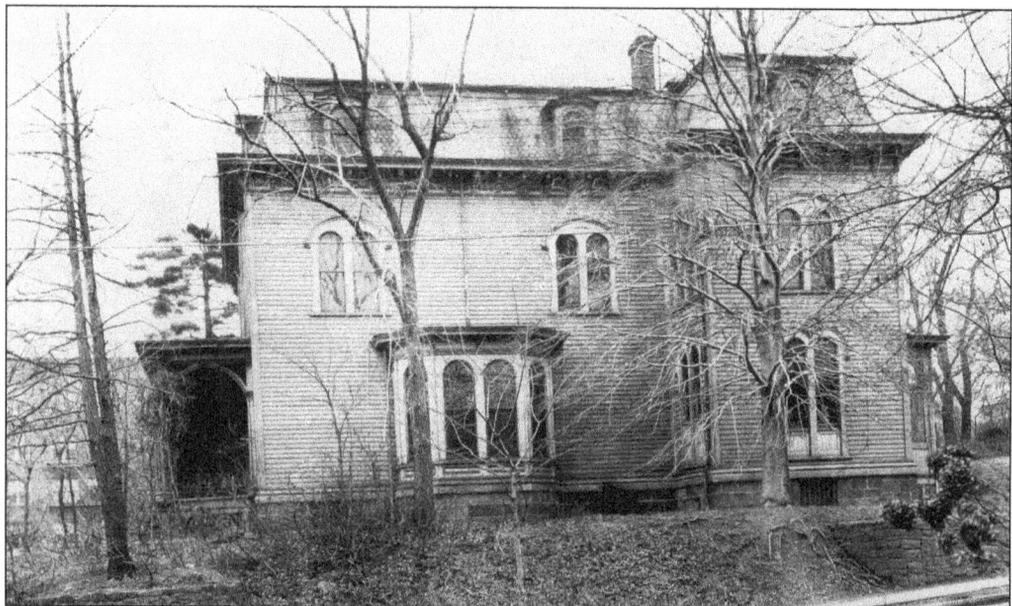

Charles Granville Jones's home and office, built in his eclectic style, sat at 125 Academy Street. Numerous buildings in town are attributed to him, including Belleville Town Hall, the First National Bank, the old Belleville High School, the Methodist church, and the public library. He also helped promote growth in Belleville by founding the Home Building and Loan Association. Jones died in 1938.

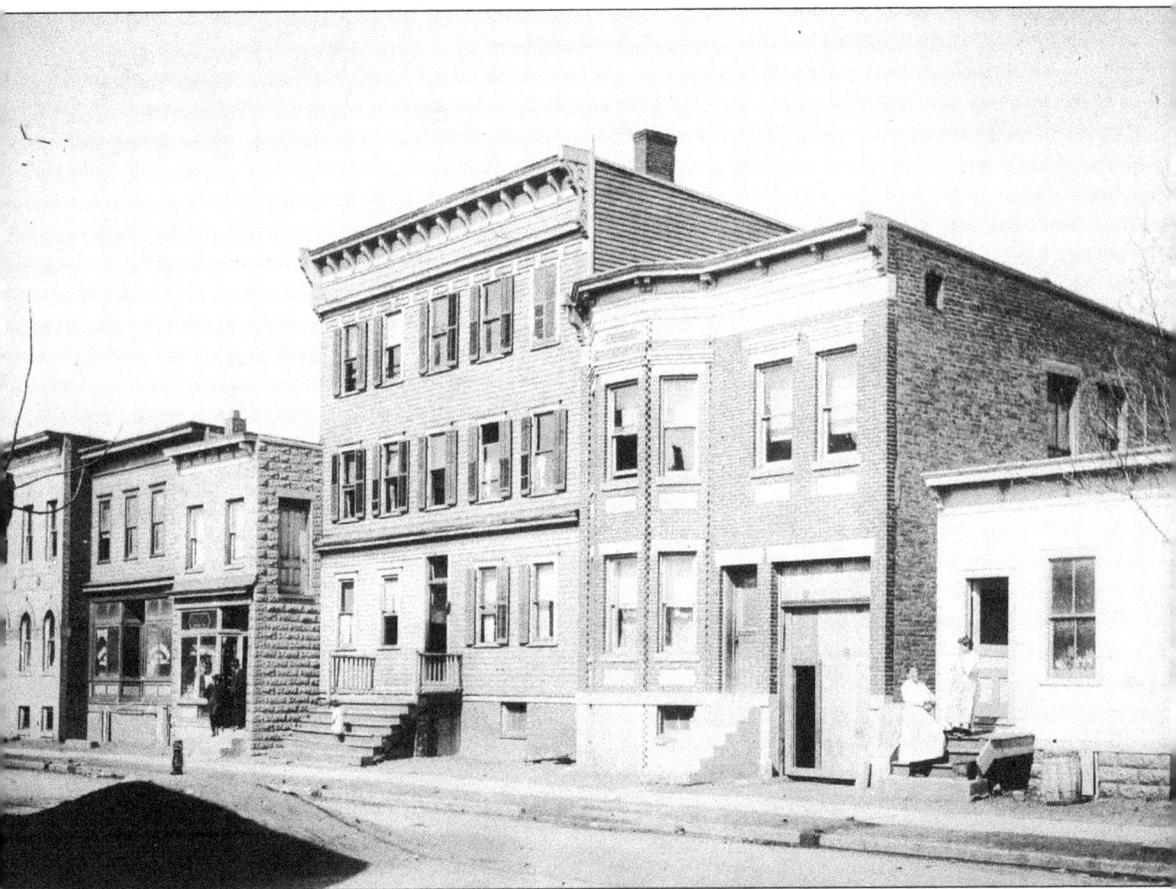

This picture gives a view of the tenement row houses along Belmont Avenue in Belleville's Silver Lake section. The closely situated homes were described as posing a serious fire risk, and the rooms were dark and overcrowded. Many tenements of this type still exist on this side of town today. The first homes went to the many Italian immigrants who came through Ellis Island to Belleville from their homeland during the late part of the 19th century in search of a better life. What is little known about this part of town is that there actually was a lake called Sunfish Pond or Silver Lake, one-half mile long and 300 feet wide. In 1730, Jasper Crane built a dam on what is now the property of St. Anthony's Church to generate waterpower for a wood-turning mill, in turn creating the lake. Picnickers and ice-skaters alike enjoyed the beauty of the lake during the year, until a storm in July 1889 caused a flash flood that wiped out the dam and drained the lake.

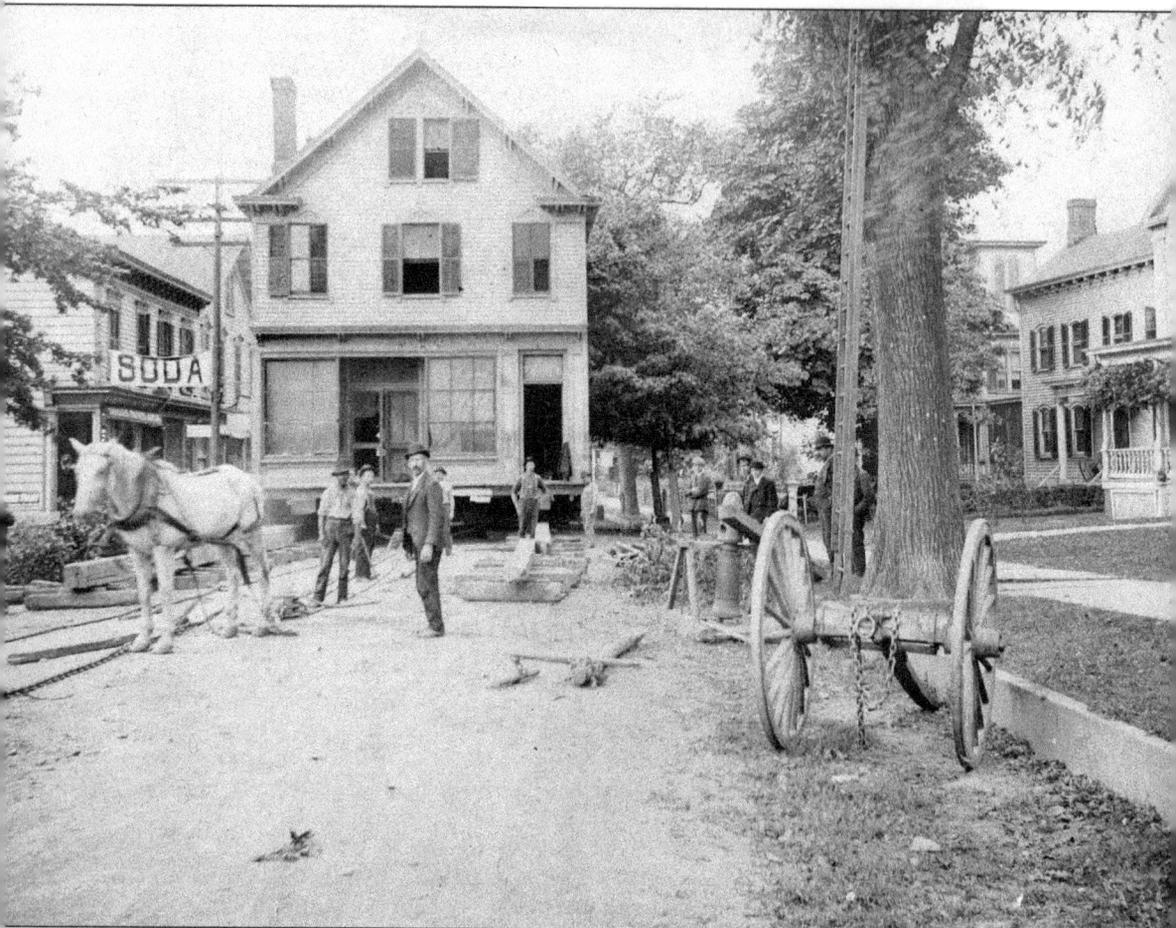

Amazingly enough, moving homes from one piece of property to another was a common occurrence more than 50 years ago. This home with its storefront was wholly moved from its original site on William Street up toward St. Peter's Church. It is hard to believe one horse could pull an entire house, but there are instances of a team of two horses being able to complete the feat. A track of sorts was constructed on the ground, consisting of a long piece of greased timber set across a row of logs. Usually the horses were not hitched directly to the home, as this one appears to be, but instead a pulley-and-weights system would be used. One end of a strong rope or cable would be firmly attached to a relatively steady object, such as a tree, and threaded through a pulley anchored to a crossbeam on the underside of the home. From here, the other end of the rope would be tied to a capstan, which the horses would walk around, therefore winding the cable around. This pulled the house forward without placing the entire onus of the weight on the poor animals.

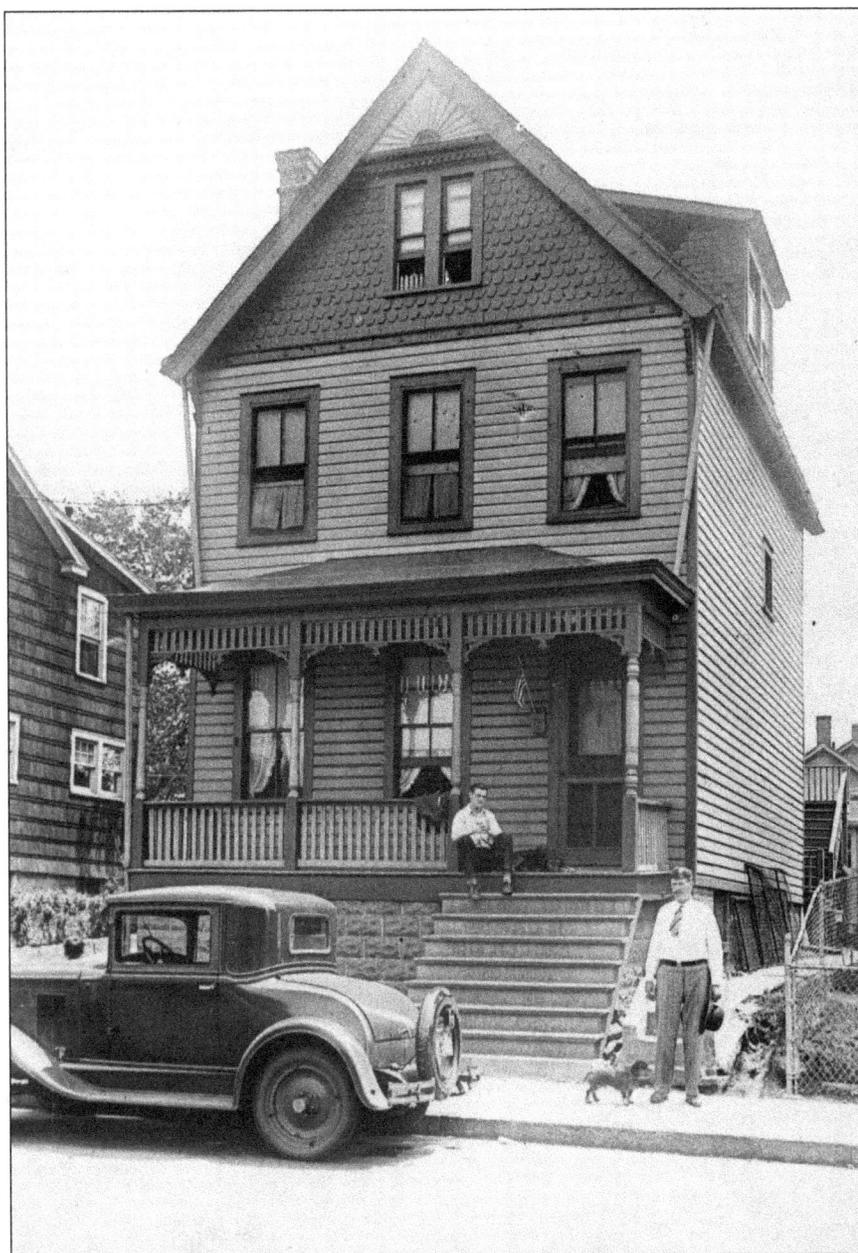

An American flag, a front porch, and man's best friends all add character to the view of the Monaghan homestead at 64 Union Avenue. Seated on the porch is Myles Monaghan, and on the sidewalk is his father, James Monaghan. After emigrating from Ireland at the beginning of the 20th century, James Monaghan and his wife, Mary, moved into a small two-bedroom rental apartment on Bridge Street behind the old St. Peter's Church. The three-story home on Union Avenue was purchased later, reportedly for $5 down and payments. Twelve children would be born, but only seven would survive to adulthood. The couple decided to build a storefront into the façade of the home at some point in the mid-1920s. The J. Monaghan Confectionary was a convenience store, selling soda, milk, bread, candy, and newspapers. Mary ran the store with the help of her older children until the property was sold in the mid-1930s.

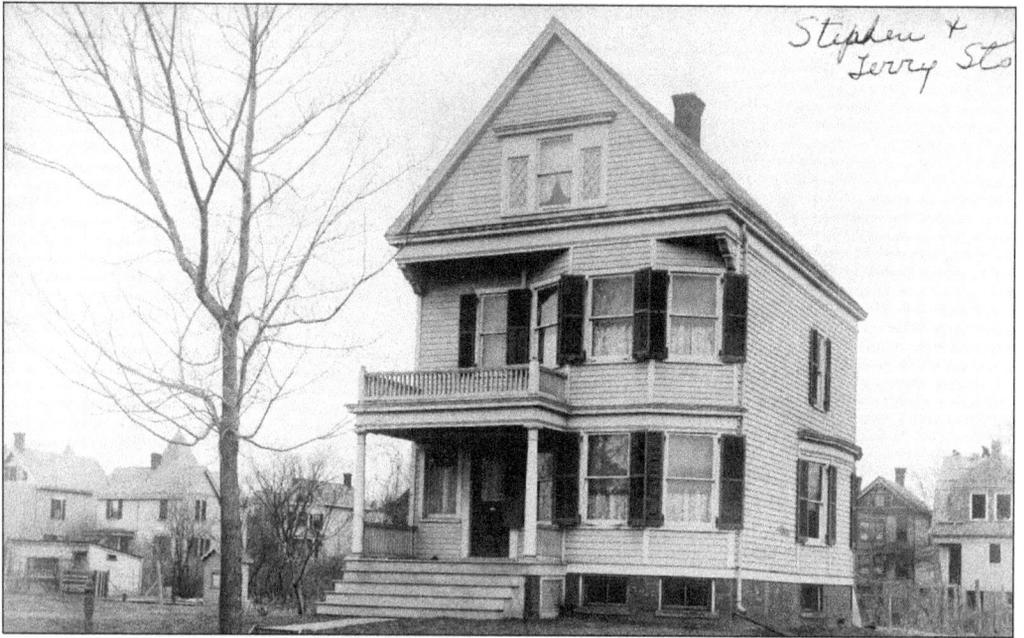

Stephen + Terry St.

At the corner of Stephens and Terry Streets stood the Garrison House, owned by the family of the same name. While living, Henry Garrison was an upholsterer and Leslie Garrison was a piano tuner. At the upholstery shop at 127 Washington Avenue, Henry Garrison made and hung window shades, built mattresses, and bought, sold, and repaired antique furniture. He was previously a cabinetmaker.

Outside of England and Ireland, it is uncommon to find a semidetached dwelling, such as this one at 417–419 Cortlandt Street. This is a different version of a duplex or two-family house in that the entranceways are located on either side of the building instead of the center, and the apartments are side-by-side, not up-and-down.

Eclectic scrollwork trim over the windows and around the porch, along with the Corinthian columns, makes this home at 9 Stephens Street reminiscent of the Victorian style of architecture. There is a side porch on the left and a pitched dormer at the top center of the structure. Other nearby residences also had unique architecture, such as the Rose Cottage at 221 Main Street, a good example of the Dutch Colonial style. Constructed c. 1680, the home was made of brownstone and was surrounded by many black beauty rosebushes. It was solidly built and featured 18-inch-thick wooden floors, window seats in the dining room, and a large fireplace in the front room. The home served as the parsonage of the Dutch Reformed Church as early as 1720. It was said that during the Revolutionary War, a British lieutenant named Brown was confined in the back room as Bellevillites fought to keep the town from being captured by the British contingent stationed just across the Passaic River.

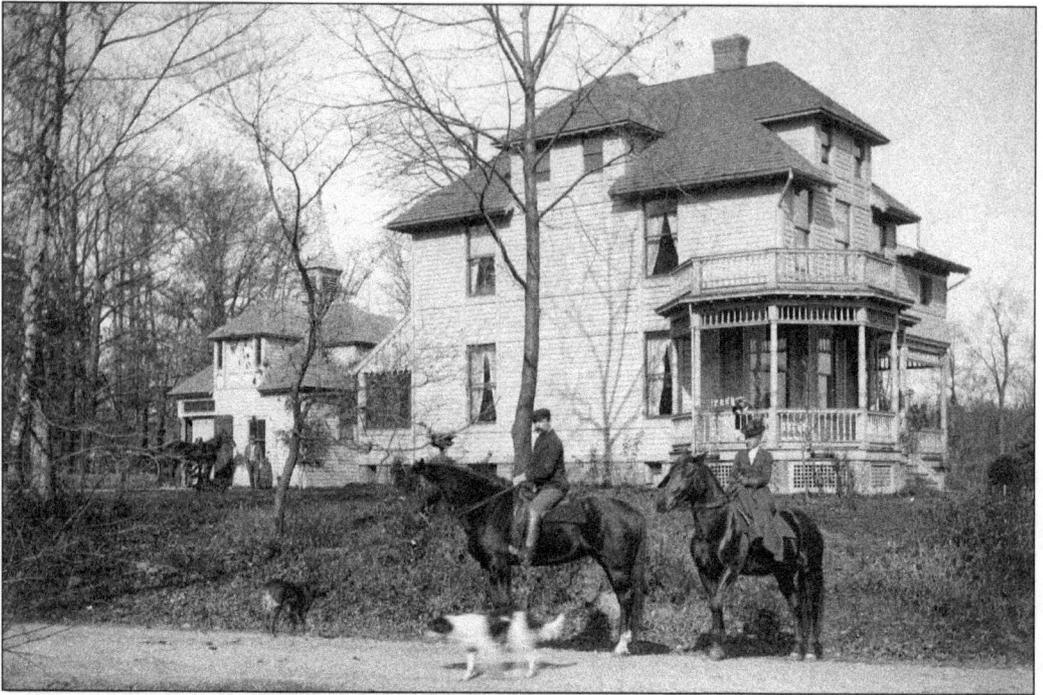

The Paul family home stood at Joralemon Street and Union Avenue, and here is how it looked in 1911. It was a large home with a separate outbuilding in the rear that might have been used as a stable for the family's horses. Hans Paul, a superintendent at Battin & Company of Newark, lived here with his family.

The Macomb mansion was built in 1798 at 125 Main Street on a 20-acre tract and sold to Sarah Macomb by Josiah and Elizabeth Hornblower. Sarah Macomb was the widowed aunt of Alexander Macomb, the famous U.S. Army general who led troops to a victory at the Battle of Plattsburg, New York, during the War of 1812. He would marry Macomb's daughter Catherine, and they lived in the home until it was sold in 1815.

Eight

PUBLIC SAFETY

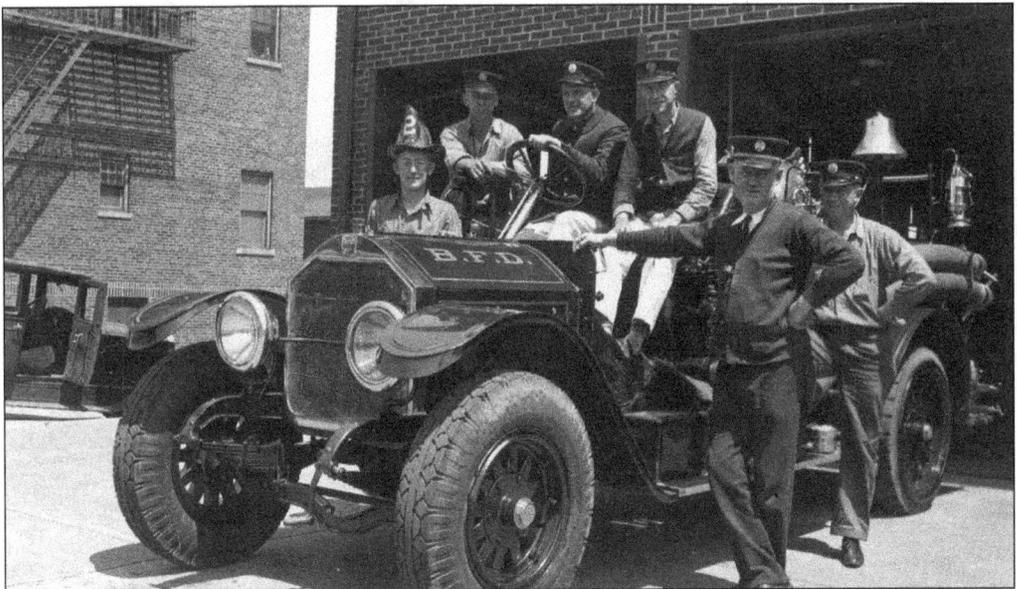

Oscar Reid, James Dunleavy, Becky Gilchrist, William Comesky, William Cullen, and the chief surround this LaFrance pumper in 1935 in front of the Washington Avenue fire station, for which ground was broken in 1923. More stations were added around town to sufficiently cover every neighborhood within Belleville. Fire headquarters at this time was at the William Street firehouse.

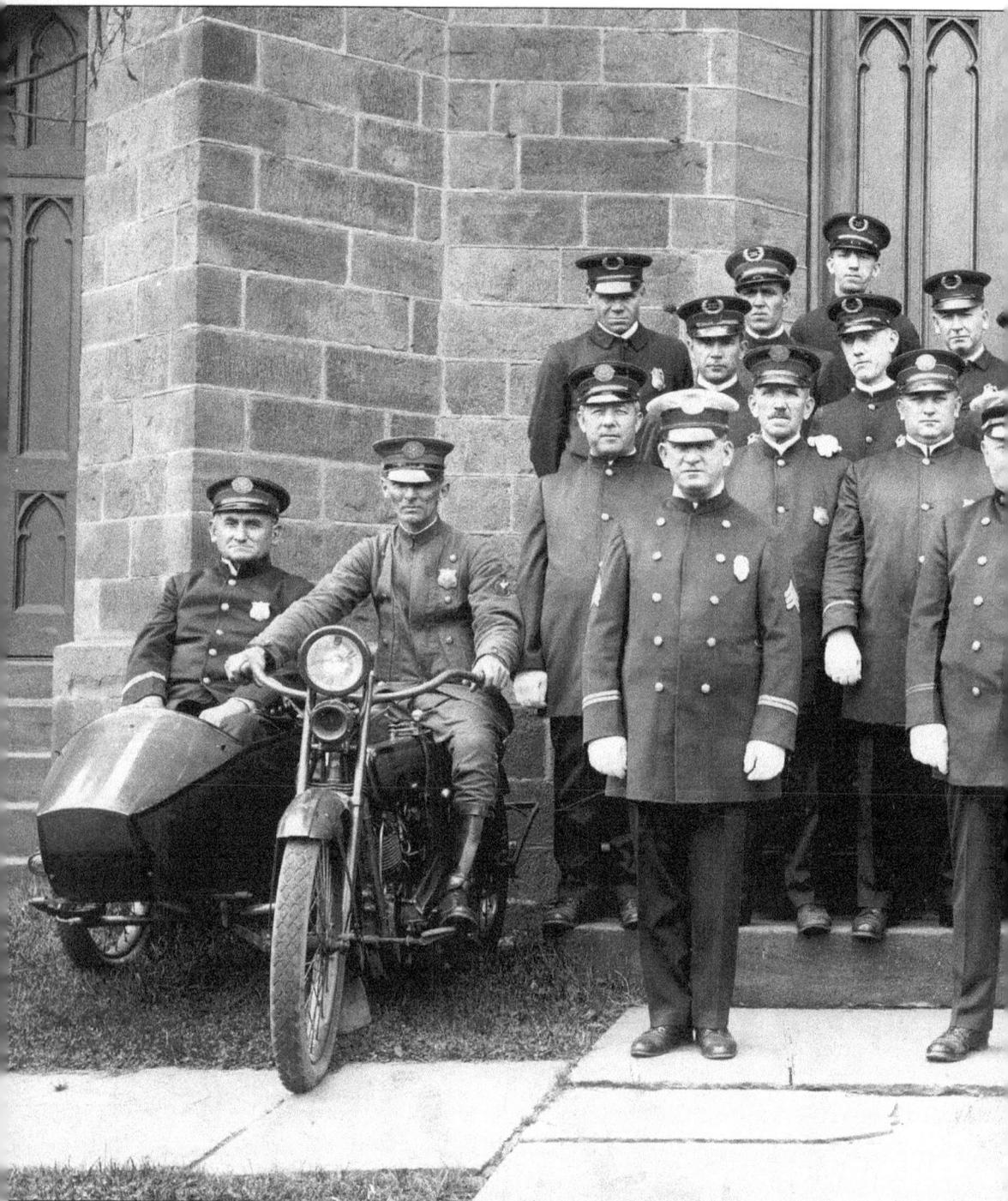

Members of the 1922 Belleville Police Department, with motorcycle officers, pose in front of the Dutch Reformed Church on Main Street on the Passaic River. They are identified by last name, from left to right, as follows: (first row) Gilman, Schurr, Pearl, Flynn, Hannon, unidentified, and Gorkan; (second row) Finn, Whalen, Gorman, Bonella, and Anderson; (third row) Hanley, Larkio, Flynn, Spatz, Nourse, and unidentified; (fourth row) Roheits, unidentified, Neilan,

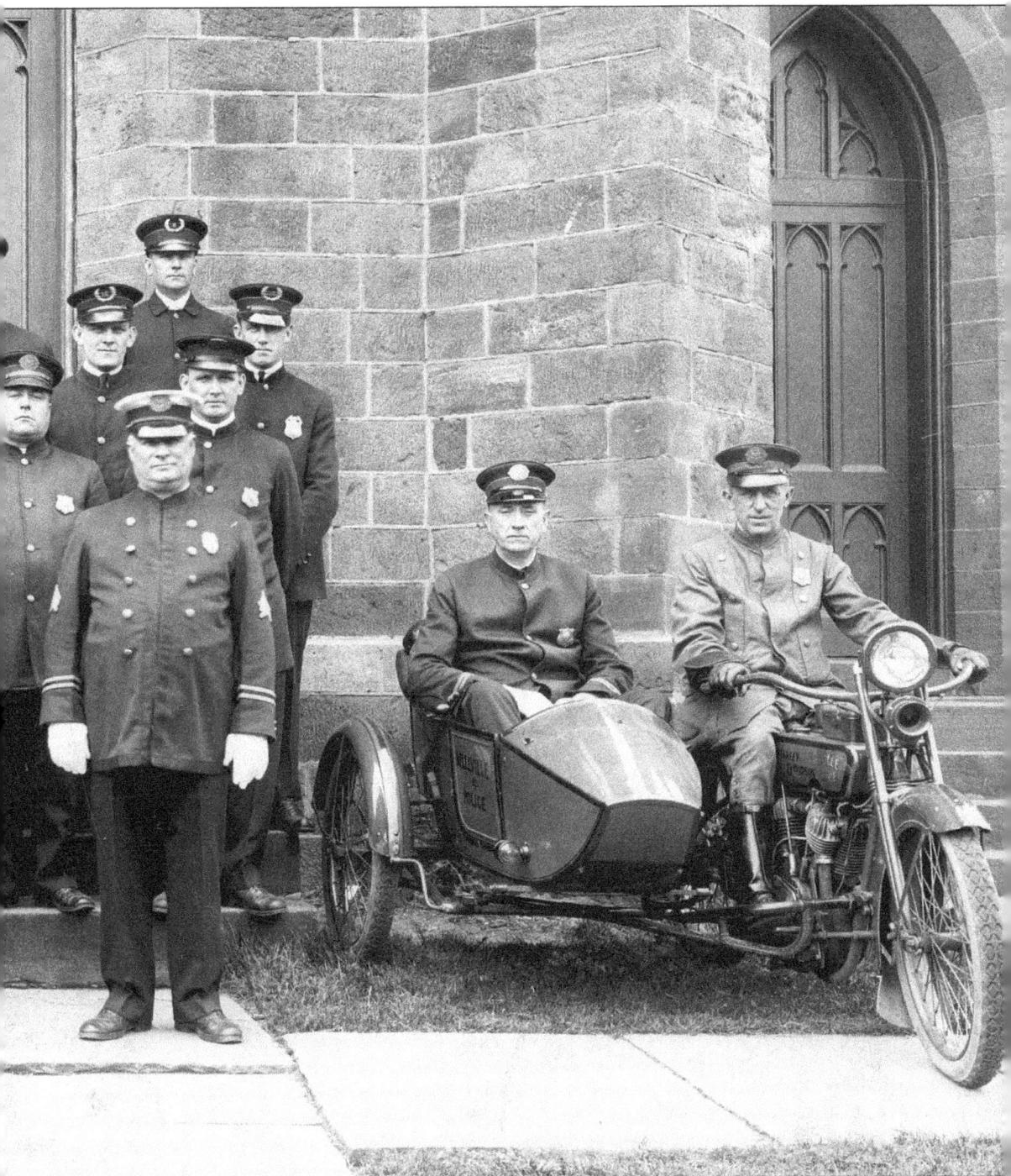

unidentified, and Burke. Harley-Davidson manufactured the motorcycles and sidecars. The first paid Belleville Police Department was not organized until 1907. Prior to that, street protectors would assure the safety of the citizens and property. They wore long coats with two rows of brass buttons and high, rounded derby-style hats. It is unfortunate that there is not much information about the history and founding of the modern Belleville Police Department.

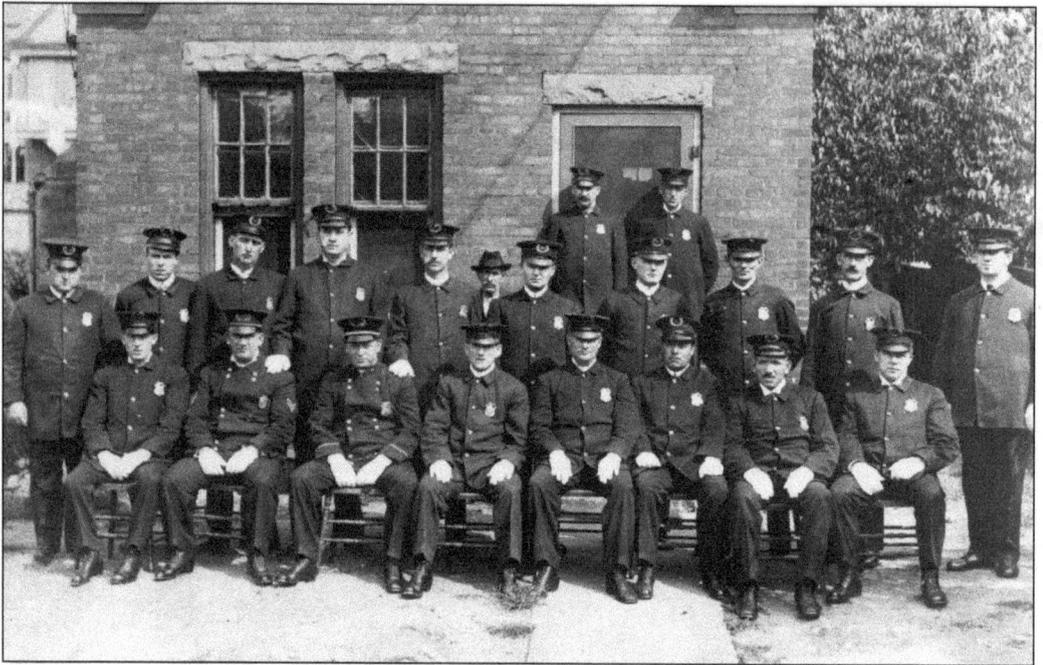

The Maltese Cross is a symbol of a firefighter's courage and of protection and has been used on uniforms of the Belleville Fire Department for many years. These proud firemen are sitting for a portrait behind one of the firehouses in the Valley section of town, one of the three volunteer fire companies at the time.

Like any other department, when one of Belleville's finest passes away, grand honors are given to the dead according to police funeral protocol. This early funeral for one of Belleville's officers shows the coffin being carried atop a dark horse and buggy, surrounded by fellow officers. Notice the lack of an American flag draped over the casket. The police department was organized on February 1, 1907, with Michael J. Flynn as chief.

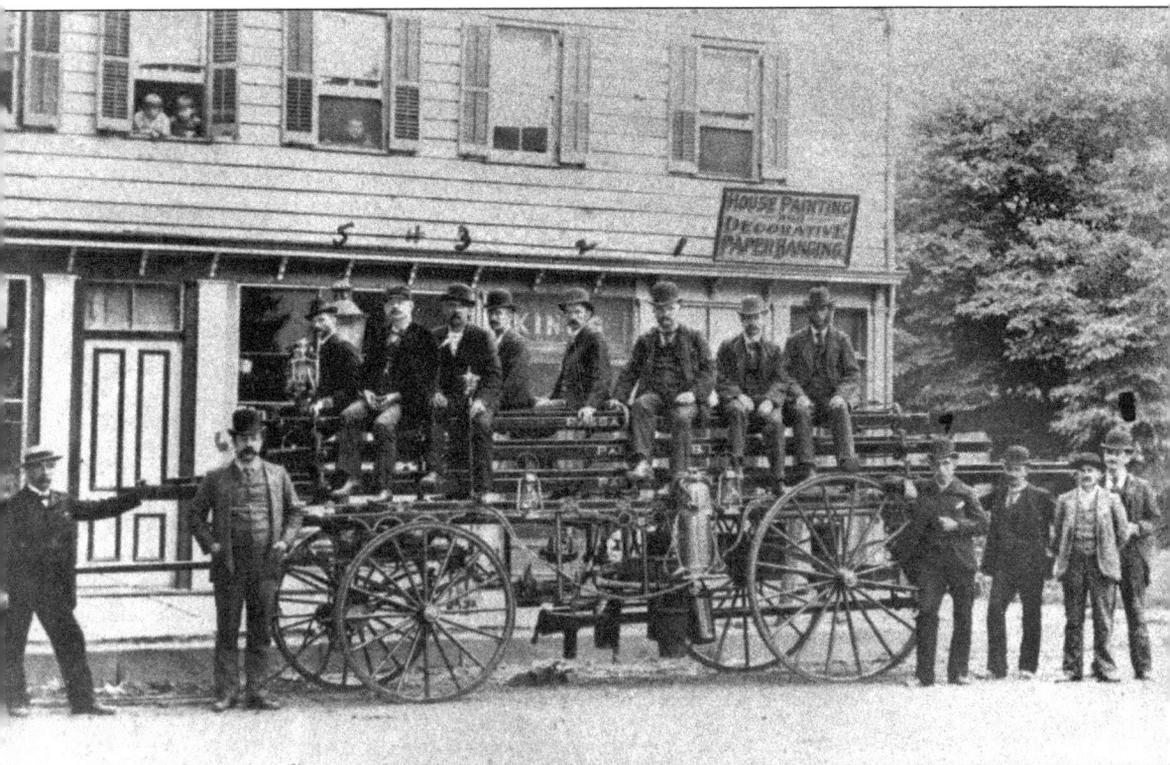

Shown here are a few of Belleville's volunteer firefighters in 1885, three years after the institution of the Valley and Eastwood volunteer hose companies. Male citizens between the ages of 21 and 45 would apply for membership in the companies and were elected for seven-year terms, after which they were granted certificates of exemption if they had responded to 50 percent of the fires occurring during that time period. Drills were frequently held with the firemen and their hose carriages, and funding for the department's operation came from a tax on property within each fire district. Prominent businessmen would also join the companies, since they had a vested interest in the fire safety of the town and its industries. Atop the hose carriage here are, from left to right, Albert Henry Stephens, Chester DePoy, James Hardman, A.H. Osbourne, Howard Osbourne, John Eastwood, Theodore Brown, and Joseph Hornblower Stephens. DePoy, Hardman, Eastwood, and the Osbournes all had their own industries operating within the town.

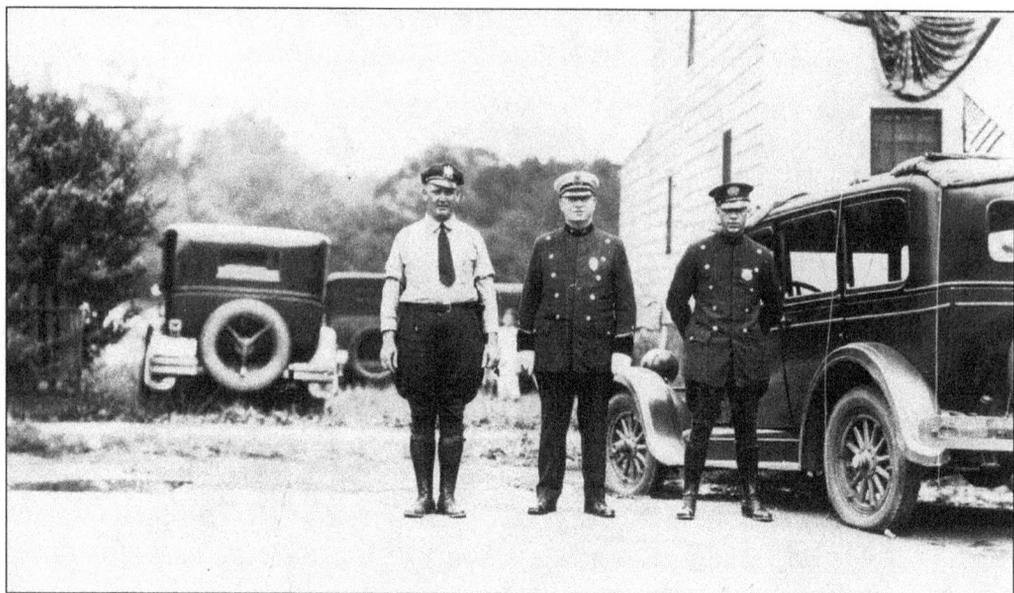

Firefighters and police officers have always worked closely together in town, responding to medical and fire emergencies. Here are a Belleville Police Department chief, a firefighter, and another officer standing in front of one of the early police vehicles. The Belleville Police Department was organized to help protect the growing population.

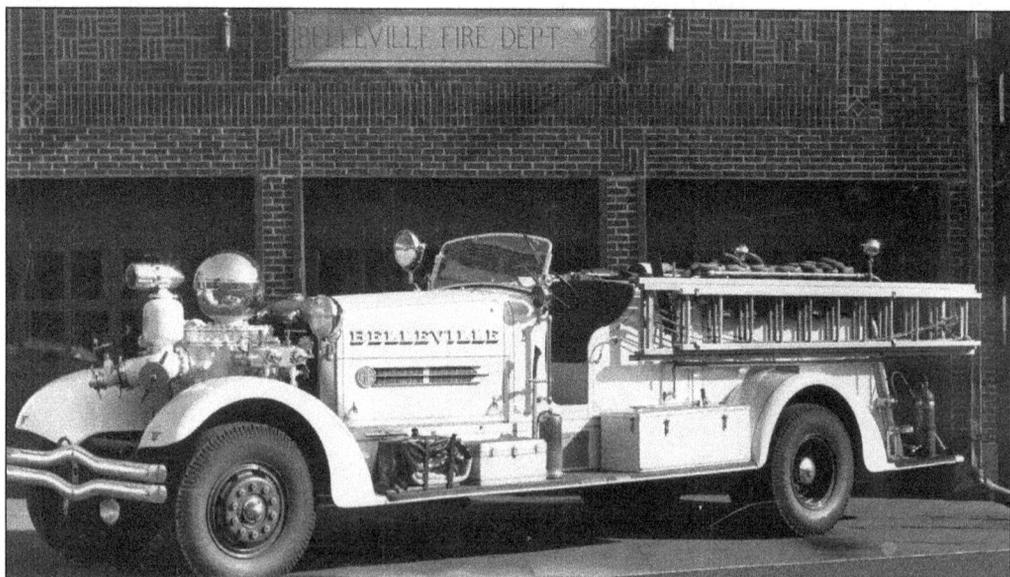

This late-1920s American LaFrance pumper called the newly built Washington Avenue fire station home in the 1930s. In 1940, the fire department also kept a hook-and-ladder truck, a Seagraves pumper, two chief's automobiles, and an ambulance at the station. A year later, the first radio communication system would be installed, with the frequency shared by both the police and fire departments.

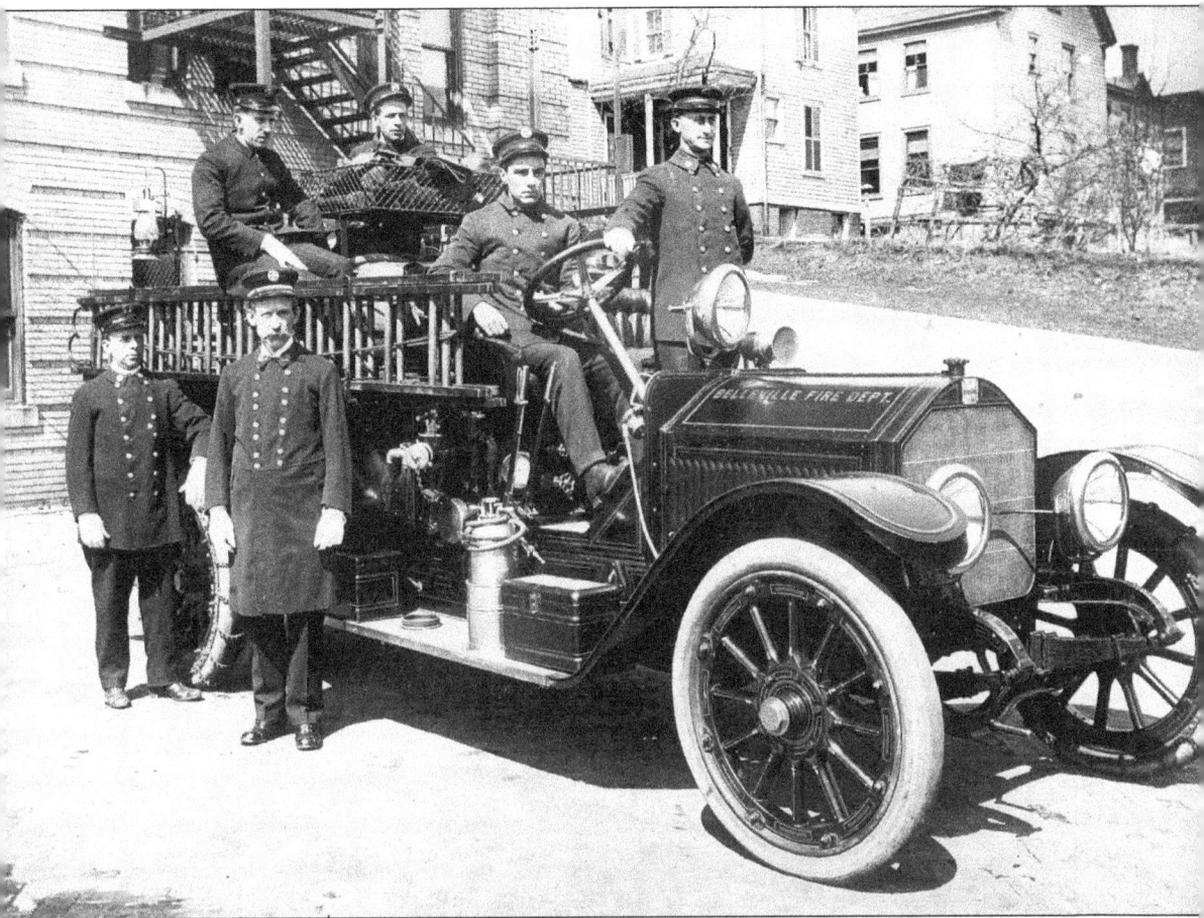

This 1914 LaFrance 500-gallon pumper was the first automobile fire engine purchased by the Belleville Fire Department in July of the same year. It allowed firefighters to get to alarms more quickly and put out fires more efficiently. The LaFrance was stationed at the volunteer Valley Hose Company, which had its headquarters in the basement of Belleville Town Hall. Chief Nicholas Comesky, Capt. James Salmon, Capt. William McCormack, John Mazza, and Capt. James McCarthy are pictured here with the pumper behind the town hall. Lt. Alexander Reid is the driver.

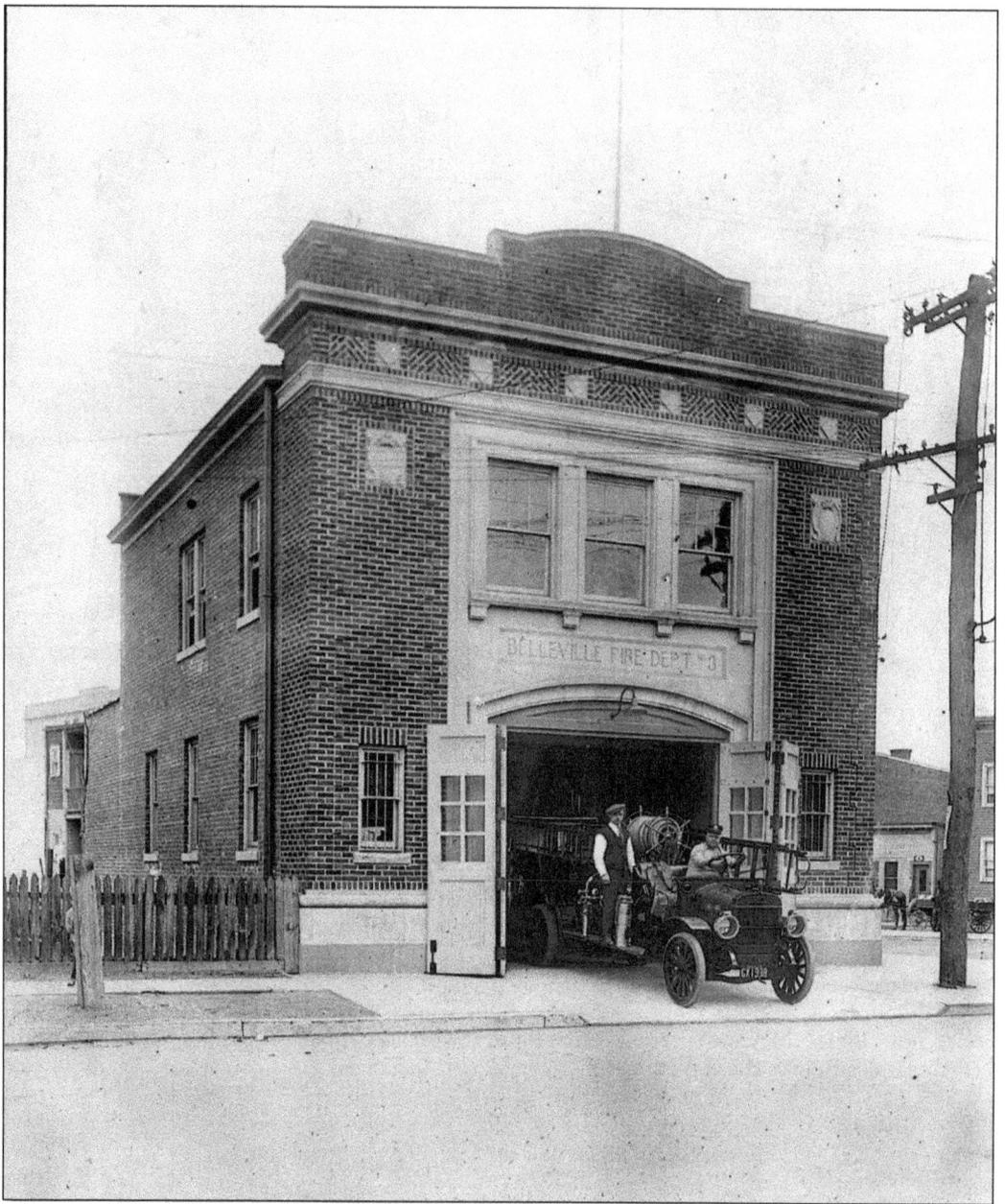

The Silver Lake station on Franklin Street was built in 1923, also the year the volunteer system was abolished because of the difficulty in getting to fire alarms, among other problems that befell the department. A combination paid and on-call department was established, naming William T. Hirdes as fire chief.

By the early 1940s, emergency medical service for the town was provided by the fire department, which acquired ambulances and trained its firefighters in first aid. Now, every Belleville firefighter is a certified emergency medical technician (EMT), and the department still covers the township's fire alarms. The ambulance has always been manned by two EMTs.

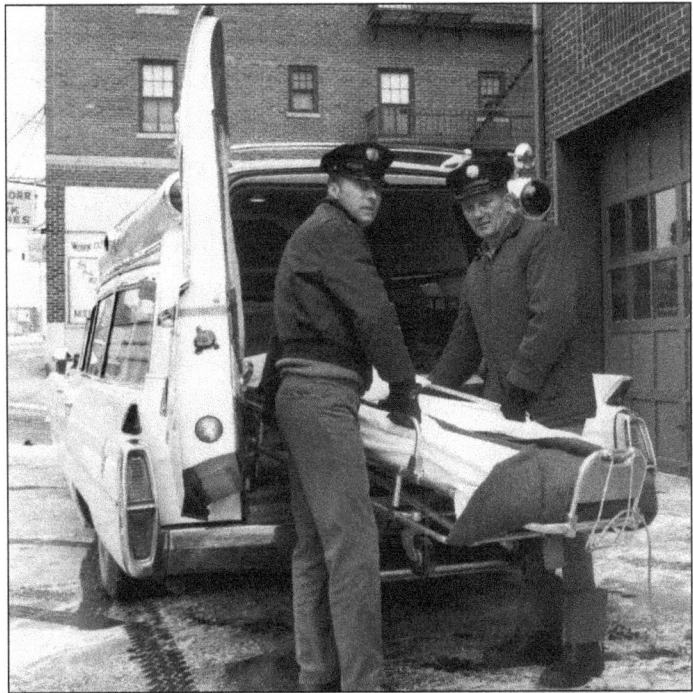

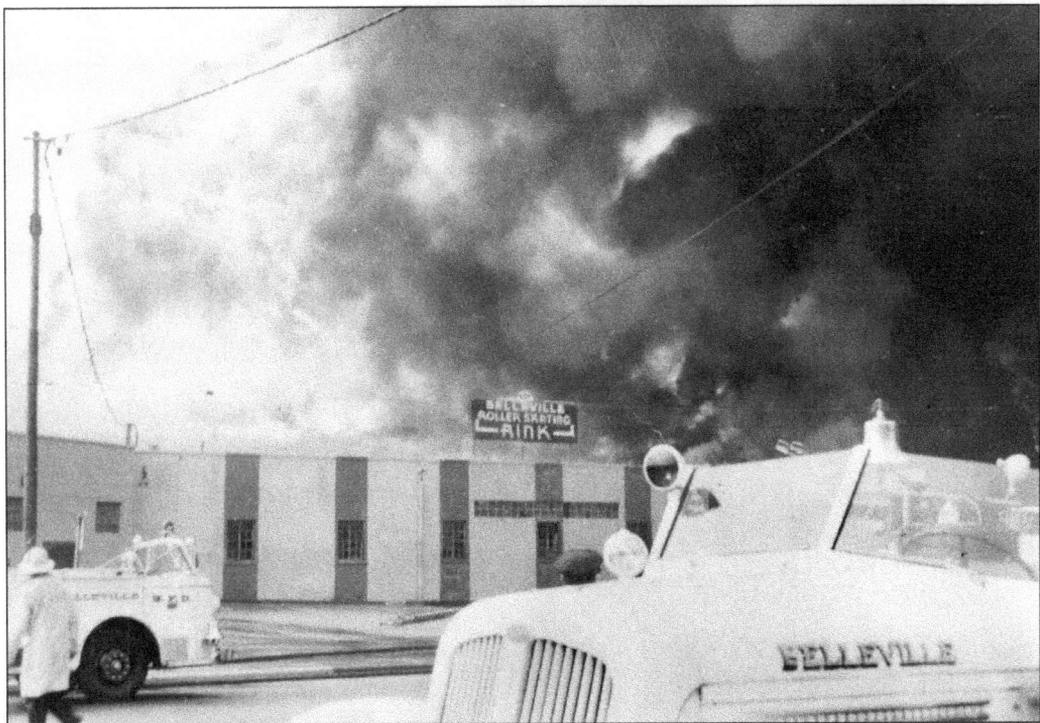

In 1963, a fire struck the Riviera Roller Rink on Washington Avenue (formerly Hillside Pleasure Park and, today, a bowling alley). The wooden building burst into flames and was completely lost, despite mutual-aid assistance from the Nutley and Newark fire departments. Containment of the fire was extremely difficult.

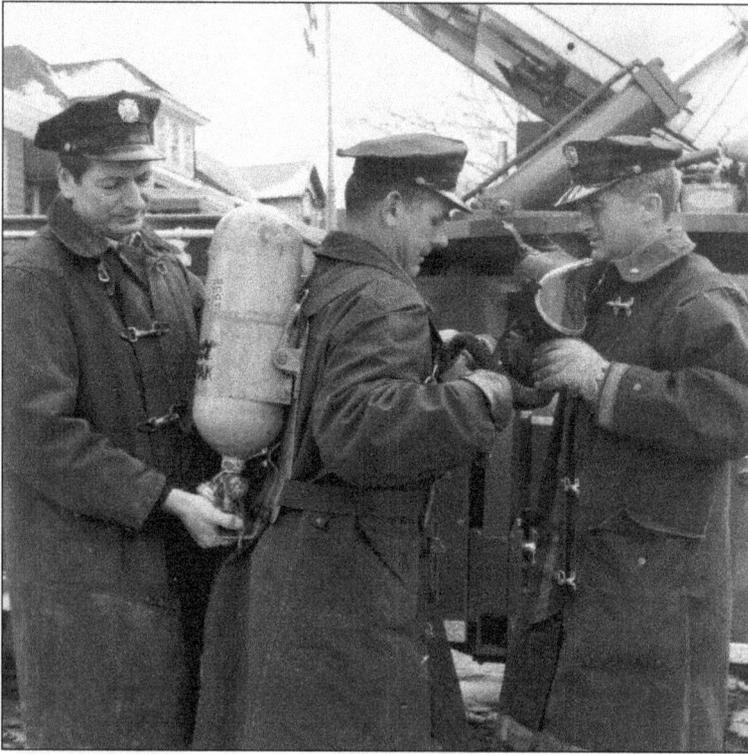

Oxygen tanks are the most important piece of equipment for firefighters. From left to right are firefighters Gasper Siciliano, Bill Buckley, and Danny Ward during a practice using the self-contained breathing apparatus (SCBA). This new piece of equipment was used for the purpose of breathing in smoky atmospheres for periods of up to 20 minutes with fresh air carried in cylinders slug across their backs.

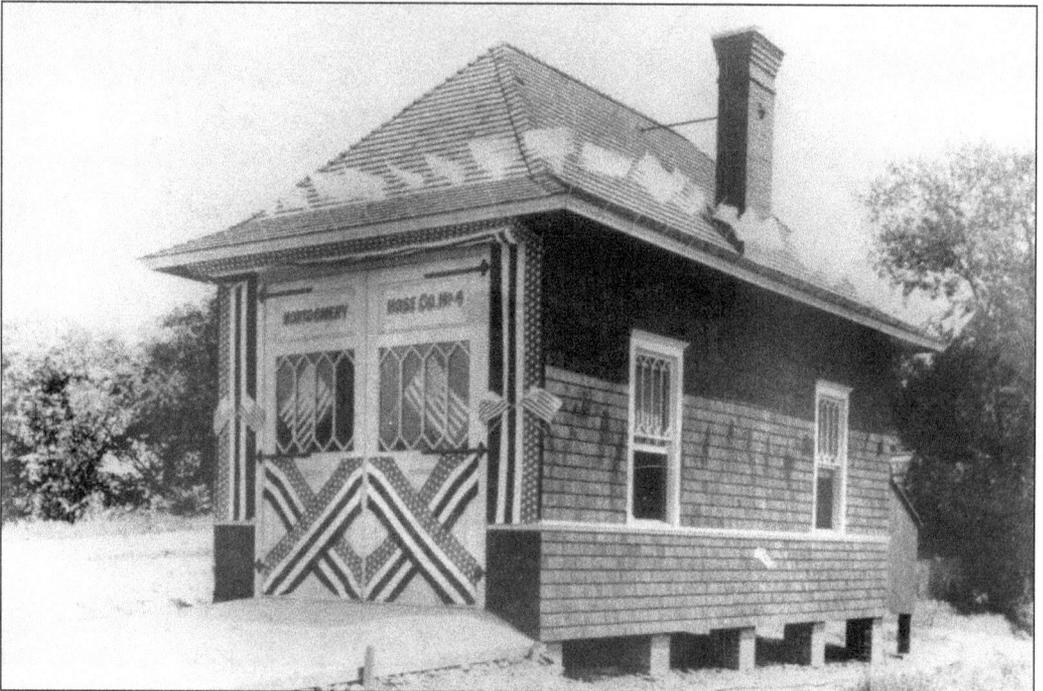

Montgomery Hose Company No. 4 was located in a small one-story structure just large enough to hold a fire engine somewhere in the vicinity of western Mill Street. The building here is decked out with a ring of American flags and patriotic trim.

The Open Door to Belleville was a booklet prepared by the Belleville Foundation for returning members of the armed services following World War II. The goal of the Belleville Foundation was to fully reintegrate the men and women into the community's "schools, churches and industries." A total of 10 committees were organized to help with the effort.

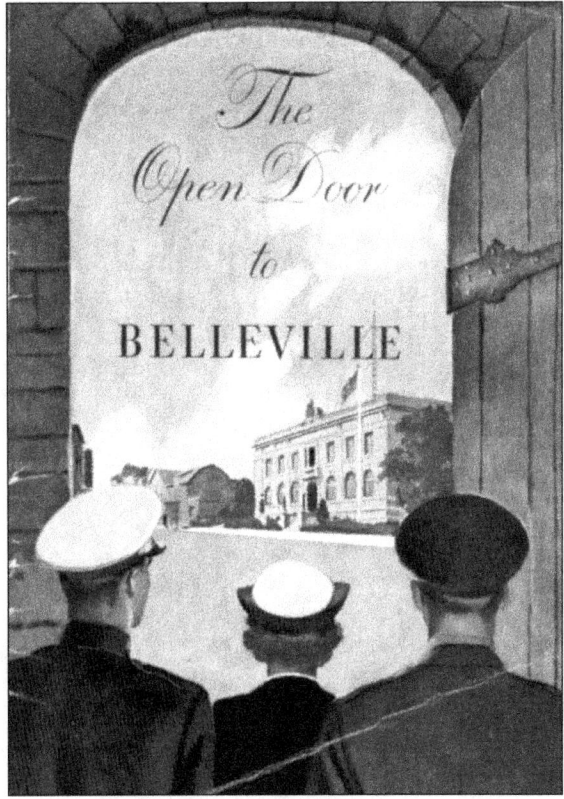

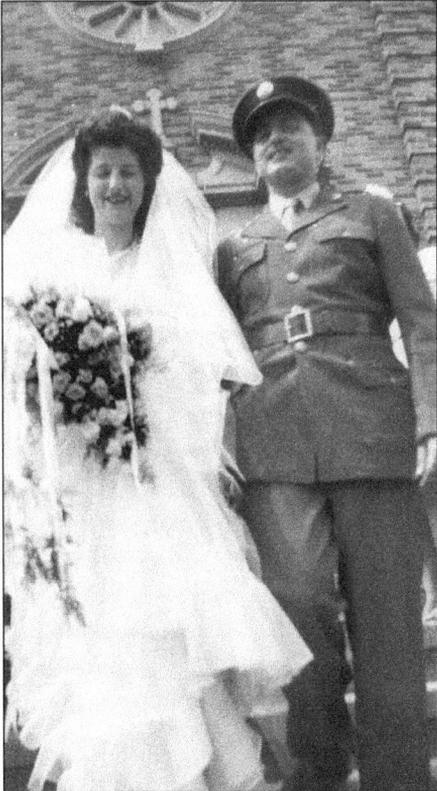

Josephine and Louis P. Maioran are seen here following their wedding ceremony at St. Anthony's Church in Silver Lake during World War II. Many of Belleville's citizens were participants in the two world wars and Korea, and there are numerous memorials scattered about town dedicated to those who fought and died for our country.

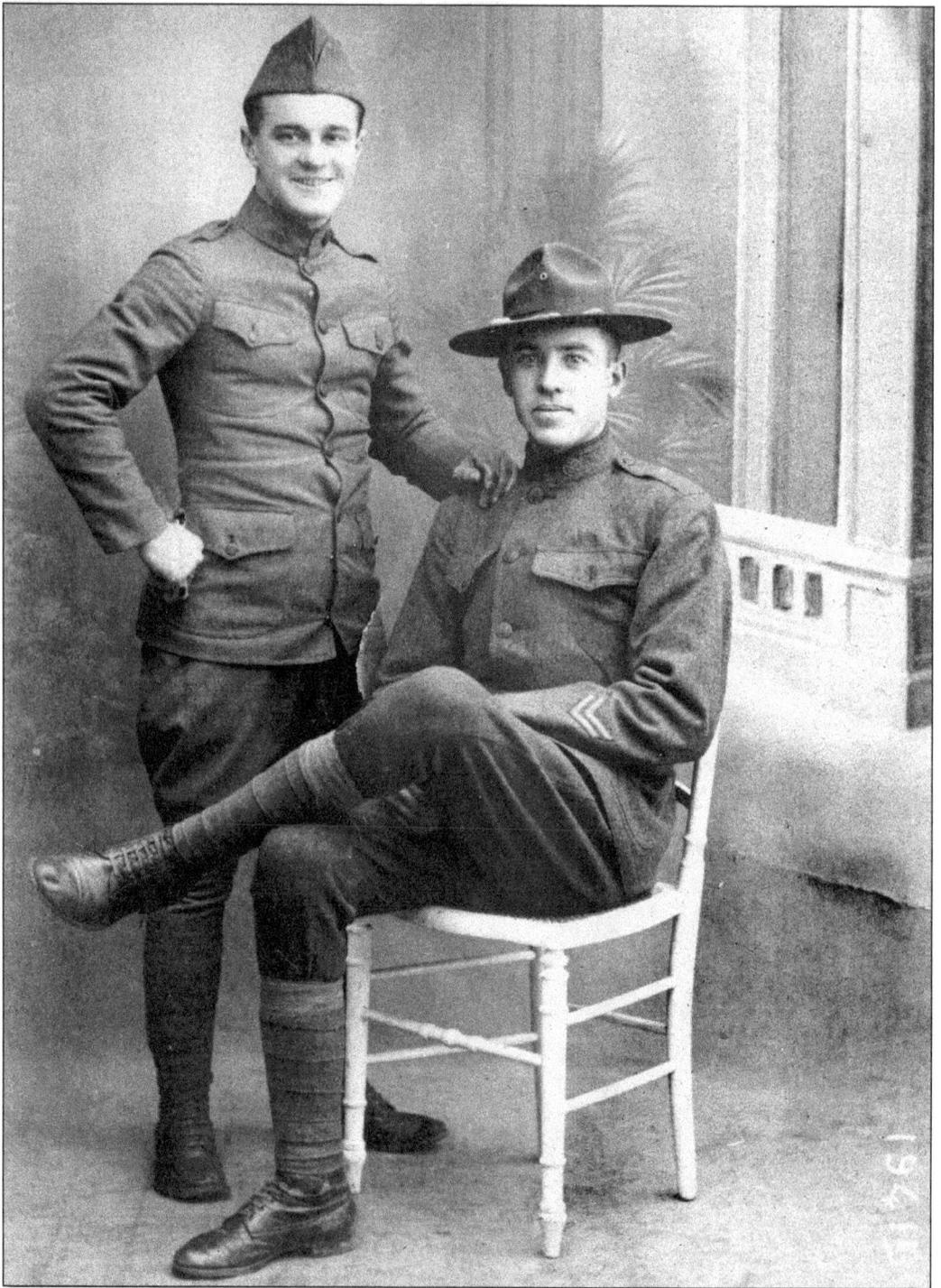

Posing for a picture are two Belleville residents in their U.S. Army uniforms from the era of the World War I. The gentleman on the left appears to be dressed in the uniform of an artillery officer, and the man seated is wearing a U.S. Army soldier's uniform, complete with the army's service hat worn by both officers and enlisted men.

Nine

LEISURE TIME

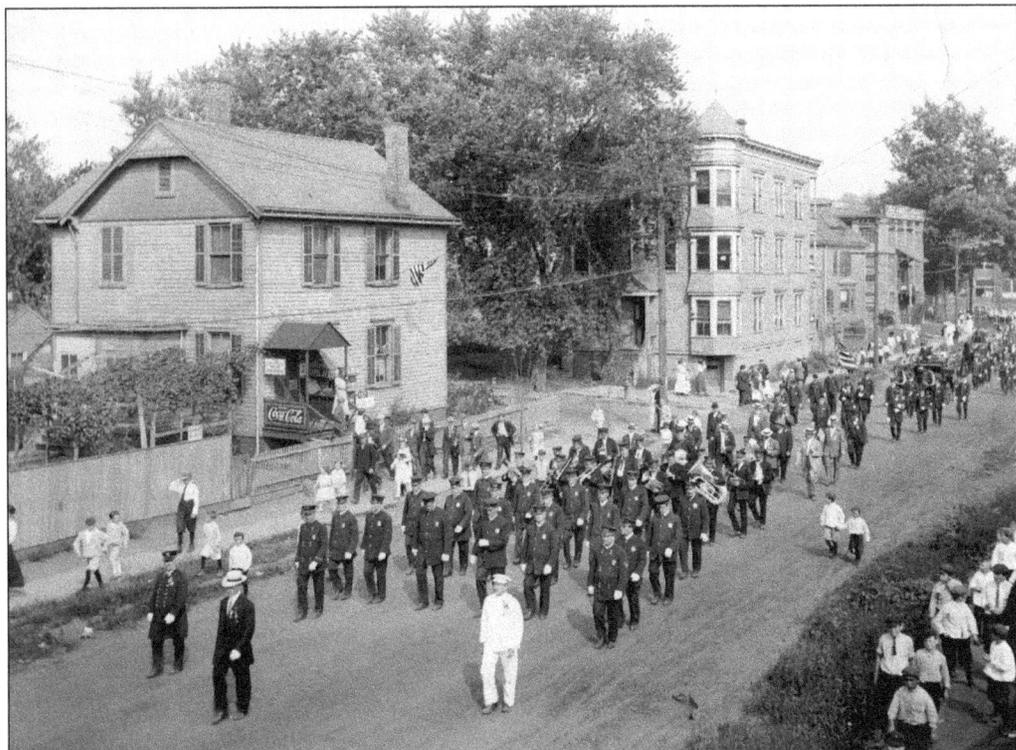

Parades and other celebrations have been held from time immemorial in Belleville up until the present times. Annual parades are held celebrating St. Patrick's Day, Memorial Day, Labor Day, and Columbus Day, sometimes in cooperation with the neighboring town of Nutley. Shown here is a parade down Mill Street in honor of Belleville Day on August 24, 1912.

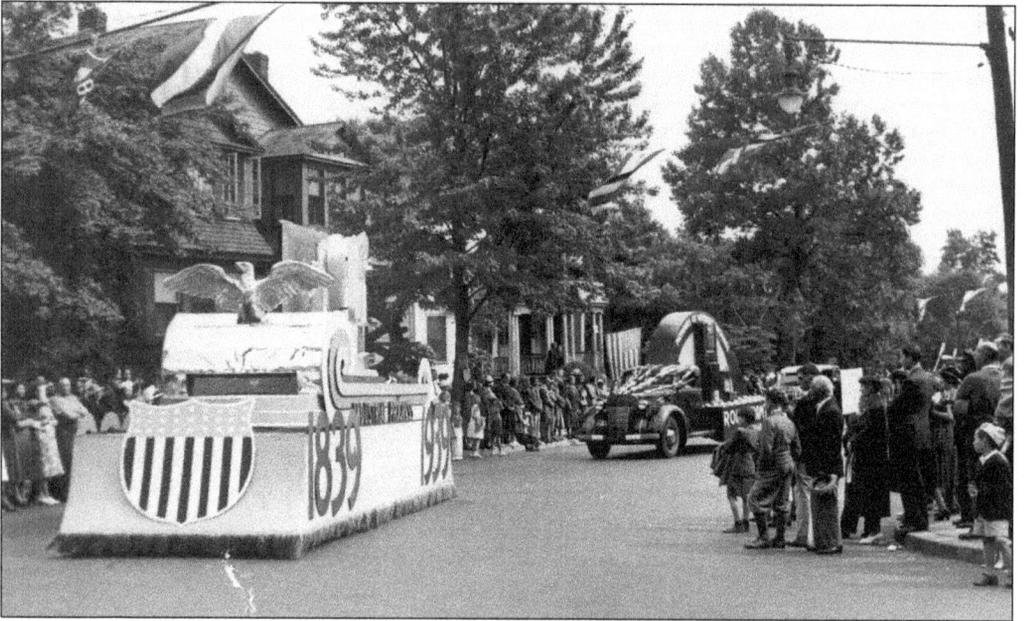

Hundreds of residents gathered to see this parade roll through town in 1939 to commemorate the 100th anniversary of Belleville's incorporation as a township. The white float is titled *Industrial Progress*, a nod to the municipality's place in history as one of the most important sites for business and industry at the start of the American industrial revolution.

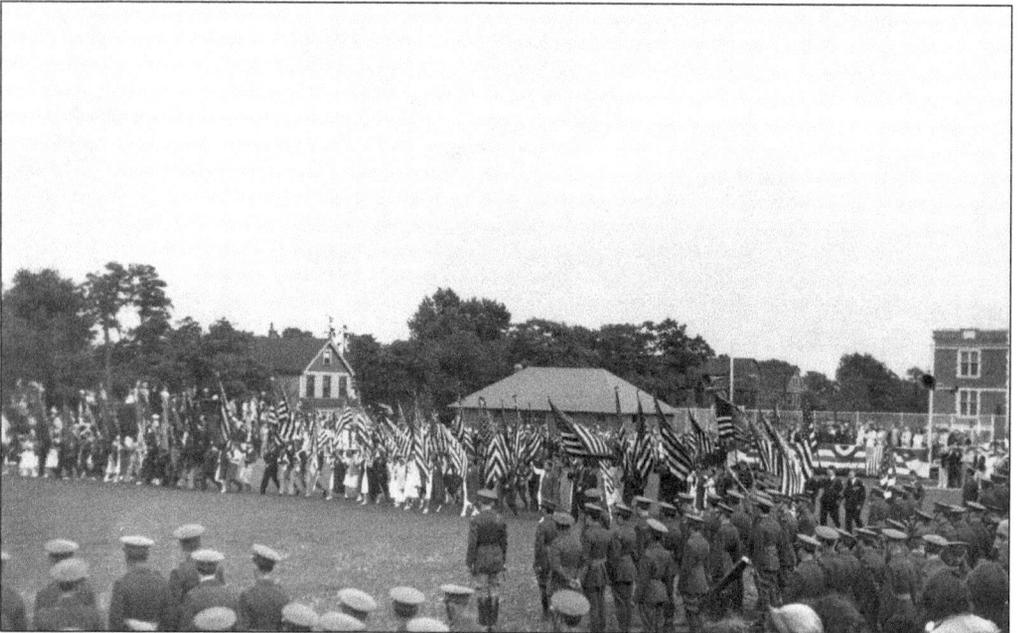

Belleville's centennial celebration coincided with a Flag Day celebration held at School No. 8's Clearman Field on the corner of Holmes Street and Union Avenue. Sponsored by the Essex County Council of Veterans of Foreign Wars posts, the program was conducted by Mayor William H. Williams on June 18, 1939. Belleville was represented by its schools, churches, Boy Scouts and Girl Scouts, and organizations.

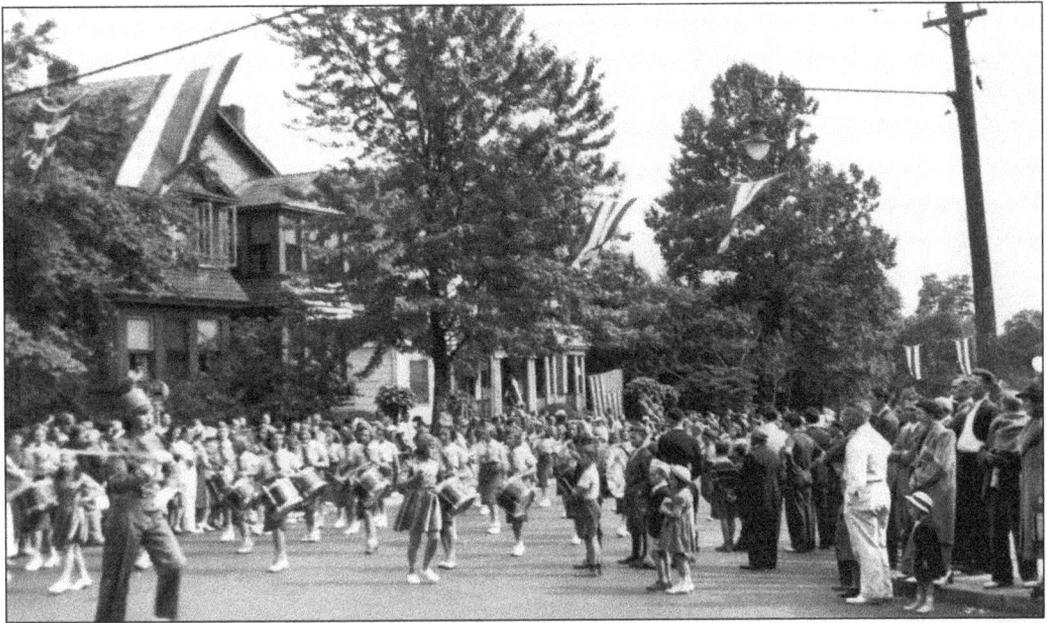

This view shows the Belleville Day Parade in 1939. Here is what looks to be an all-girl drum corps. It is interesting to see the American flag hanging from the porch of a home in the background—it only has 48 stars, since Hawaii and Alaska had not become states yet.

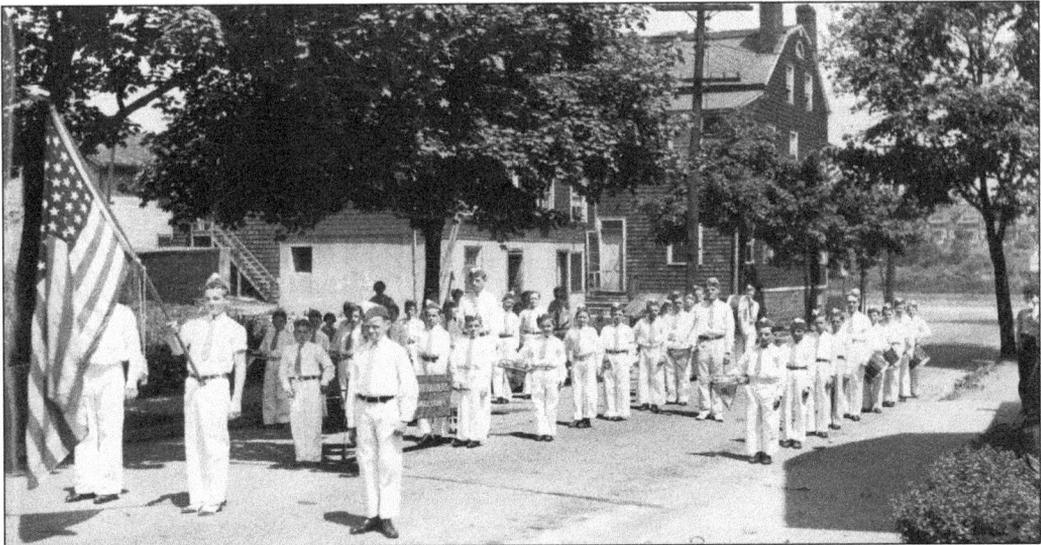

The Belleville Grenaders Drum and Bugle Corps stands poised and ready in this 1936 photograph. The picture was taken in front of the Veterans of Foreign Wars post on Belleville Avenue near Main Street. Originally, the building was used as the first firehouse in town for the Valley Hose Company volunteers. It would later catch fire, causing $10,000 worth of damage.

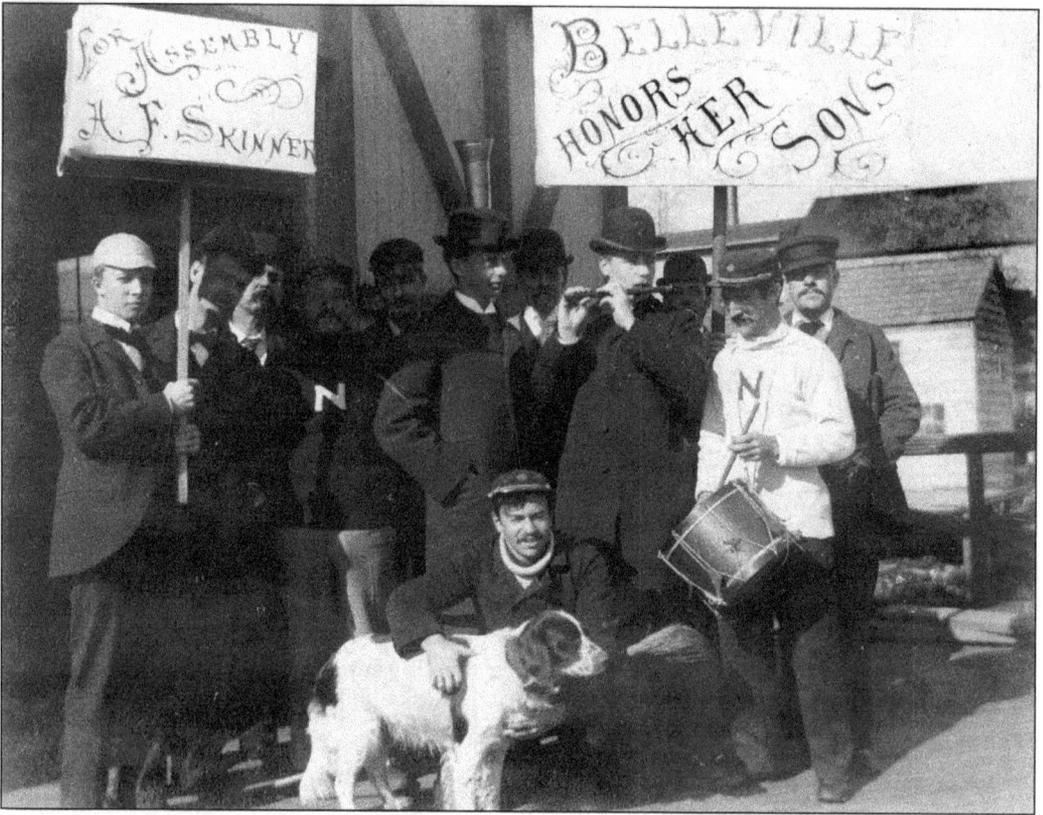

Members of the Nereid Boat Club stump for A.F. Skinner for an upcoming assembly election. Up front with his dog is E. Schuyler Webster, presumably a member of the esteemed Schuyler family, who owned copper mines across the Passaic River. The Nereid Boat Club was founded in 1875 and rowed the waters of the Passaic.

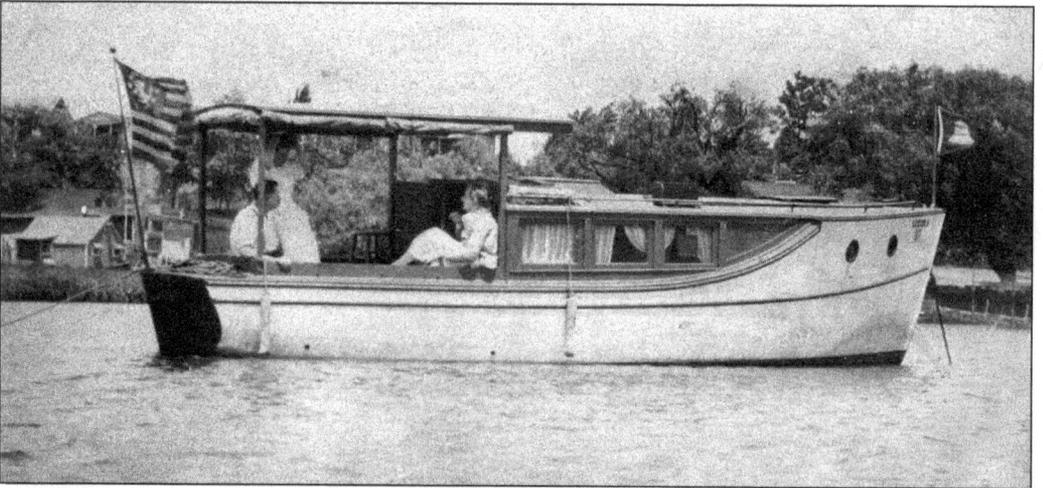

This 1880s group is anchored on the Passaic River in their boat, the *Lizzie S.* The origin of the flag aloft at the bow is unknown, but it has 13 stripes, a field of stars, and a crescent moon. Boating was a popular activity in the times before industry took hold in Belleville, as was fishing. On a good day, the river was teeming with bass, perch, sunfish, catfish, and other freshwater fish.

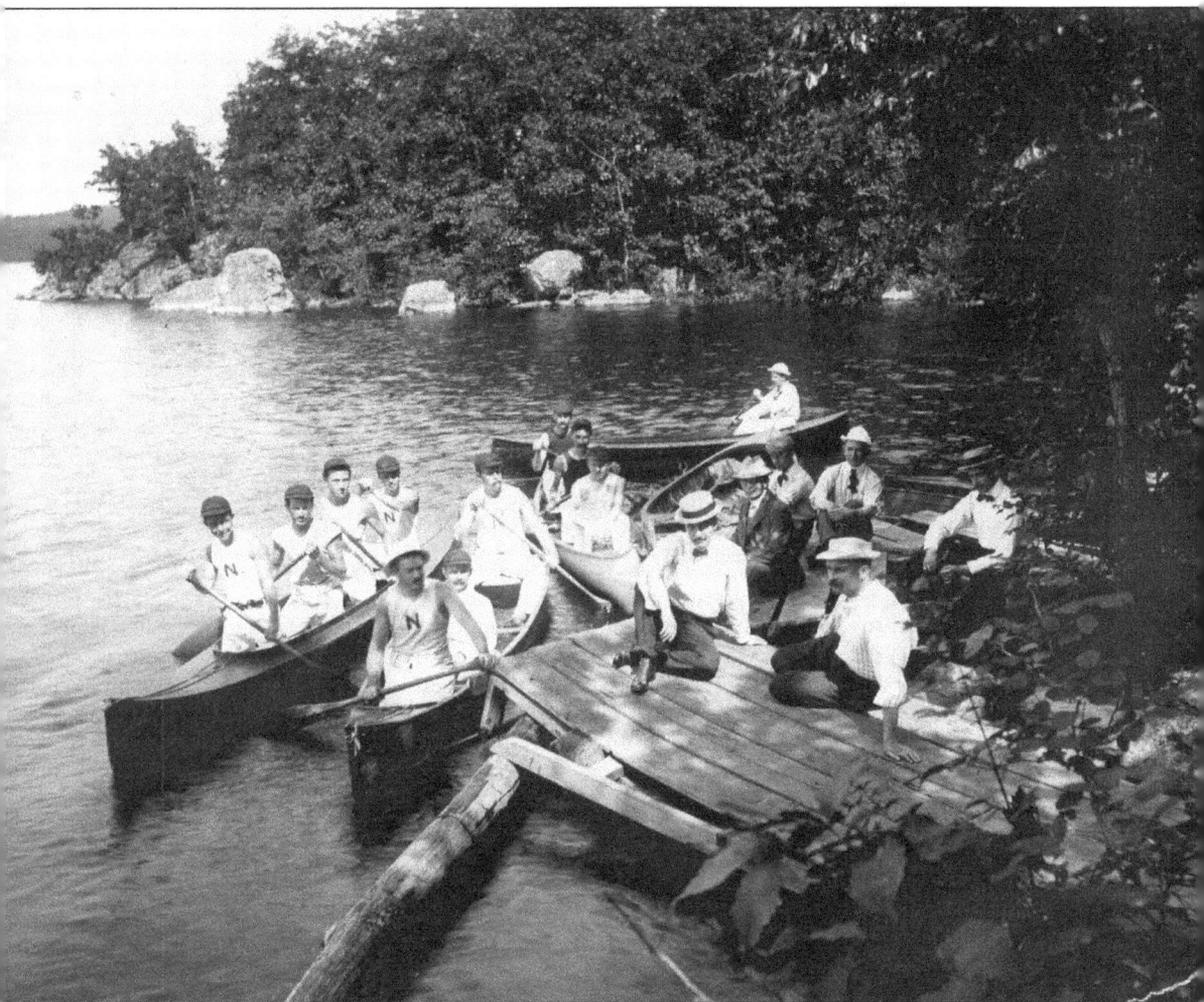

Here, members of the Nereid Boat Club dock their sculls on a bucolic stretch of the Passaic River. The organization was founded in 1875 in what was known as North Belleville, later to become present-day Nutley. In 1882, a residence previously owned by the Woodside Rowing Club on the east bank near the Erie Railroad bridge at the Newark border was transformed into a headquarters and clubhouse for the Nereid group. It served its purpose until an arson fire destroyed the building and all of the equipment in 1964. A conflicting historical account puts the club's founding in May 1866 in the city of Newark, with its official incorporation two years later. This group may have merged with the Nutley-Belleville group by 1875. Eventually, rowing on the Passaic would become so popular that Kearny, Belleville, and Nutley schools would begin their own rowing clubs, which continue until this day. Today, the crew teams all operate from a boathouse located across the Rutgers Street bridge in Kearny.

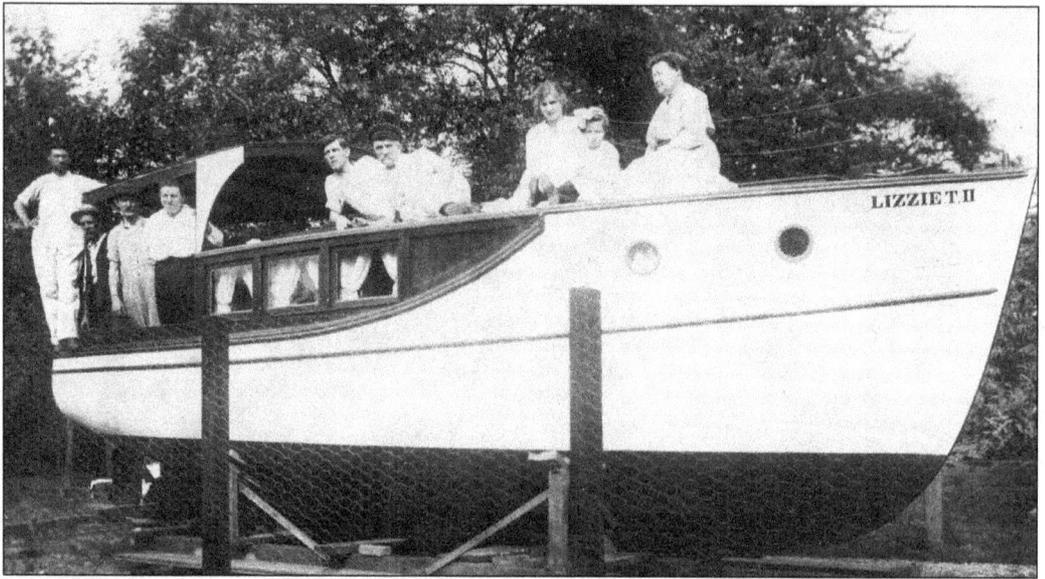

This watercraft appears to be a sister boat to the *Lizzie S.*, as it is called the *Lizzie T.II*. The dry-docked boat was one of many to roam the waters of the Passaic River. In earlier times, steamboats chugged up and down the river, ferrying passengers and goods to Newark and beyond to New York. These early boats inspired the creation of the Belleville Steam Boat Company in 1857, which carried 60,000 passengers in its first two years. Many boats would be put into service and later fail, due to either a lack of funds or repairs.

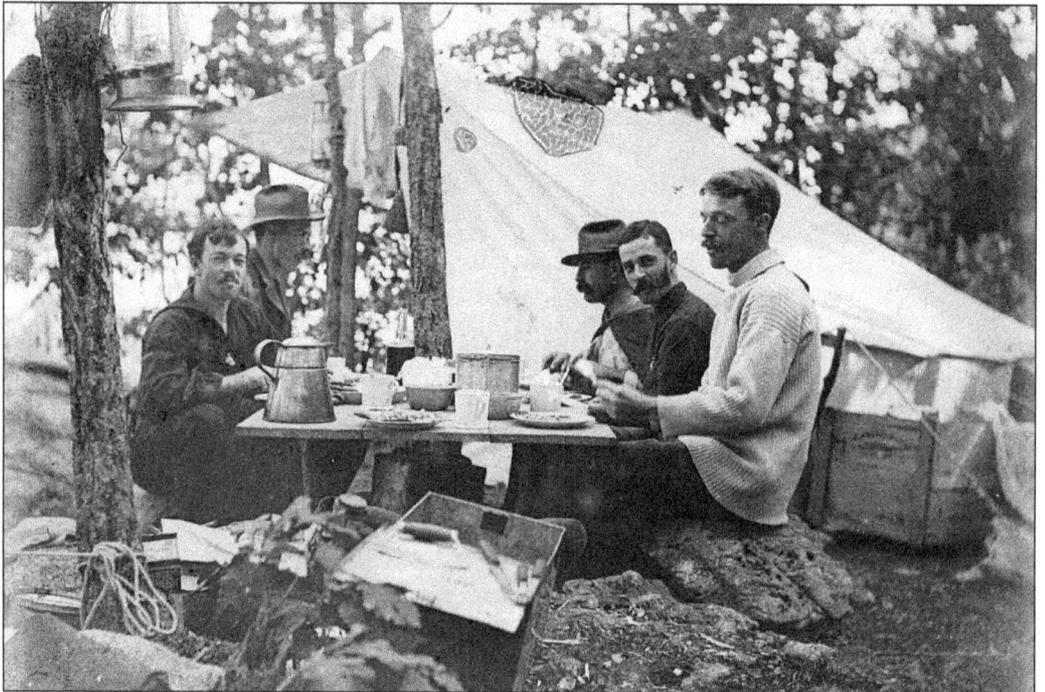

The banks of the Passaic River were a scenic place for picnicking and camping. Rocks made for a makeshift seat, and a piece of wood served as a table. The lantern provided light in the evenings (as did campfires), and an improvised tent gave shelter from the elements.

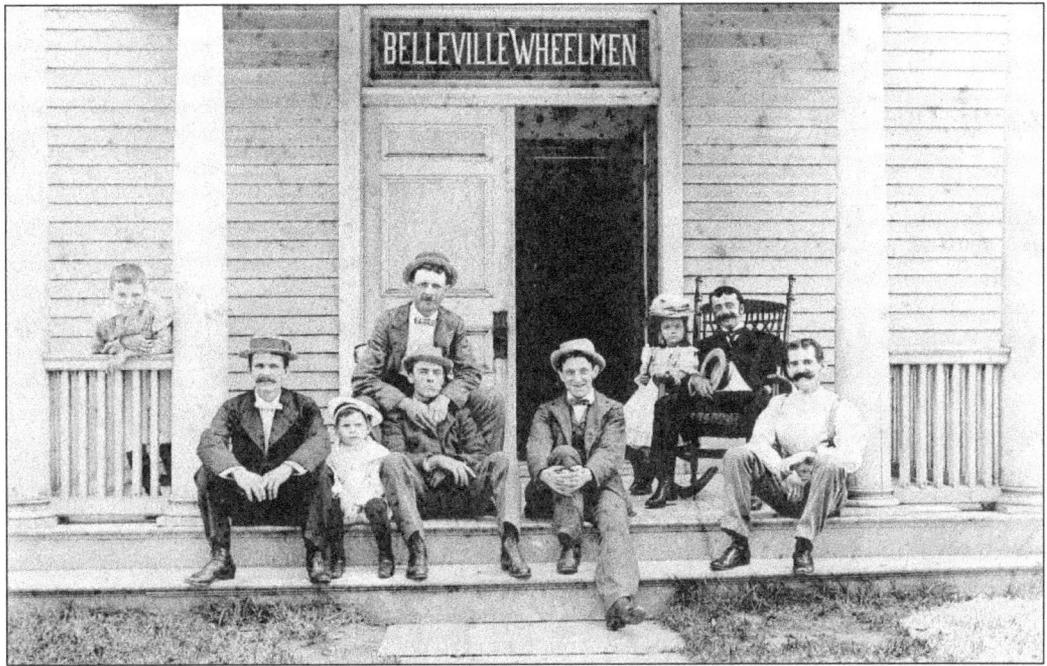

A bicycling club called the Belleville Wheelmen was organized in 1888, with its headquarters at a residence on Washington Avenue and Academy Street. Later, the group would add younger children to its ranks and continued to be competitive as the Bicycle Club into the 1950s. Tournaments were held in town and attended elsewhere by the members.

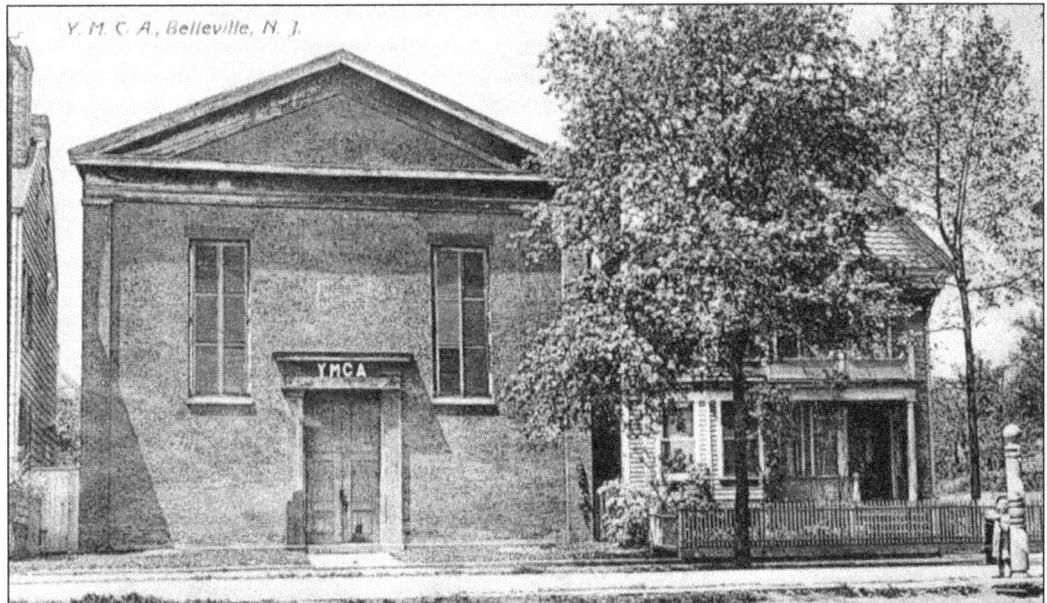

A YMCA was established in the old Wesley Methodist Church on Main Street to cater to the town's residents. Begun in England as a Bible group to keep the poorer folks off the gritty streets of London, the movement spread to the United States in 1851. Exercise and sports were later emphasized, and dormitories were built into the newer buildings to help fund the program and help those in need of an inexpensive place to stay.

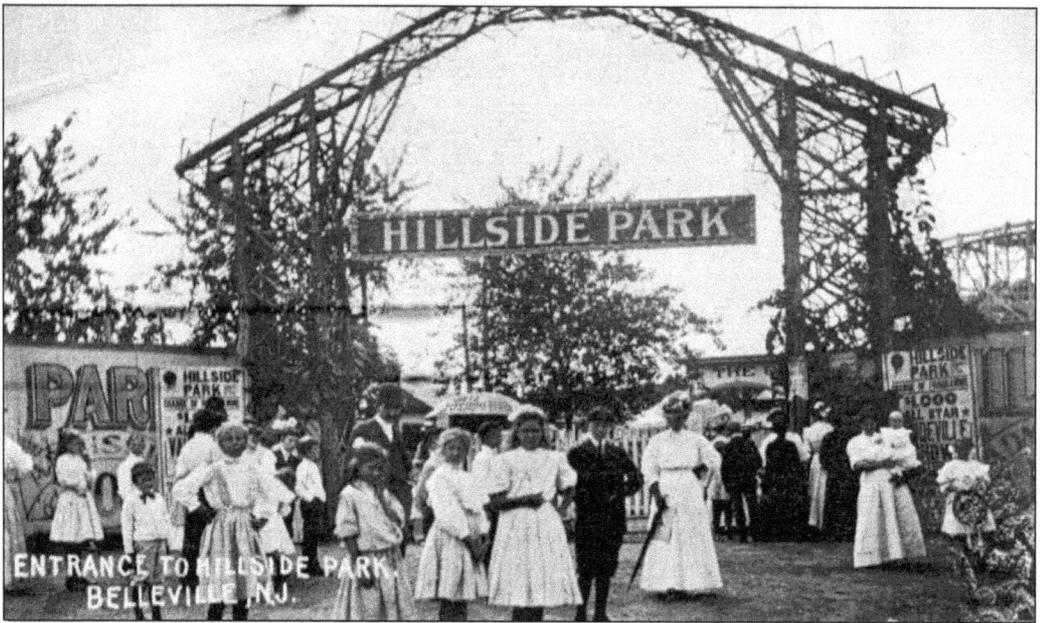

Hillside Pleasure Park was a mecca for local residents at the beginning of the 20th century, drawing nearly 10,000 visitors on a clear Sunday. Begun as a picnic grove and saloon on Washington Avenue near Greylock Parkway, it was expanded to include a man-made lake, hot-air balloon, vaudeville show, roller coaster, merry-go-round, Wild West show, and a host of other amusements.

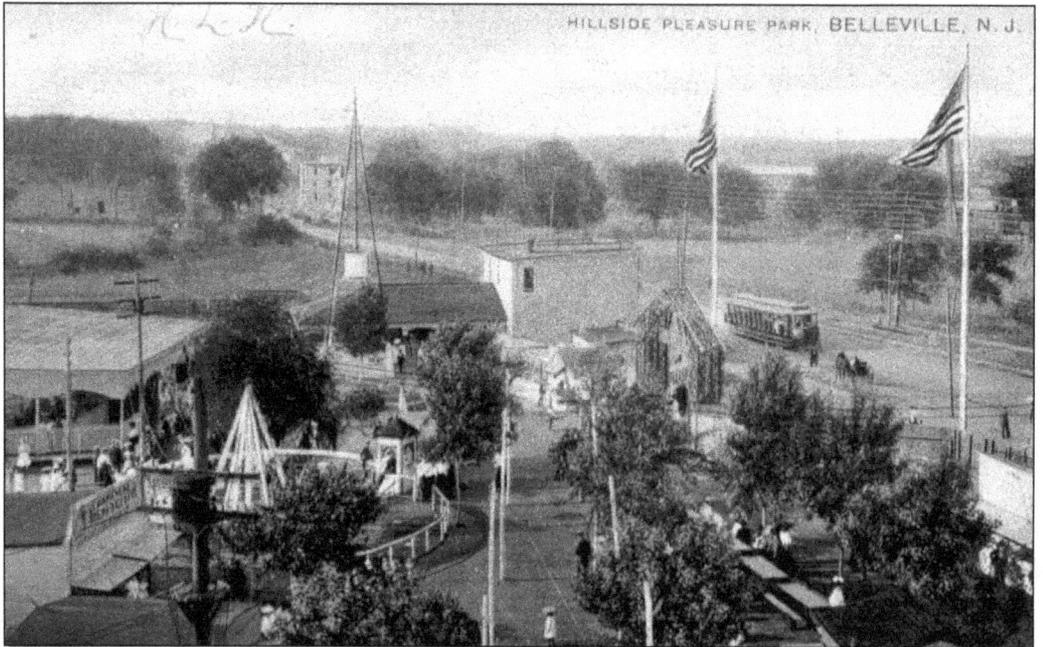

Trolley cars brought people from all over the Essex County area to Hillside Park. The carnival-like atmosphere made it a popular place for weekend excursions. A dime would admit patrons to the park, which stood where the bowling alley and McDonald's are today. Dance marathons were held during the Great Depression, followed years later by roller skating. An athletic field played host to youth football and soccer games.

Most notable of the amusements at Hillside Park was the Wild West show. Shooting and lasso-roping tricks were the specialty of the cowboys, who sometimes held mock battles on horseback in the open field, raiding the Native American village set up on the infield of the track. Pictured here is part of the cast of the 1911 show. They are, from left to right, as follows: Harry Janicke, Ben Fay, George Baston, John Franz, Minnie Gill, ? Slack, and Bert Rollins. Rowboats could be rented by the hour and paddled around the man-made, spring-fed lake. These romantic cruises were said to have been a popular way for boyfriends to pop the big question. The park would give way to a roller-skating rink and Riviera Park, later to be turned into a housing development. The Big Tree Garage, owned by New Jersey Transit, was also part of the property tract.

In the Roaring Twenties, men, women, and children would pack Hillside Park. This group depicts the era perfectly, with the young women dressed in knickers and collared shirts, ties, and overcoats, just as their male counterparts did, but sans hats. Wild animals were held in cages that lined an entire block as part of the sights. The park began as the Thaller and Crowley Saloon, with a picnic grove alongside it.

These young boys took up boxing at an early age, part of Play Day festivities in Belleville in 1922. All township children were invited to participate in a host of activities, from sports to arts and crafts. Decades later, the public schools would institute an annual Fun Day for the students.

A men's Bible class met at the Masonic Temple on Joralemon Street near Washington Avenue during the 1930s. Belleville Lodge No. 108, Free and Accepted Masons, was founded in 1870. Other fraternal organizations in town included the Knights of Columbus, Rotary, Lions, the Italian-American Civic Association, the Woman's Club, the American Legion, Elks, Kiwanis, Moose, and Veterans of Foreign Wars.

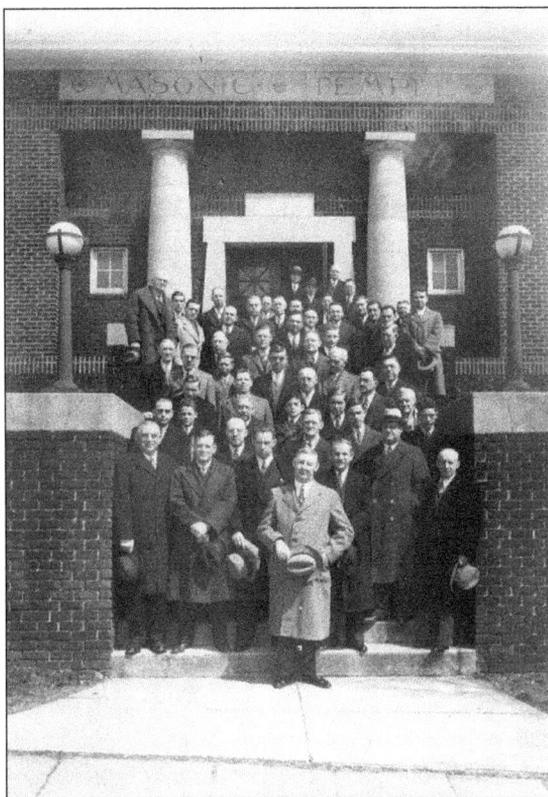

The Rotary Club of Belleville is an organization that has been heavily involved in fundraising activities for local charities and community events over the past 50 years. Pictured are the members of 1942 at a luncheon. Business owners and professionals are very involved in Rotary clubs, and more than 1.2 million people are members worldwide.

The Boy Scouts program was chartered in 1910, and many troops sprung up across the country, including one in Belleville. Boy Scout leader Harry French (back left) stands with Mayor Isadore Padula Sr., recreation superintendent Bob Cook, and a local pastor during a presentation to the local Boy Scouts and recreation program participants in the late 1950s. Padula was Belleville's first mayor of Italian descent and served from 1954 to 1962. The Boy Scouts program is still active in town today and is based in both the public and parochial schools. Scouting was intended to teach young boys the benefits of physical fitness, to build their character, and to show them how to participate in their citizenship. The recreation program has also grown over the years and has its headquarters at the Recreation House on the corner of Joralemon Street and Garden Avenue, the former site of the town farm and poorhouse. "Doc" Hood, the old baseball umpire, lived with his family in the house and served as caretaker of the property.

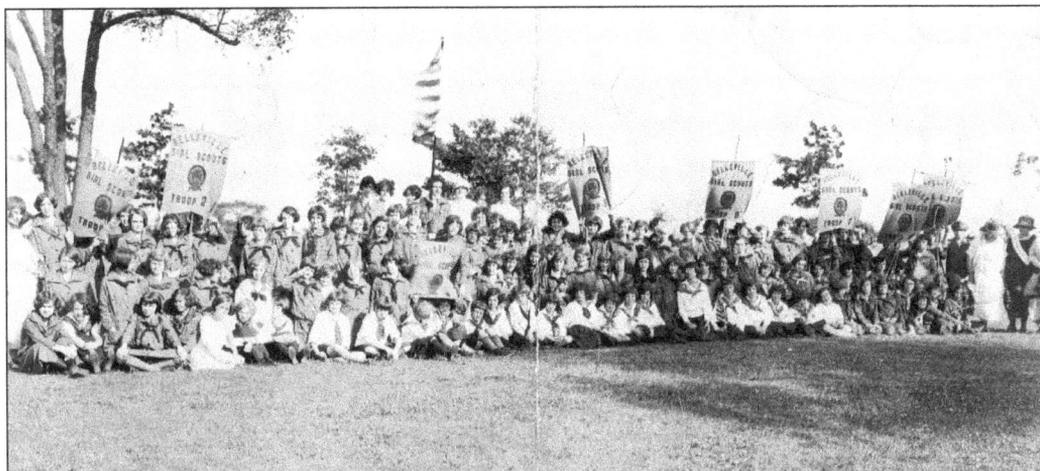

Girl Scouting has held an important place in the lives of Belleville's young women for many years. In its heyday, there were nine scout troops in town. The organization began as the Girl Guides in 1910 in England but was renamed to Girl Scouts in 1913 when the movement was brought to America. Many young Belleville women have achieved the Gold Award, Girl Scouting's highest honor.

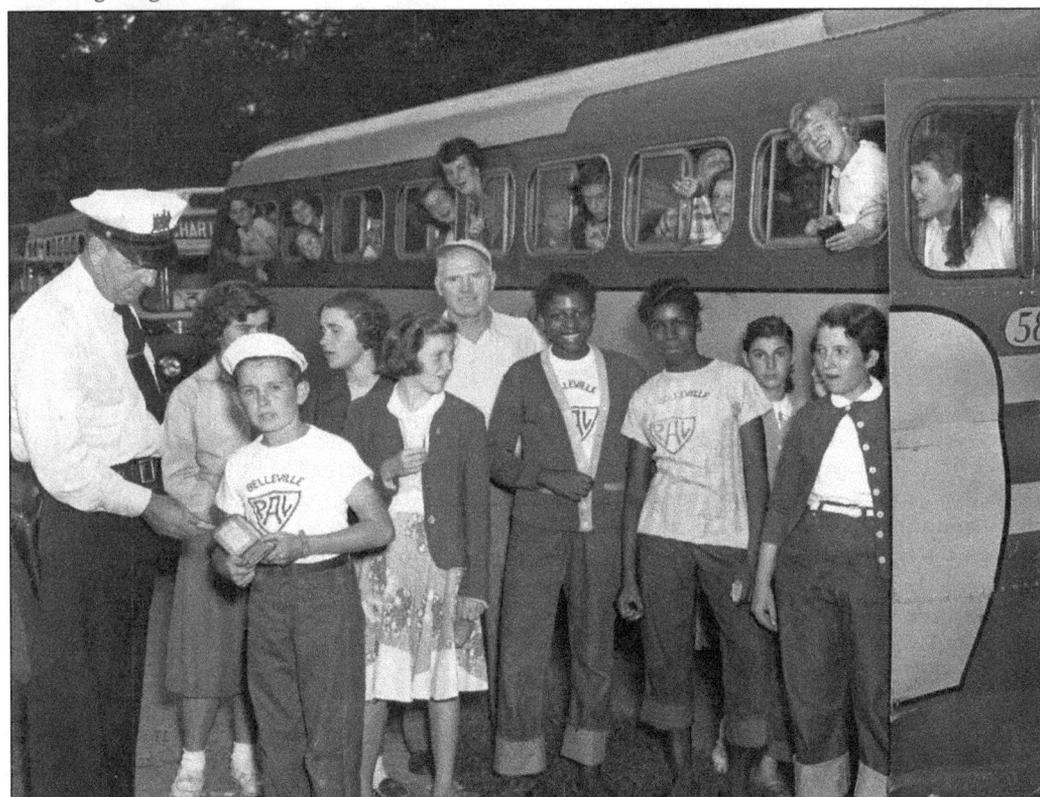

The Police Athletic League was begun in the 1930s to develop a strong bond between children and police officers and to foster respect. These Belleville children are leaving on a trip to Yankee Stadium to see a baseball game. The league also sponsored sports teams in addition to the recreational teams.

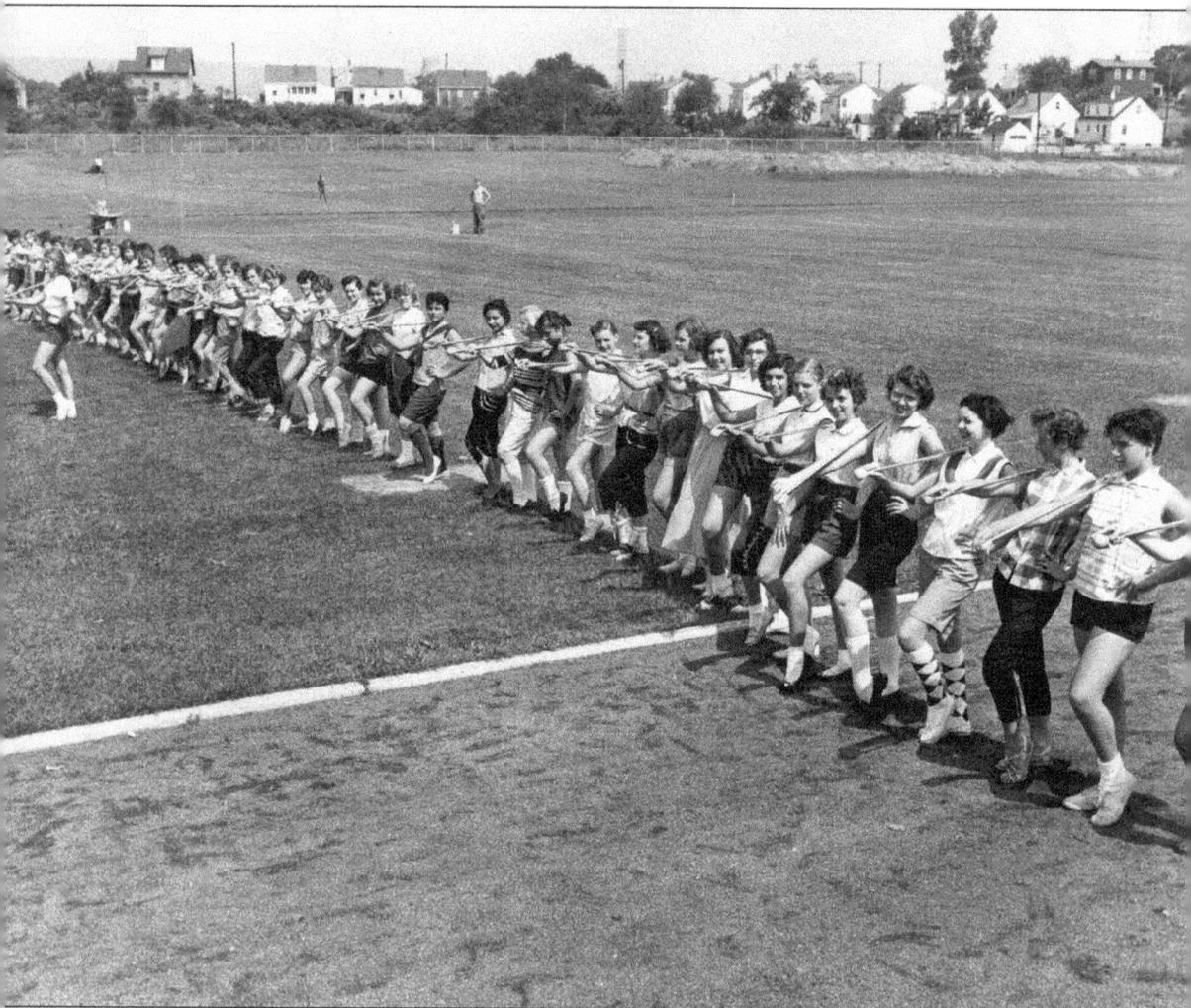

Generations of Belleville women have been involved in the recreation program's twirling clinics, which became so popular that they were held at numerous public schools a few days a week in season. These twirlers are practicing on the Municipal Stadium field, where the football team and track team competed. Girls of all ages participated, and exhibitions were held. The groups also marched in most of the local parades, from the littlest girls to high schoolers. Twirling schools would eventually open in town due to the demand of little girls wanting to learn baton techniques. The recreation department now sponsors teams in baseball, basketball, soccer, volleyball, and other sports for local adults and children alike. A summer day camp is held on the Recreation House premises, and other events take place throughout the township at different fields.

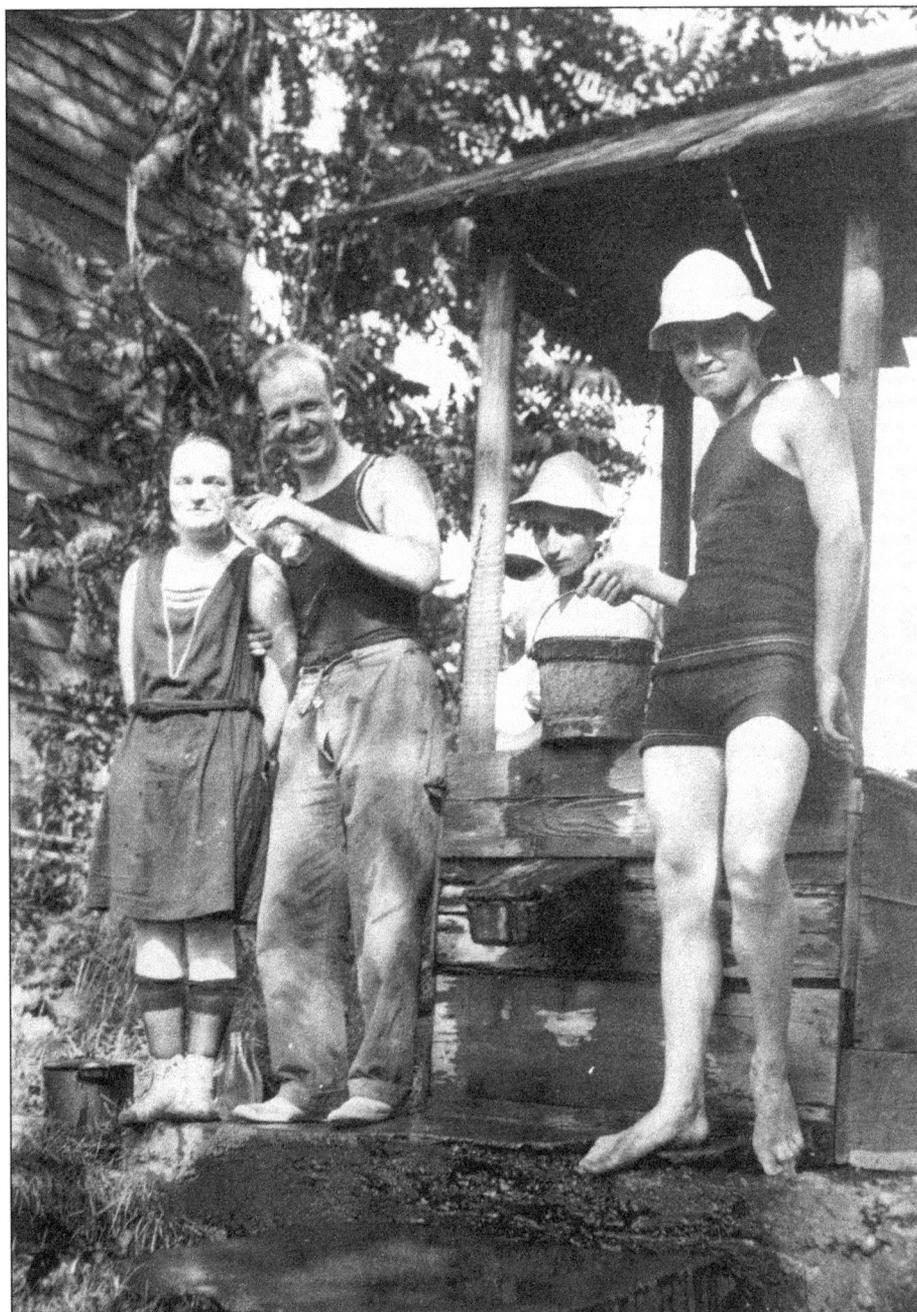

Camp Carragher was originally called the Belleville Recreation Camp and was located behind Chestnut and Hill Streets near the town's western border with Nutley. A rubber masonry wall meant to encircle the campgrounds was built during the Great Depression as a Works Progress Administration project for the sum of $875. The camp was named for Frank Carragher, a former Belleville resident and town council member. A successful businessman, Carragher was a maker of sashes and blinds for windows and also a door maker, carpenter, and building contractor. He lived at 23 Clinton Street. Recently, the former campsite was cleaned up, but its future use is still unresolved.

Built in 1920 by Joseph Stern, the Capitol Theatre stood at the corner of Washington Avenue and Joralemon Street. Movies of the time period were shown, along with short news and sports features. Playing at the theatre in 1924 were the silent movies *The Lady*, *Rose of Paris*, and *The Reckless Age*, which starred Reginald Denny.

Another program from the Capitol Theatre tells its patrons to "relax and enjoy a good show." Local businesses advertised in the small program, and a column revealing the gossip revolving around certain movie celebrities takes up an entire page. Admission to the theatre in the 1920s cost 25¢ for adult matinees and 30¢ in the evenings.

RELAX & ENJOY A GOOD SHOW

CAPITOL THEATRE

362 WASHINGTON AVENUE BELLEVILLE

TEL. PLymouth 9-9813

PROGRAM SUBJECT TO CHANGE WITHOUT NOTICE

WED THRU SAT MAT AUG 7—10

— MATINEE AT 1.15 PM —

1963

CAPTAIN

TECHNICOLOR and WONDRASCOPE MGM

SINDBAD

PLUS!

'DRUMS of AFRICA'

COLOR

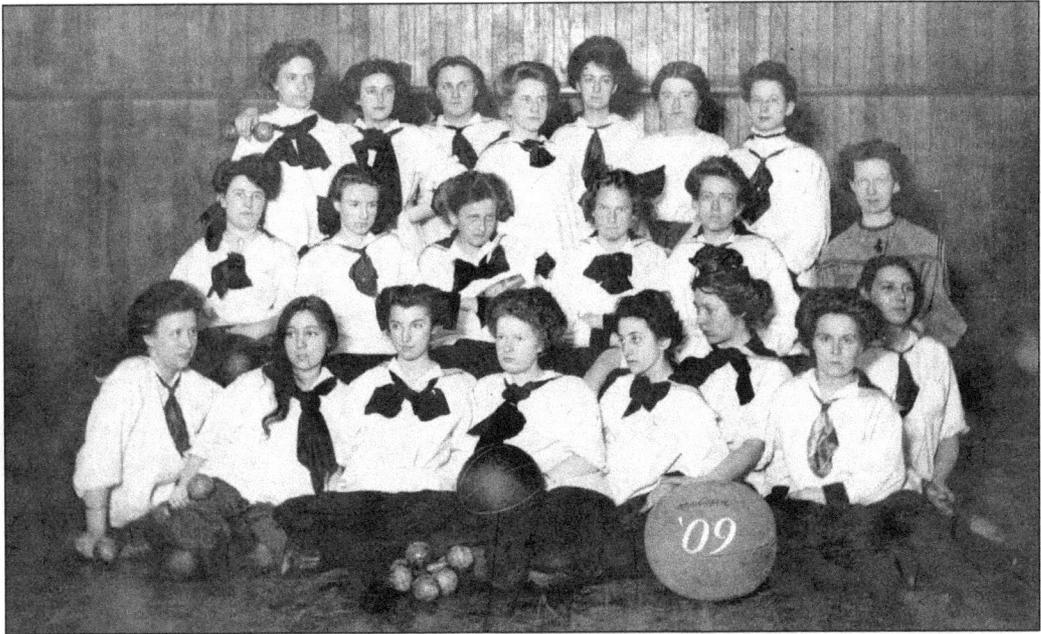

The 1909 Belleville High School girls' basketball team appears very determined in this photograph. Notice that some of the girls are holding barbells, and the two different-sized basketballs stand out. Basketball had only been in existence for two decades when this picture was taken, yet women began playing within a few years of its inception.

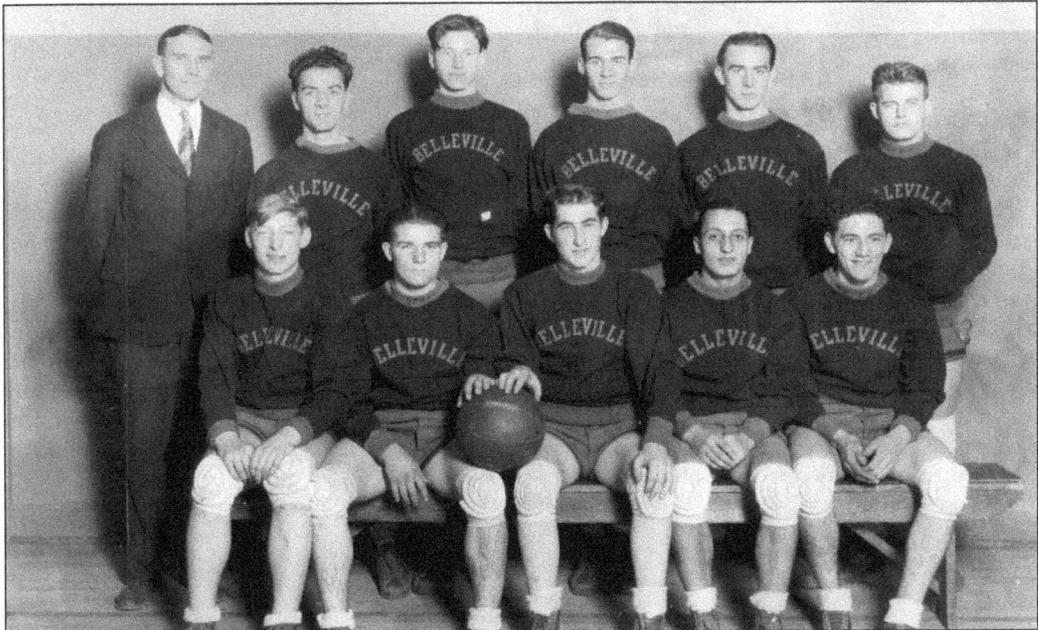

Most of the high school athletes shown in this picture from the early 1930s are unidentified, but the Belleville High School basketball team advisor, a Mr. Kittle, is in the back row on the far left. Only the names of Bill Bennett and Ralph Casale were recorded. What is unique here is that the sneakers the boys are wearing, Converse "Chuck Taylor" sneakers, were named after a basketball player who promoted the shoes in basketball clinics across the country in the 1920s.

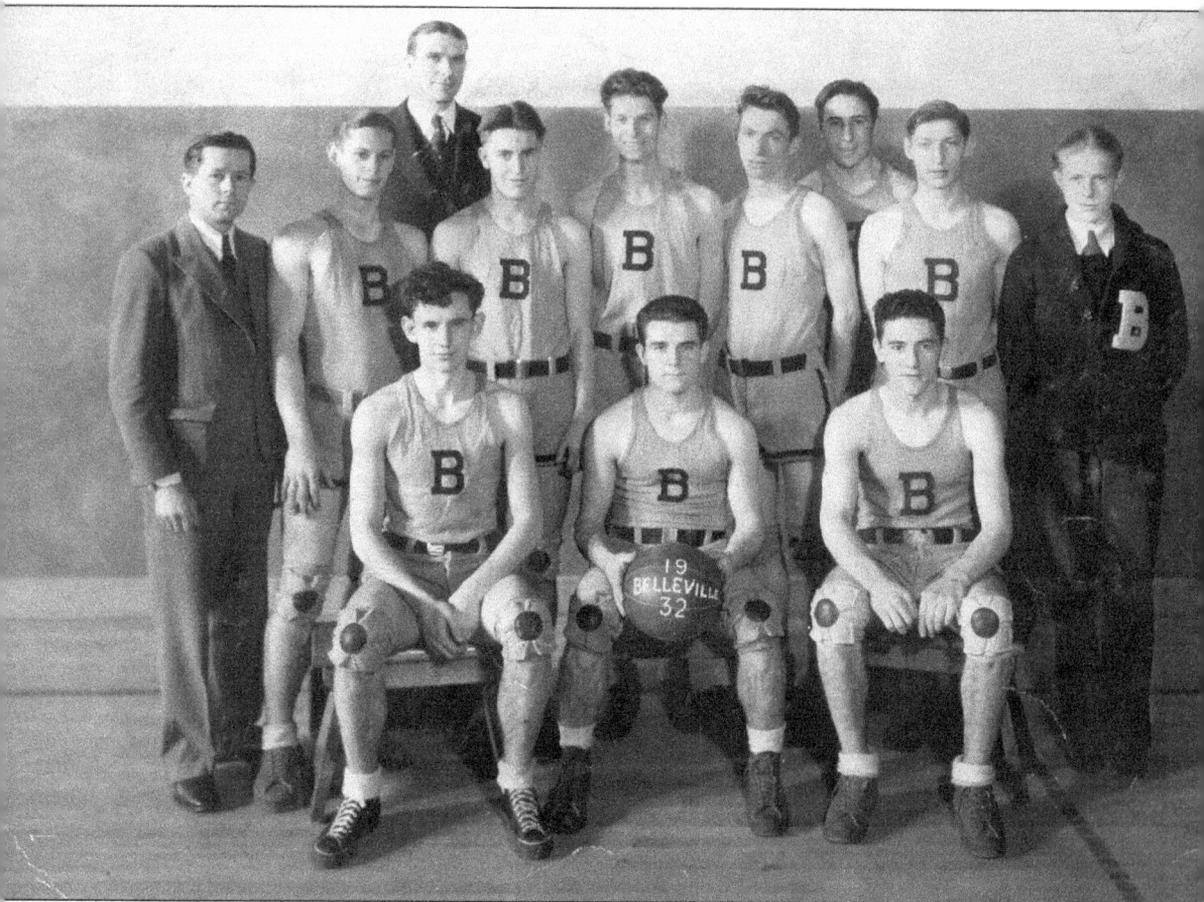

The Belleville High School basketball team in 1932 carried the nickname the "Bees," which was the moniker for boys' athletic teams before changing to the Bellboys and then the Buccaneers. Pictured from left to right are the following: (front row) Ray Smith, Mac Lamp (captain), and Nick Bonavita; (back row) ? Kittle (faculty advisor), Carl Wittish, ? McBride (coach), Eddie Mutch, Henry Bohrer, Eddie O'Neil, Joe Roberti, Louie Westra, and George Anderton (manager). The game itself was claimed to have been invented in 1891 by James Nasmith, who called it "basket ball" and gave it 13 basic rules. The game would evolve and capture the attention of high school students, including these young Belleville men. Originally, a basketball hoop was closed, so when a basket was made, a string had to be pulled to let the ball out. It was not until 1906 that netting for the basket was opened to let the ball fall through. Early basketballs were made from panels of leather stitched together and covered with a cloth lining. The insides were lined with a rubber bladder.

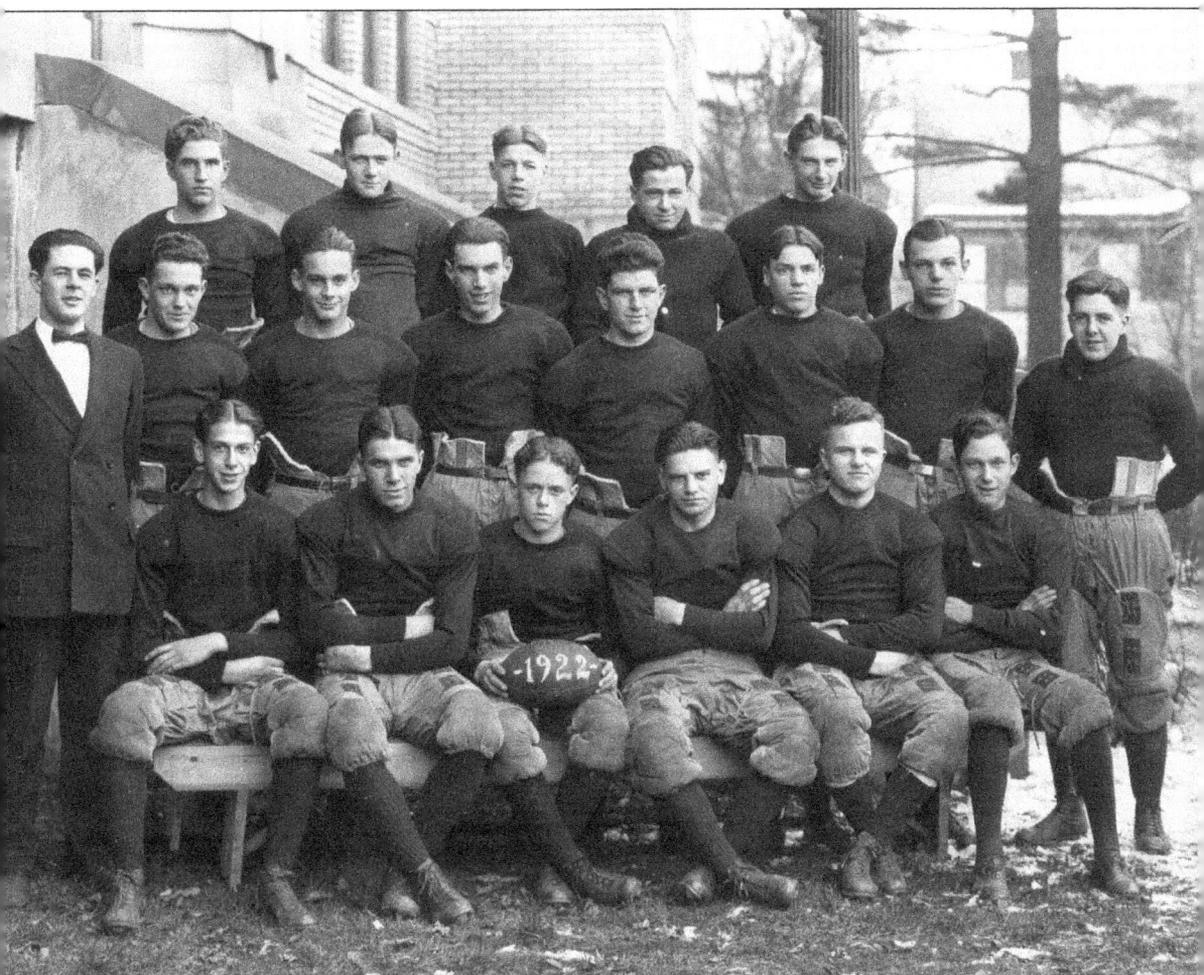

Football has always been a popular sport with the youth of Belleville, even as far back as 1922, as seen here. This team had a rough-and-tumble look to it. They are wearing small shoulder pads compared to the equipment of today, and padded pants helped insulate from the cold and from hard hits on the field. Helmets were sometimes worn on the field, also padded and nowhere near as comprehensive as those used nowadays. Some of the players known to be in this photograph are Bill Hirdes, Red Kane, Bob Much, Art Patten, "Fat" Sanborn, Buddy Greories, and Jack Boyd. Many players were multilettered stars and competed in different seasonal sports. These young men were playing in all kinds of winter weather—even here there is snow on the ground. Two years before this photograph was taken, the National Football League was established, with a total of 14 competing teams, nearly 60 years after the game first gained popularity.

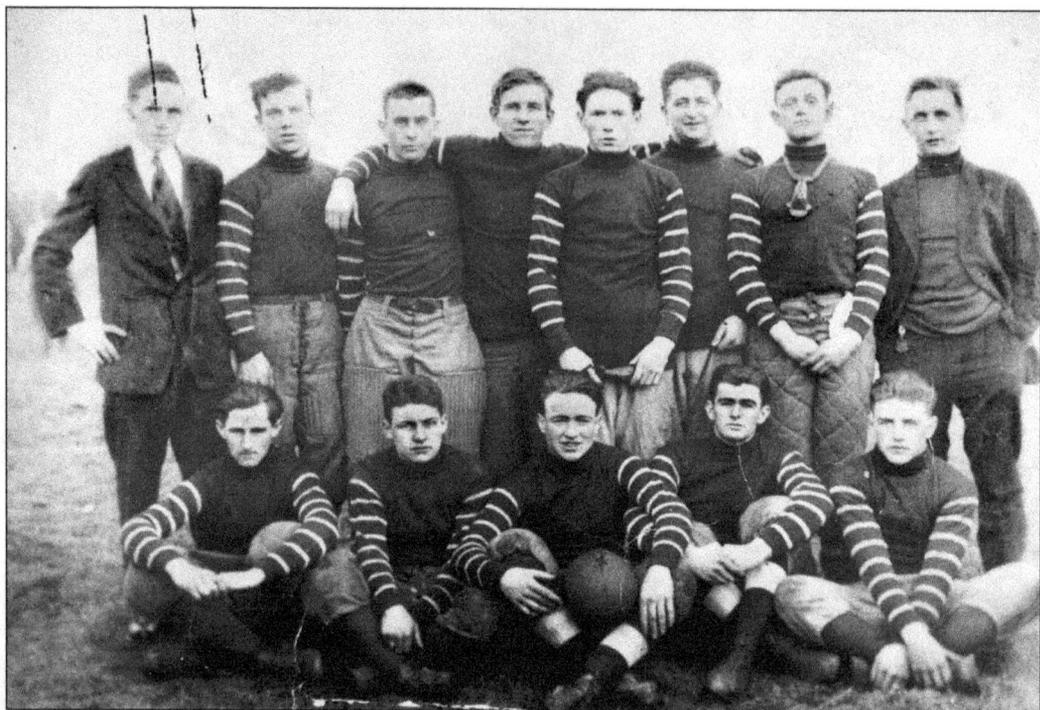

Even the local parochial schools became hooked on the sport of football, which had its roots in the 1820s as a barbaric way of "initiating" college freshmen. This 1915 team played for St. Peter's School. From left to right are the following: (front row) Thomas Monaghan, Paddy Byrnes, John Oldham, Frank Ward, and John Byrnes; (back row) Alex Derbyshire, James Dunleavy, Harry Ward, Joseph Lister, Terry Hughes, Charles Ward, Owen Travis, and Joseph Byrne.

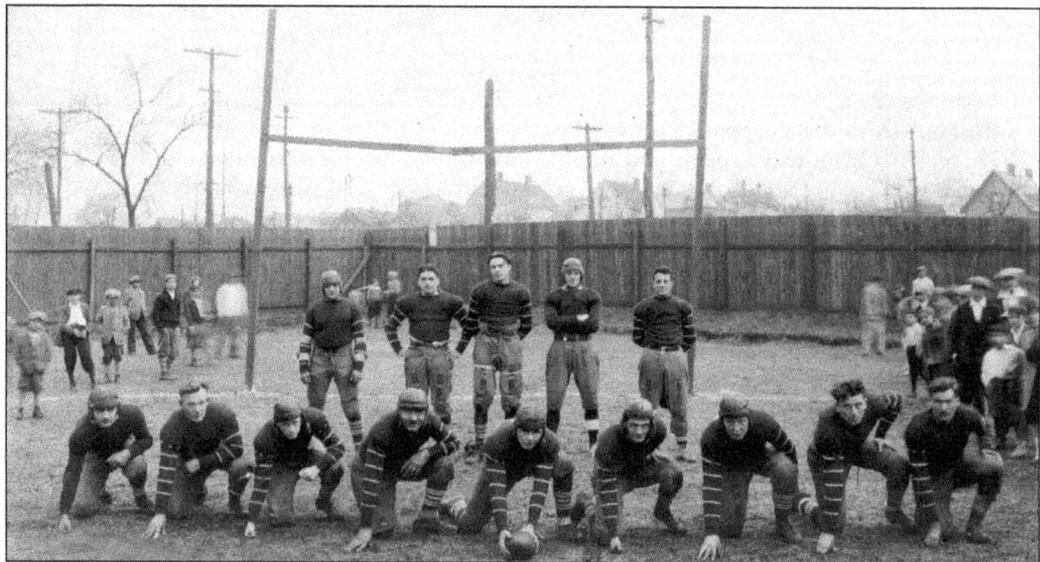

This 1927 Capitols football team from Belleville looks ready to crush its Nutley opponents. From left to right are the following: (front row) ? Bowman, Les Bought, Willie Reilly, Pat Pucillo, Pat Dunn, Joe Gibbons, Len Bought, Oliver Scott, and Chet Seagraves; (back row)-Woody Stahile, Harry Sullivan, Bob Mutch, Al Maun, and Artie Macaluso.

124

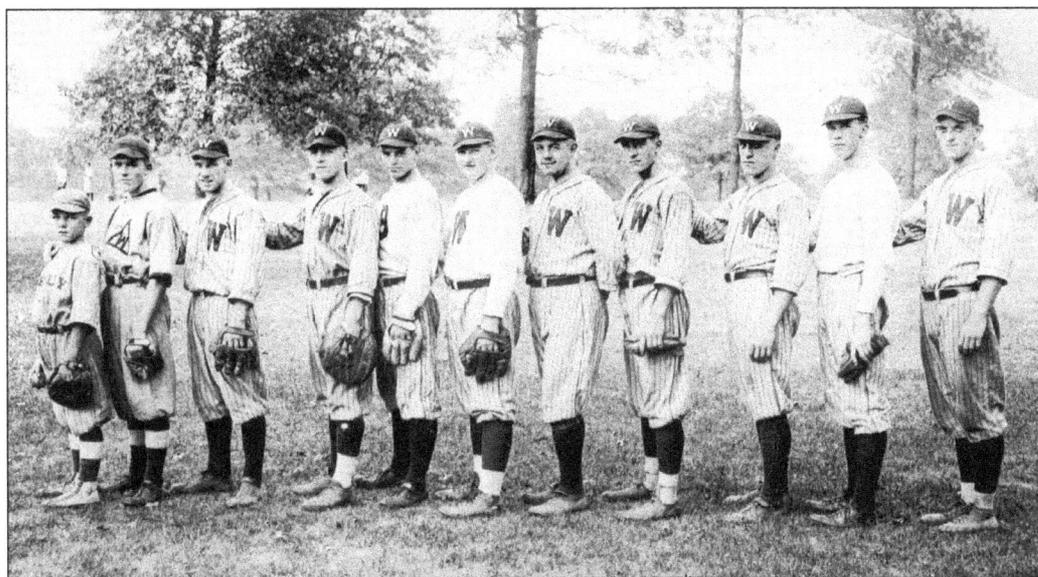

Wesley Methodist Church fielded its own baseball team, shown in this undated photograph. The catching gloves ranged from small everyday gloves to large padded styles and gloves that were not webbed. From left to right are ? Machamb (bat boy), Dave Lamb, J. Carlough, J. Lamb, B. Williston, W. Bradshaw, F. Shofield, Artie Lamb, G. Riggs, C. Davis, and B. Jacobsen.

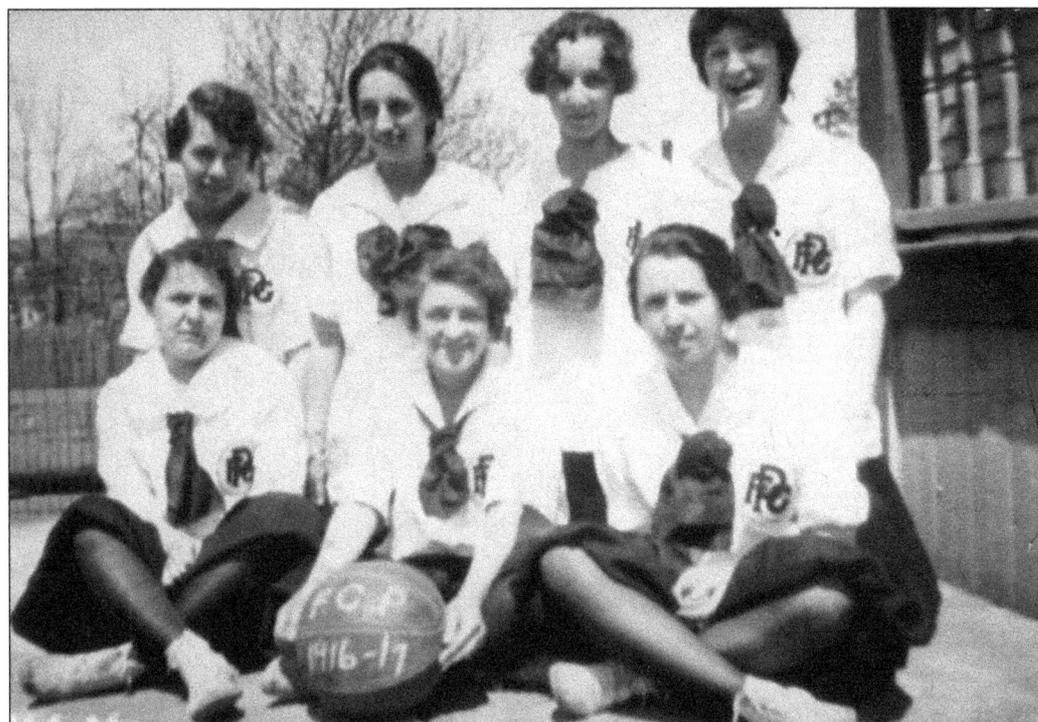

The girls on this basketball team from the 1916–1917 season might have represented one of St. Peter's athletic clubs, but the author has not been able to positively identify the FGP logo on the uniforms. It was hard to field a full basketball team, as the game may not have appealed to the sensibilities of young women at the time.

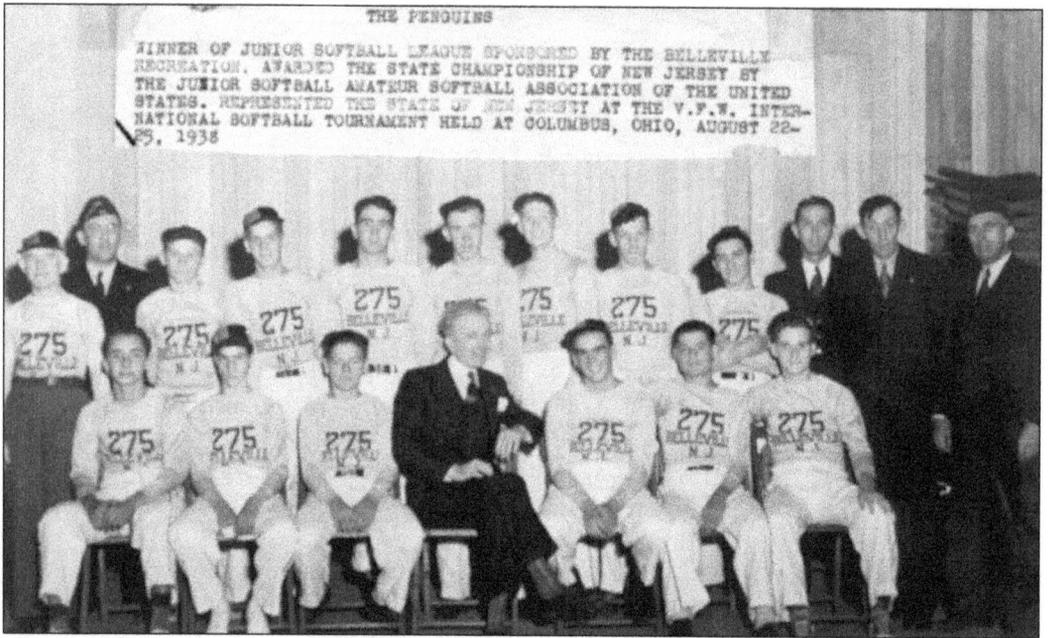

THE PENGUINS

WINNER OF JUNIOR SOFTBALL LEAGUE SPONSORED BY THE BELLEVILLE RECREATION. AWARDED THE STATE CHAMPIONSHIP OF NEW JERSEY BY THE JUNIOR SOFTBALL AMATEUR SOFTBALL ASSOCIATION OF THE UNITED STATES. REPRESENTED THE STATE OF NEW JERSEY AT THE V.F.W. INTERNATIONAL SOFTBALL TOURNAMENT HELD AT COLUMBUS, OHIO, AUGUST 22-25, 1938

The Belleville Recreation Department's Penguins junior softball team was the winner of the New Jersey state championship, awarded by the Junior Amateur Softball Association of the United States in 1938. The team represented the state of New Jersey at the VFW International Softball Tournament held in Columbus, Ohio, in August of that year.

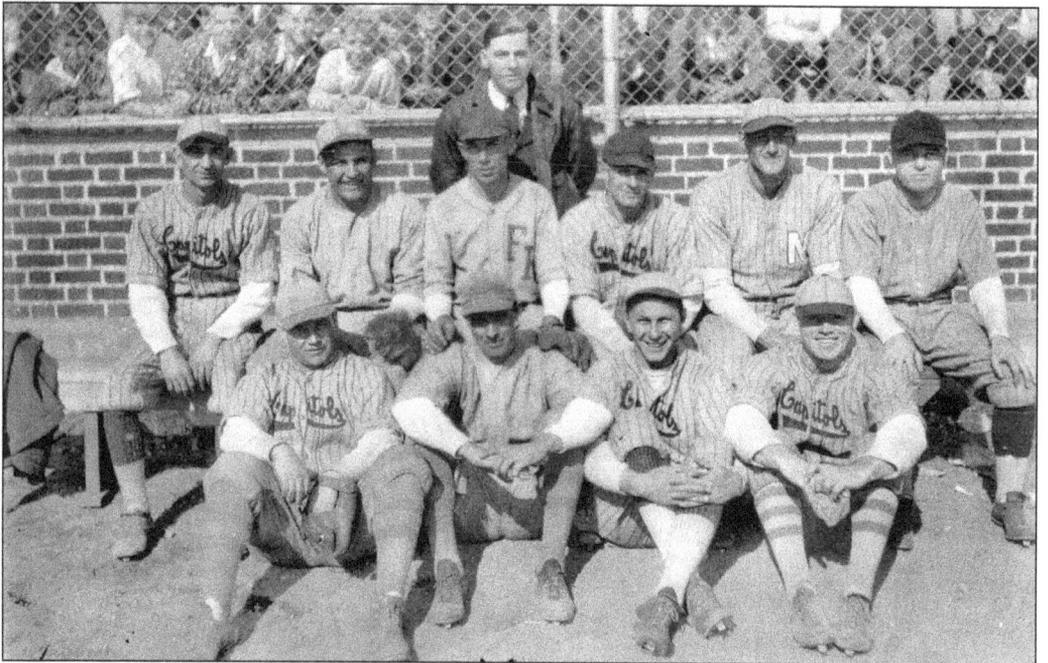

The Capitol Theatre also sponsored the 1929 champion young men's baseball team, which played at Clearman Field. Coach A. Caruso, in the rear, led the group. From left to right are the following: (front row) John Mallack, ? Galshen, ? Klenz, and Tom Dunn; (back row) Joe Flynn, Jim Mallack, J. Dunleavy, C. Schleckser, ? Kintzing, and Jim Dunn.

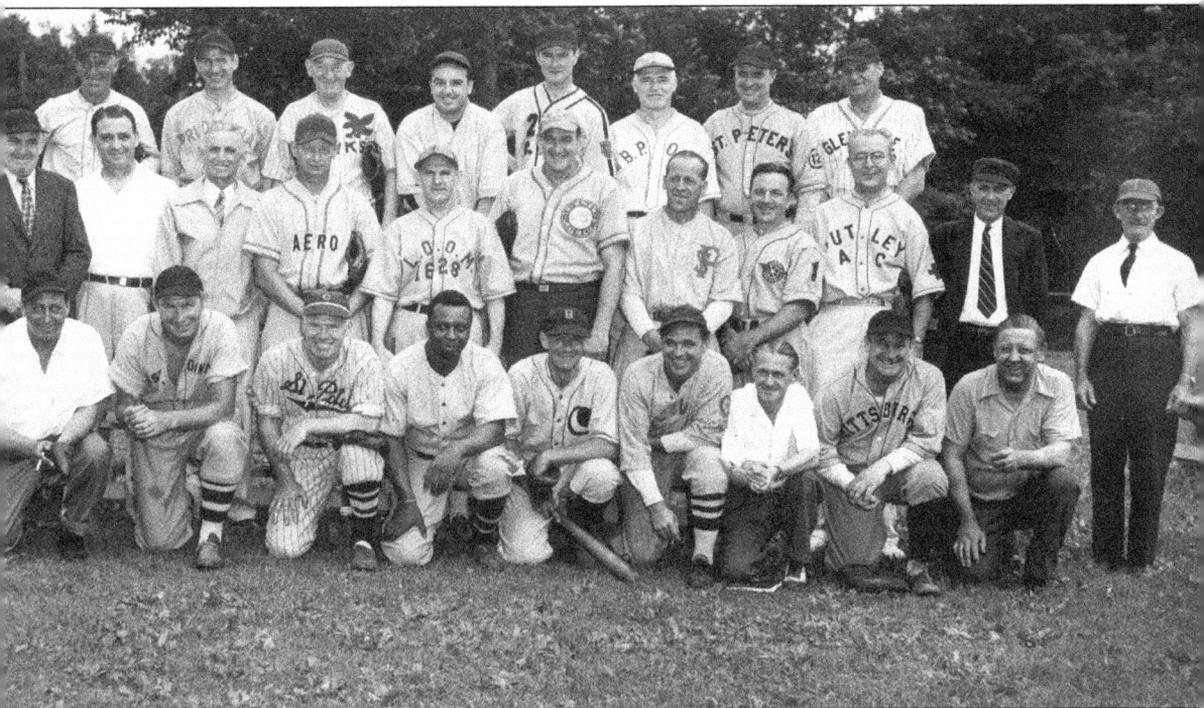

An eclectic bunch of middle-aged and older men, the Twilight League Old Timers played on many of Belleville's recreation baseball teams. This photograph was taken after a game on July 4, 1945, toward the end of World War II. Pictured from left to right are the following: (front row) ? Juliano, ? O'Neil, T. Dunn, ? Hardaway, ? Schleckser, D. Dunn, ? McCarthy, M. Mallack, and ? Lou Beleski; (middle row) "Bun" Derbyshire, ? Caputo, ? Machette, ? Lawson, ? Stout, ? Kintzing, ? Kastner, ? Kappeler, ? Costenbader, ? Jackson, and "Doc" Hood; (back row) J. Dunleavy, ? Kinnealy, ? Flynn, ? Christell, ? McHugh, J. Dunn, ? Gelshen, and ? McDaniel.

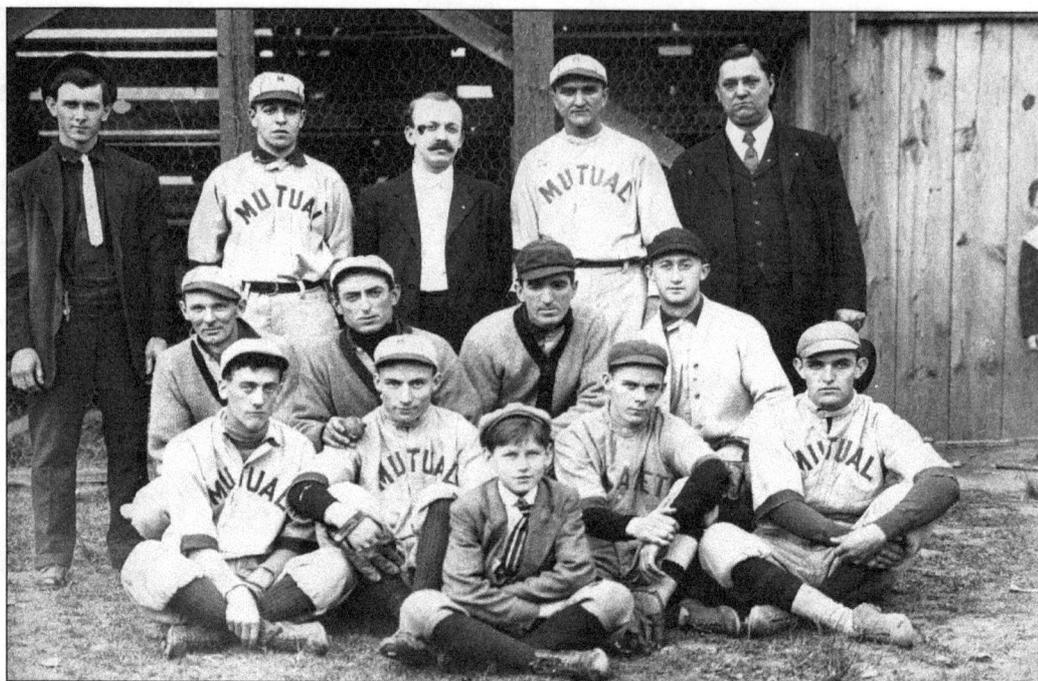

This team played in 1910 as the Mutuals, possibly sponsored by the Mutual Benefit Life Insurance Company of Newark, which was founded in 1845. Pictured from left to right are the following: (front row) ? Wilderman, M. Welsh, ? Gracie, and G. Schwartz; (middle row) J. Schurr, S. Machette, J. Wirth, and J. McCarthy; (back row) ? Anderson, B. Crisp, A. Crisp, B. Fry, and ? Brooks. The boy up front is a younger Brooks.

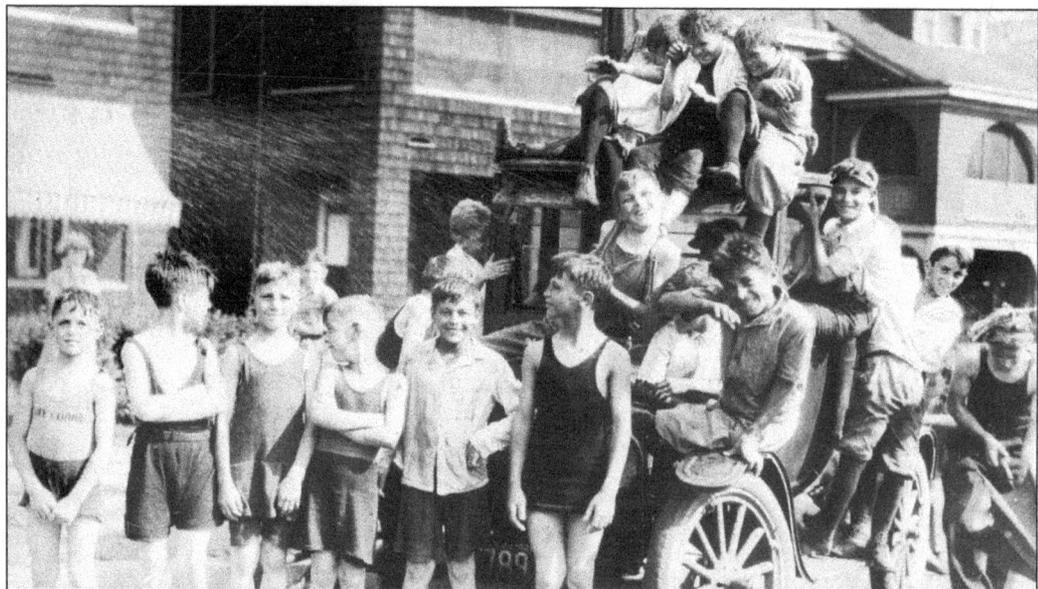

A group of children surround a c. 1920s automobile just outside the Washington Avenue fire station. This hardy gang frequented the station to spend time with the firefighters on call and hope for a spray of cool water on hot summer days. Water hydrants were one way of escaping the heat. The homes behind the youths are still standing to the right of the station today.